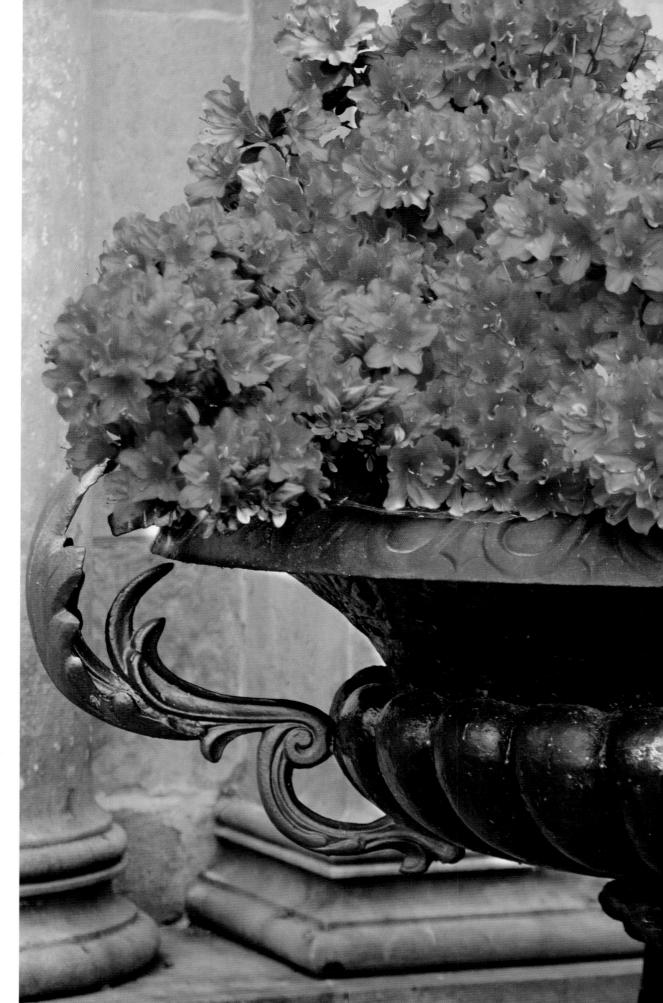

Look to this day!
For it is life,
the very life of life...
For yesterday is but a dream
And tomorrow is only a vision,
But today well lived makes
every yesterday a dream
of happiness
And tomorrow
a vision of hope.
Look well, therefore,
to this day!

Kalidasa

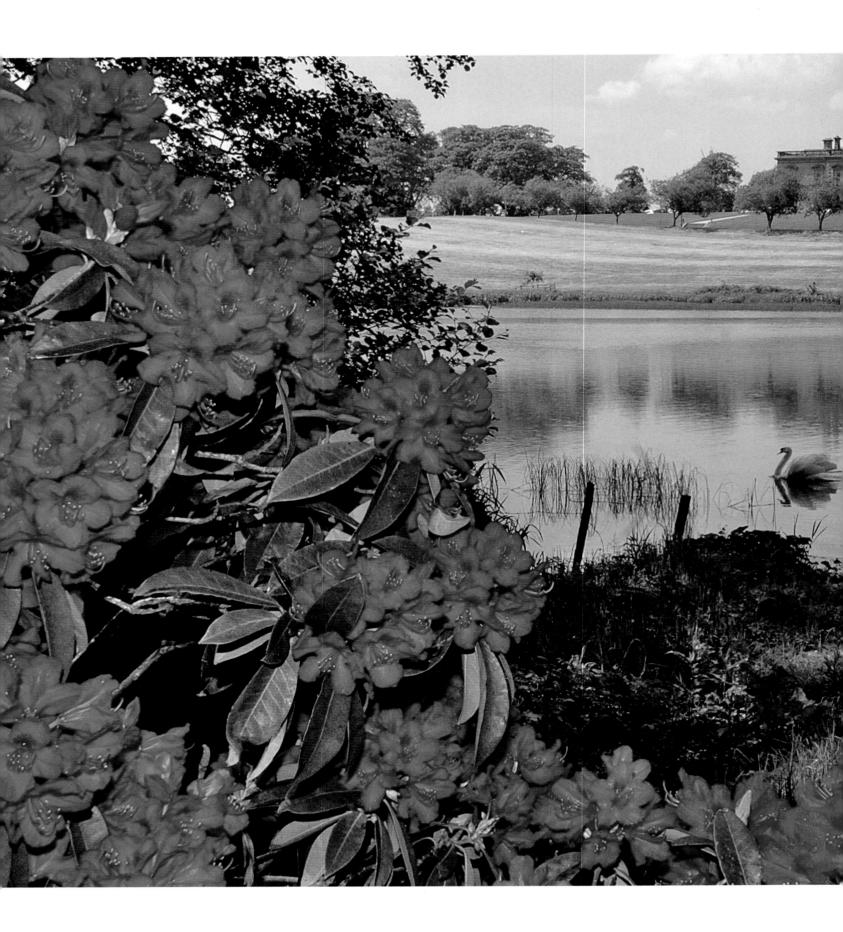

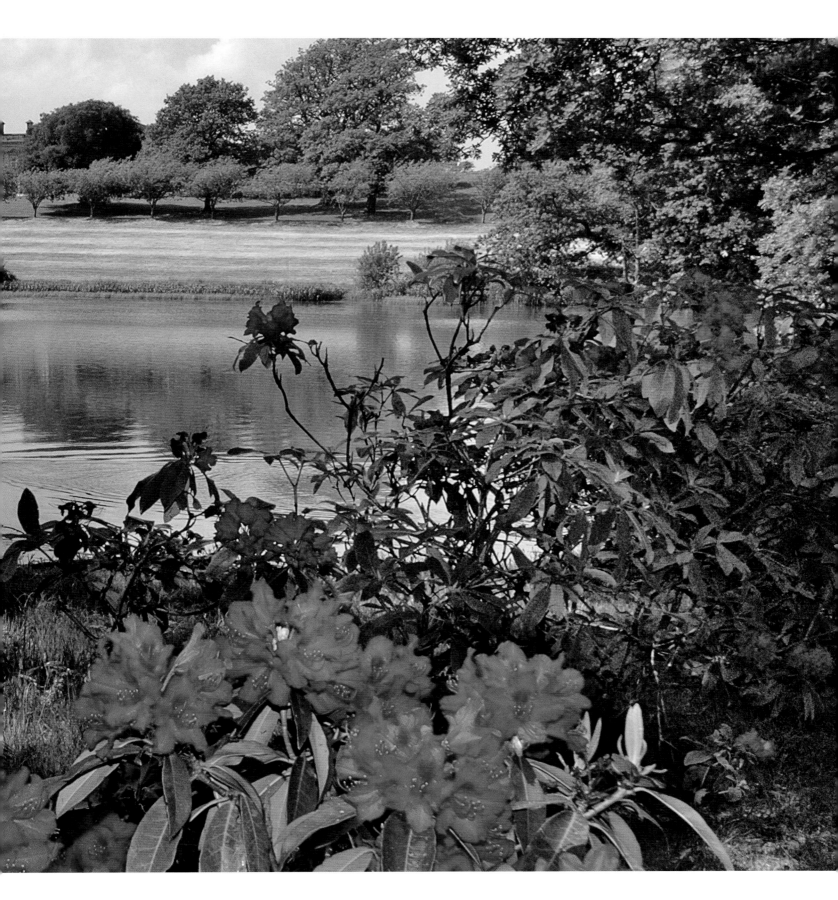

Dromantine in Bloom

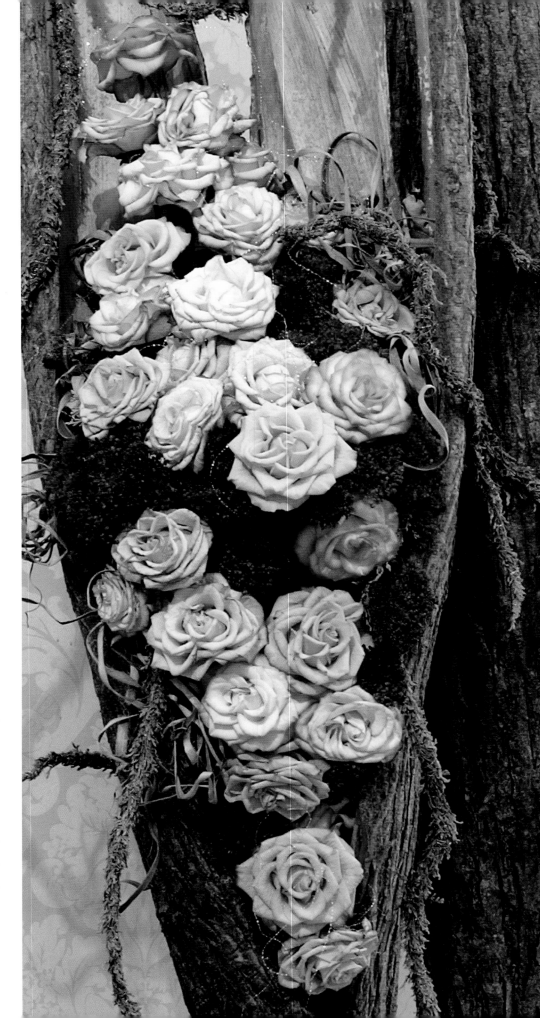

This rich spiritual soil,
this great earth alive with the diversity
of people and traditions —
giving rise to new culture,
a new humanity...

Continue your uncompromising quest
for your truer roots
in the deepest regions of your lives,
Seek out the primordial "roots" of humankind...
If one reaches back to these fundamental roots,
all become friends and comrades...

Now is the time for you to realize
that through relations
mutually inspiring and harmonious,
the "greater self" is awakened to dynamic action,
the bonds of life are restored and healed.
And blossoms in delightful multitude
exude the unique fragrance
of each person, of each ethnicity.

Daisaku Ikeda

Floral Design by
Floreat Workgroup
Isle of Man

Dromantine in Bloom

Flowers in Praise of Diversity

Pamela J

I hope this publication will be a source of inspiration to all who view and reflect upon the images and accompanying poetry and prose. The beauty and wonderment that the floral creations give rise to are captured for time evermore… a keepsake for future generations.

Our creations are part of God's greater creation.

Fr P J Gormley SMA
Superior of Dromantine

Dromantine in Bloom

Flowers in Praise of Diversity

All photographs © Pamela J
(except as noted in Acknowledgements)

Design: Pamela J

Production: Mike Miller
Prism Photographics, Inc., Santa Cruz, California, USA

Editor: Jean Brook

Published in 2007 by Pamela J Photography
180 Ruby Avenue
San Carlos, California 94070 USA
www.pamelajphotography.com

FIRST EDITION

ISBN 978-0-9777713-1-8

Printed and bound by Tien Wah Press, Singapore

Below: Floral design by representatives of NIGFAS
Northern Ireland Group of Flower Arranging Societies

Contents

Foreword

The extraordinary success of Floral Design 2000 inspired us to consider a similar event as part of the Society of African Missions' 150th anniversary celebrations in 2006.

Previous committee members agreed to reassemble, and with a few additional members, they met regularly over a three-year period. Their enthusiasm was infectious, some travelling hundreds of miles to attend meetings. We are immensely grateful to them.

The initial response and suggestions from those who had attended the Floral Design 2000 event encouraged us to enlarge on that programme. In 2006, the new wing at Dromantine was opened and this provided us with an exquisite display and activity area.

Fr P J Gormley, Superior of Dromantine, anxious to have a pictorial record of the event combined with a brief history of Dromantine, approached talented American photographer Pamela J of San Francisco to document the event. Her work is now captured in this splendid publication. Colourful images portray the rich diversity of those who attended as delegates. Twenty-one countries were represented, united in a love of flowers.

The skill and artistry of those who demonstrated and taught, those who decorated the chapel and the house, and those who competed have all been captured in this wonderful book. Pamela has also recorded the public response. Thousands of people travelled from all over Ireland to view the exhibits, place a rose in "A River of Roses," and attend the innumerable events staged throughout the grounds. Unity in diversity was certainly obvious during that memorable week in May and June 2006.

Pamela J's sensitive images have provided us with a lasting and beautiful record of a truly memorable event in the life of Dromantine. And the inclusion of aptly chosen poetry, prose and quotations, serves to enhance the images and give the book a universal spirit, thus lending another dimension to our enjoyment of the book. We thank Pamela most sincerely.

We also wish to place on record our sincere thanks to Mrs Bernie Monaghan, secretary of our committee. Her attention to detail and ability to remain smiling, despite the many demands on her time and energy, were crucial to the smooth running of the event.

This was a very special week in the lives of all who attended and one that will remain with us for a long time to come.

REV WILLIAM McMILLAN MBE FR EAMONN FINNEGAN SMA

CO-PRESIDENTS OF FLORAL DESIGN 2006

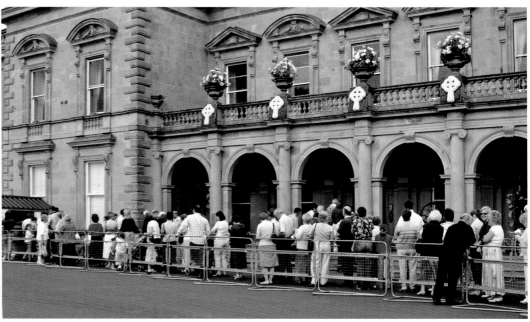
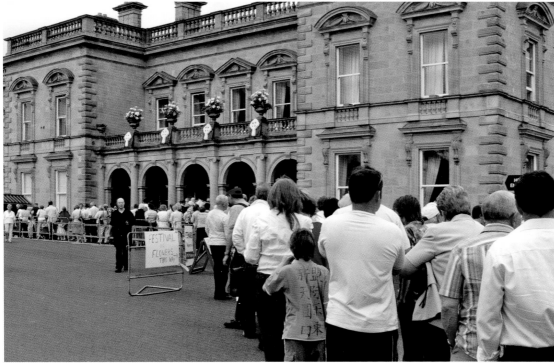

While each individual flower has its own beauty and significance, it is only when we see how well it works among others that its true beauty and character can be fully appreciated. There is beauty and strength in diversity. A very diverse group of people worked together to bring Floral Design 2006 to fruition, and during the week's events, people from every corner of the world came together in Northern Ireland to celebrate diversity, in flowers and indeed in people.

Fr P J Gormley SMA
Superior of Dromantine

P.J. Gormley

I Know a Place in Africa

My heart is at home in Africa
Where the sound of drums beat in my chest
And the songs of time ring in my ears
Where the rainbow mist glows in my eyes
And the smiles of friends make me welcome

My mind is at ease in Africa
Where the people still live close to the soil
And the seasons mark my changing moods
Where the markets hustle with trading
And Creation keeps its own slow time

My soul is at peace in Africa
For her streams bring lifeblood to my veins
And her winds bring healing to my dreams
For when the tale of this land is told
Her destiny and mine are as one

Wayne Visser
Excerpt © 2006

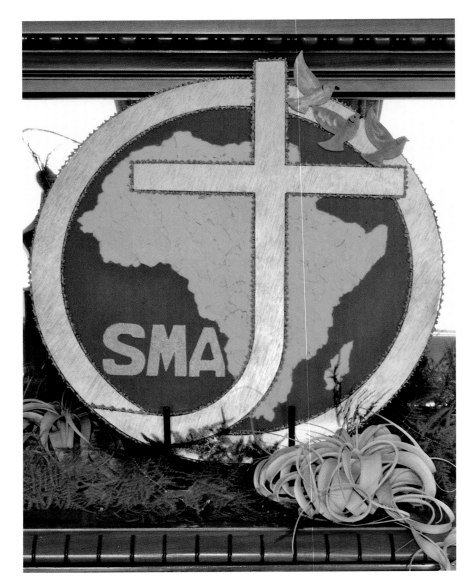

Following an international competition, the above SMA logo was approved in May 2005. Beautifully recreated entirely in plant material by Betty Birney of Northern Ireland, the logo expresses the mission of the SMA in the world today. Africa, the heart of SMA missionary activity, is surrounded by a circle leading to the Christian Cross, which covers the continent, offering protection. The three doves represent love, hope and peace, and their flight around the Cross symbolises the new life that it brings. The colours are also symbolic: blue for the Blessed Lady and yellow for the link of SMA missionary activity and the Church in Rome.

Opening Address
Floral Design 2006

The Society of African Missions (SMA) is very proud and honoured to be associated with Floral Design 2006 – international symposium of floral art and design.

On behalf of the SMA Irish Province, I welcome all of you individuals and groups of more than 180 floral artists who have gathered from 21 countries to Northern Ireland and to Dromantine. This is a week when our very souls are nourished by the splendour of God's creation married to human imagination and expertise.

One might well ask why a missionary society would become associated with a festival of floral design. The connection might not be immediately obvious. However, when one reflects that one of the attributes of God is that of beauty, then the connection becomes self-evident. Few things in life are more beautiful or exquisite than a well-constructed floral design. This surely gives glory to God.

We in the SMA are thrilled that once again, this wonderful setting of Dromantine has been chosen as the site of giving such glory to God. It is a festival befitting the place and a place befitting the festival. To see the 200-year-old building and grounds adorned with such beauty is a real joy to behold.

SMA is also thrilled to be associated with the festival because of its international character. The SMA draws its membership from each of the five continents and works on mission in 17 African countries. We are a community of Christ's disciples, founded in France in 1856, and we seek to live the values of the Gospel in all that we do. On this, the 150th anniversary of our foundation, it is a special honour to host this outstanding exhibition.

In the millennium year, the floral festival showed Dromantine at its very best. Thousands of people flocked here to be nourished by beauty and inspired for living. That notion of living is important because Dromantine is a living place. As the SMA looks beyond this anniversary year to its future mission, Dromantine assumes significant importance. We see Dromantine not just as a beautiful house and grounds, but as a place of rest and a place of peace. And we want to use the facility of this magnificent structure as an agent of peace and reconciliation among communities. This flower festival is another occasion when the bonds of friendship and affection across communities and religious faiths are strengthened.

What most impresses me about this festival is its ecumenical, inter-religious and cross-community dimension. We would like to think Dromantine can serve as an oasis of calm and peace in a truly ecumenical spirit. In a strange historical happenchance, the very early days of SMA had an ecumenical character. The founder of the SMA, Bishop Melchior de Marion Bresillac, travelled to Freetown, Sierra Leone in May 1859. He arrived just as an epidemic of yellow fever was raging. He, along with four of his five companions, succumbed to the dreaded disease. As he lay dying, no priest was present to pray the last rites and on his death, no priest could offer the funeral liturgy. A Protestant minister stepped in to say some prayers over his grave. This early expression of ecumenism may not have been of human design, but it was clearly of God's design.

Today, then, it is fitting that I pay sincere tribute and abundant thanks to Rev William McMillan MBE, MA, ML. I know he is not a man for titles, but there is a time for formality. Reverend Mac, as he is affectionately known to you all, was the inspiration and dreamer behind the first festival here six years ago. It was again his dynamism, encouragement, infectious enthusiasm and good humour that has made the festival of this great year possible. I'm sure I don't need to tell you that he has gained the highest honours at international festivals for the quality of his work. But one comment is this: that the Reverend Mac invests such love into his creations that we are drawn to look not just at the flowers, but into the flowers. That is a beautiful tribute. Wherever there is love, there is God.

Of course Reverend Mac could not put on such a wonderful display on his own. He has been supported by a very hard-working and gifted committee. And no one works as hard as the Co-President, Fr Eamonn Finnegan SMA. I live with Eamonn or – at least when he is not organising flower festivals or other events – we live together in Cork. I know that he, along with Fr P J Gormley, has put a huge amount of time and energy into trying to get this event together. The committee has been working for over two years now. It is both an encouragement and a reproach to observe your total commitment to this project: the huge amount of hours selflessly given, the pride you take in your works of beauty, and especially the joy you not only give to others but that you obviously have yourselves as you go about your business.

To the entire community of the SMA Dromantine project, I want to say thanks for your support of this event and the extra work demanded by this festival. To the secretaries, treasurers and the entire membership of the committee who have put this festival together, I want to offer my very sincere thanks on behalf of the SMA. We are truly indebted to you and assure you of remembrance in our prayers.

So, without further ado, it gives me great pleasure to declare Floral Design 2006 open.

Fr Fachtna O'Driscoll SMA
Provincial Superior
Irish Province of the Society of African Missions

Fachtna O'Driscoll

29 May 2006

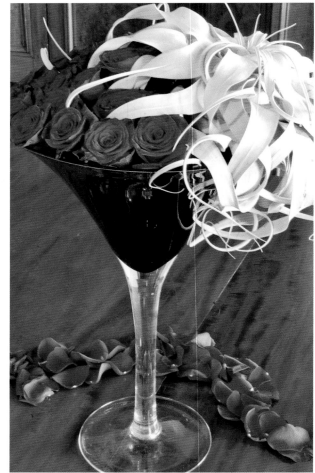

Northern Ireland

Rev William McMillan MBE

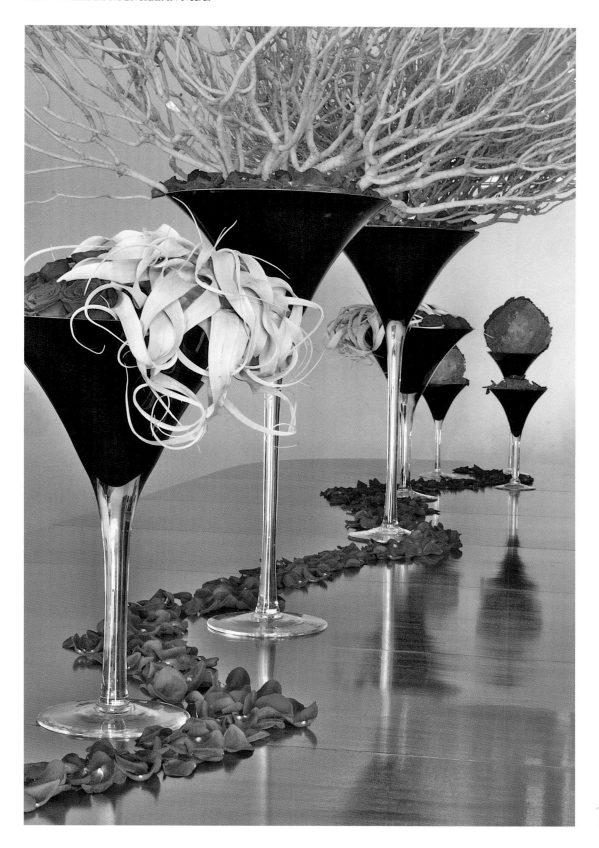

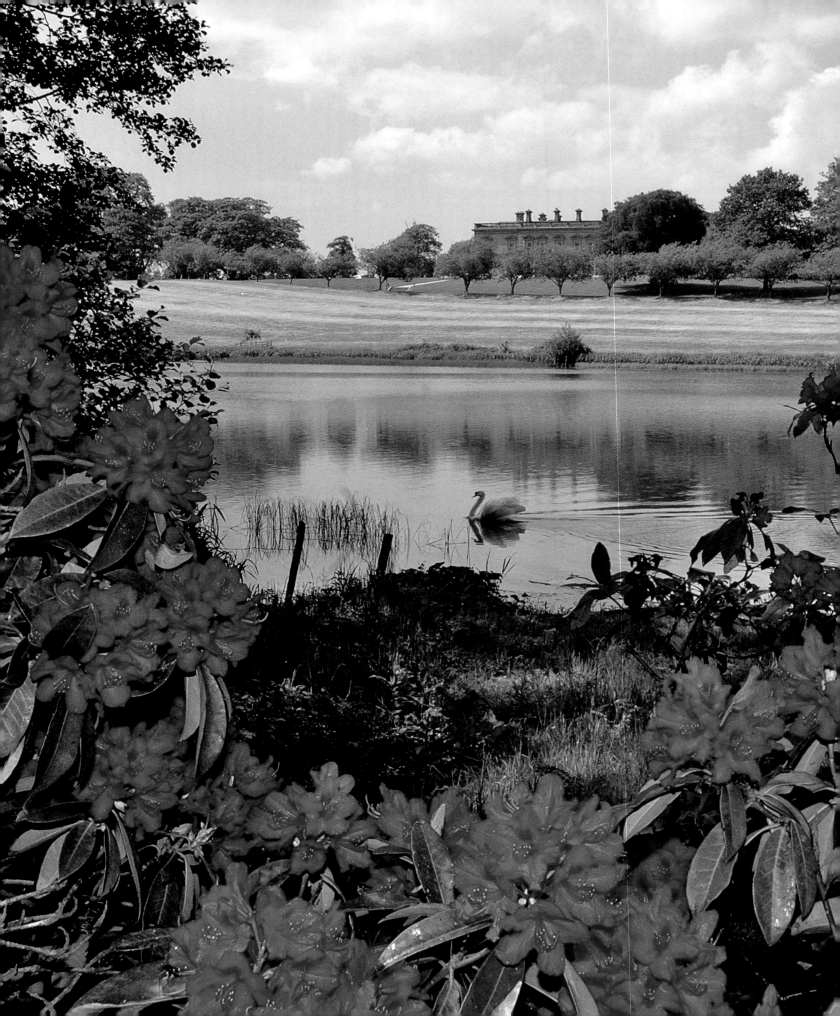

Dromantine Beauty

And beauty is not a need but an ecstasy.

It is not a mouth thirsting nor an empty hand stretched forth,

But rather a heart enflamed and a soul enchanted.

It is not the image you would see nor the song you would hear,

But rather an image you see though you close your eyes and a song you hear though you shut your ears.

It is not the sap within the furrowed bark, nor a wing attached to a claw,

But rather a garden for ever in bloom and a flock of angels for ever in flight.

People of Orphalese, beauty is life when life unveils her holy face.

But you are life and you are the veil.

Beauty is eternity gazing at itself in a mirror.

But you are eternity and you are the mirror.

Kahlil Gibran

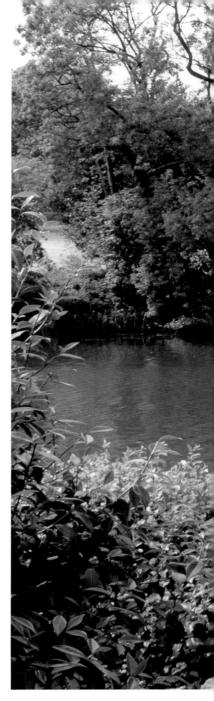

The Rhodora: On Being Asked, Whence is the Flower

Rhodora! if the sages ask thee why

This charm is wasted on the earth and sky,

Tell them, dear, that if eyes were made for seeing,

Then Beauty is its own excuse for being;

Why thou wert there, O rival of the rose!

I never thought to ask, I never knew:

But, in my simple ignorance, suppose

The self-same Power that brought me there brought you.

Ralph Waldo Emerson

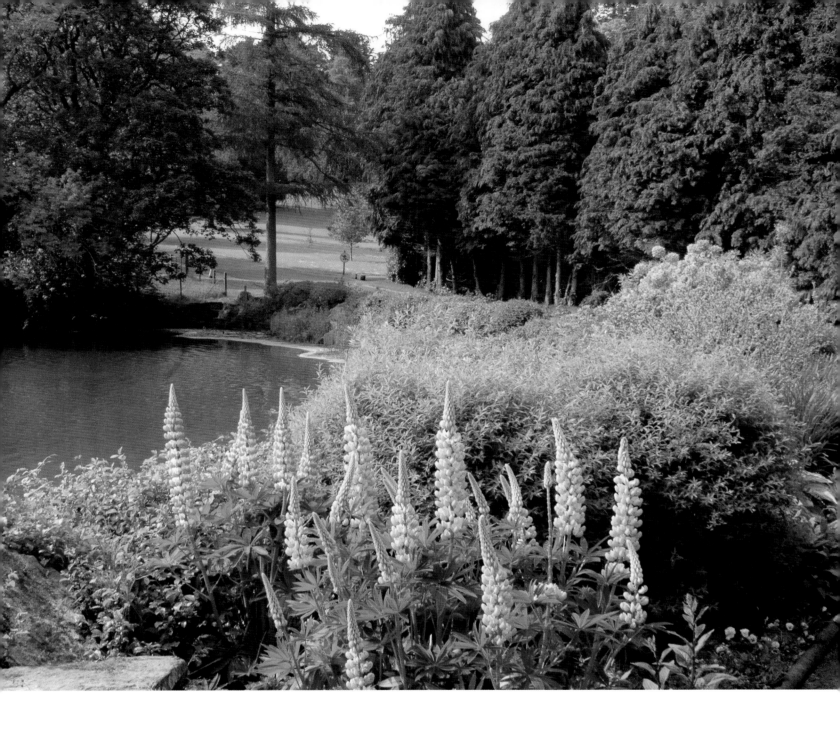

A profusion of colourful blooms including rhododendrons, lupins, peonies, lilacs, pansies, columbines, roses and foxgloves offers a cheerful welcome along the road leading to Dromantine. Among these, the foxglove, *sian,* which was closely associated with fairies in ancient Irish lore, may also be connected to the early naming of Dromantine. The old Gaelic name *Drium Ant-Sidheain* (a fairy ridge) was anglicised in various ways. *Dromantean,* the form most favoured at first, gave way in the 1740s to *Dromantine.* The name brings to mind fairies, dwelling in a fairy mound, *sidhean,* on one of the ridges that stretched across the townland. However, in other Irish lore, it is supposed that the name "Dromantine" is derived directly from *sian*, a foxglove, which was the *mear-acan siodhain* (the fairy finger or thimble) on which fairies were believed to have lavished healing properties, and it was often called simply *siodhan*. Whatever the case may be, it seems likely that this fairy connection influenced the christening of Dromantine.

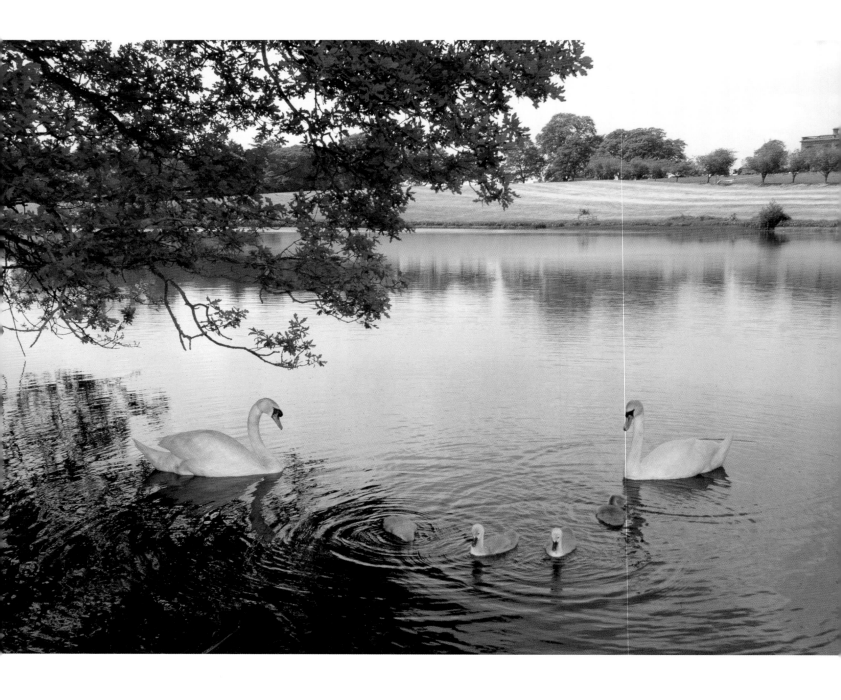

A swan family makes their home amidst the peaceful waters and along the verdant banks of the lake below Dromantine. Trusting and at ease with human friends, the proud parents eagerly approach, anticipating a welcome hand-out and then pausing with their offspring for a family portrait.

Hello! Ciao! Ni Hao!

There are moments when
one smiles despite oneself
and wants to share a few words
with someone, anyone.
Not only people
but also plants, flowers and
birds
have smiles for us and things to
tell us.

Soka Gakkai
© 2003

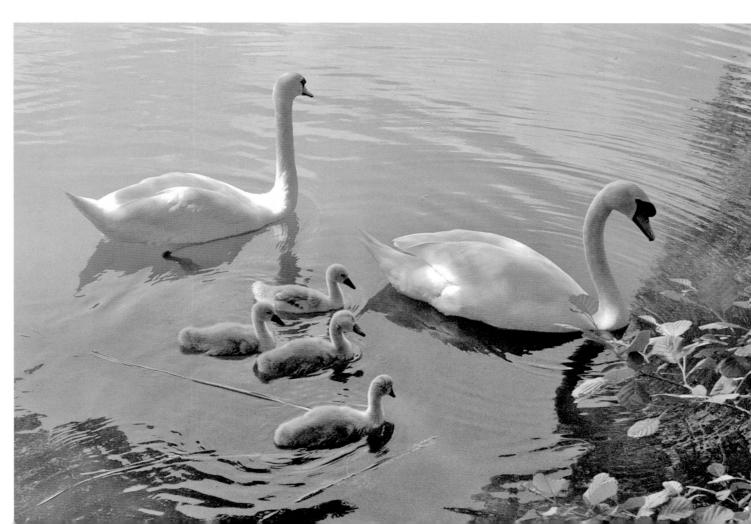

The Sailor Lad from Mourne

When I came home 'twas oft I said
I'd sail the seas no more;
Safe is the roof, and soft the bed
A sailor finds ashore.

And sweet it is to walk the ways
My forebears' feet have worn,
But the restless tide won't let me bide
In the heart o' kindly Mourne.

So it's off on the old track again,
'Midst yellow folk and black again,
It's round the world and back again,
And far from kindly Mourne.

Their spring blossom extravaganza now given way to verdant green, a stout-hearted parade of cherry trees proudly line the upper driveway, offering a regal welcome to Dromantine and a graceful prelude to the hills of Mourne beyond.

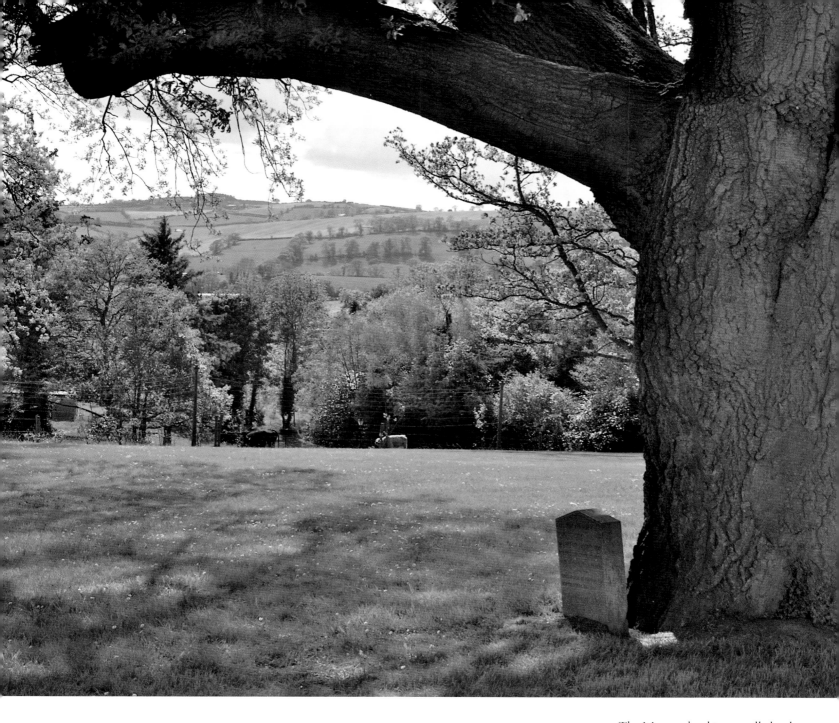

The Mourne land is a goodly land
Its valleys rich to till,
But the salt sea-flood flows in my blood,
And oh! I can't be still.

So it's off on the old track again,
My feet must tramp the deck again,
God send I'll still come back again
To die in kindly Mourne.

Richard Rowley
County Down Songs

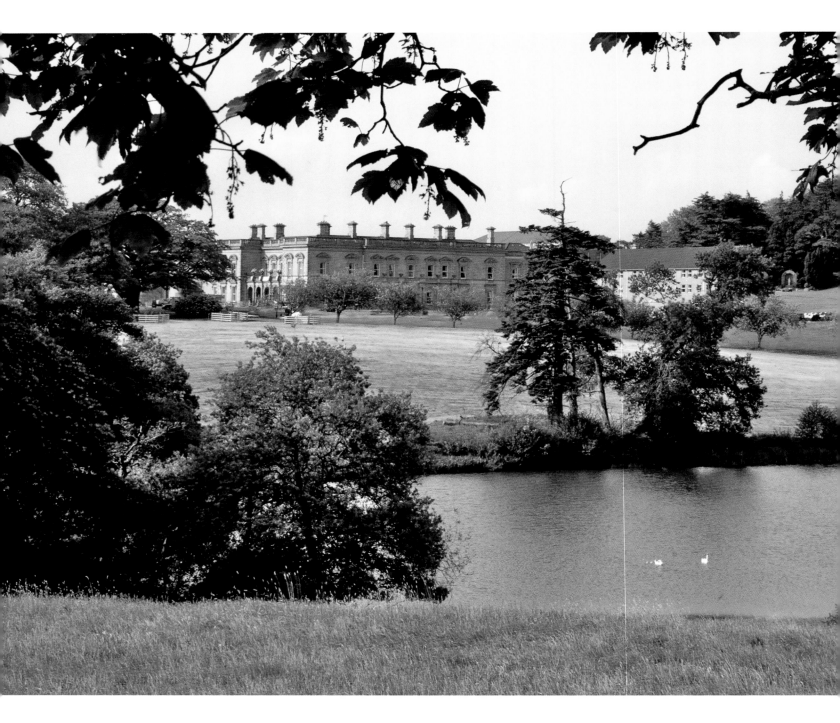

A Song of Joys

O to make the most jubilant song!
Full of music – full of manhood, womanhoood, infancy!
Full of common employments – full of grain and trees.

Walt Whitman

A Rainy Day in April

When the clouds shake their hyssops, and the rain
Like holy water falls upon the plain,
'Tis sweet to gaze upon the springing grain
And see your harvest born.

And sweet the little breeze of melody
The blackbord puffs upon the budding tree,
While the wild poppy lights upon the lea
And blazes 'mid the corn.

The skylark soars the freshening shower to hail,
And the meek daisy holds aloft her pail.
And Spring all radiant by the wayside pale
Sets up her rock and reel.

See how she weaves her mantle fold on fold,
Hemming the woods and carpeting the wold.
Her warp is of the green, her woof the gold,
The spinning world her wheel.

Francis Ledwidge

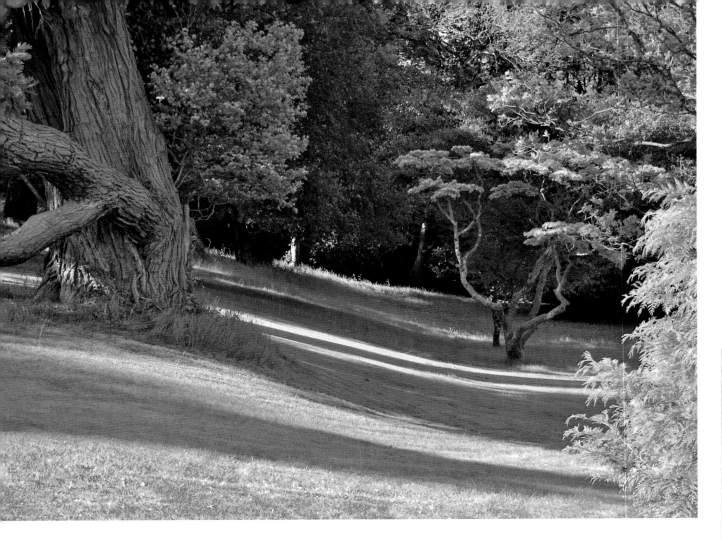

Go into the woodland if you seek for peace of mind,

At this time when nature's mood is gentle, quiet and kind....

When soft winds fan the trembling

Leaves about the cloistered glade,

And paths go winding deep into

The green and breathless shade.

Patience Strong

Trees of Brilliant Green

Green – you are the colour of life,
with you all living beings regain the hue of health.
Green – you are the colour of hope,
with you the voices of children echo all around.
Green – you are the colour of harmony,
with you the citizens of the world come together,
with your benediction
people and nature press cheek to cheek in harmony.

Daisaku Ikeda

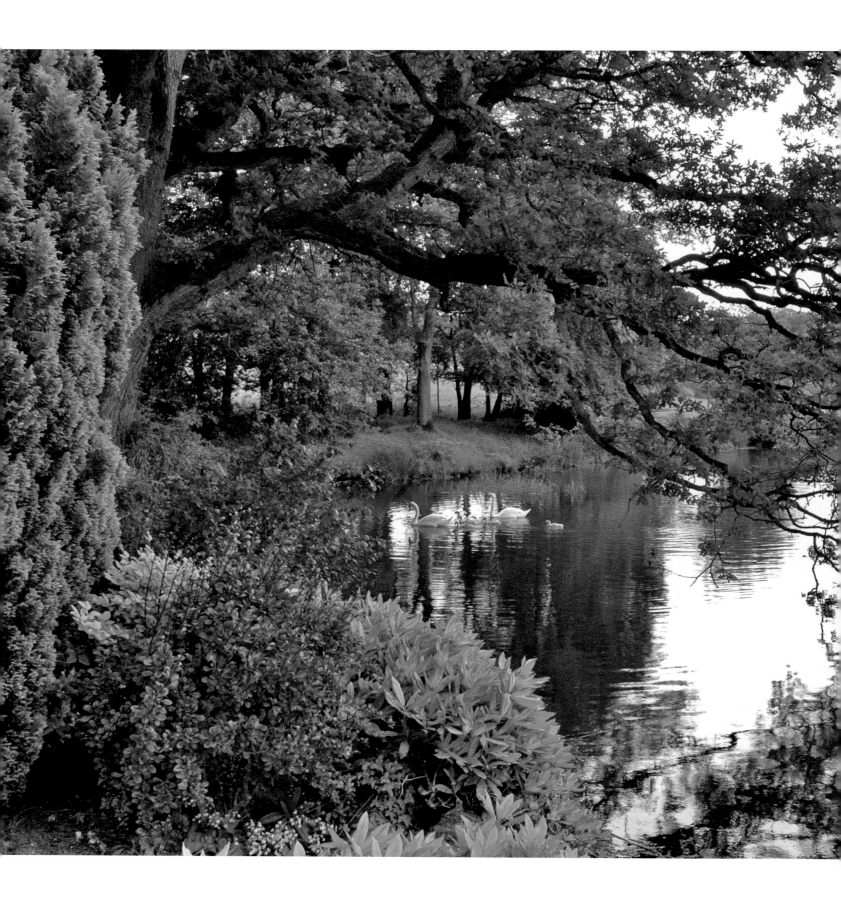

The Lake Isle of Innisfree

I will arise and go now, and go to Innisfree,
And a small cabin build there, of clay and wattles made:
Nine bean-rows will I have there, a hive for the honeybee,
And live alone in the bee-loud glade.

And I shall have some peace there, for peace comes dropping slow,
Dropping from the veils of the morning to where the cricket sings;
There midnight's all a glimmer, and noon a purple glow,
And evening full of the linnet's wings.

I will arise and go now, for always night and day
I hear the lake water lapping with low sounds by the shore;
While I stand on the roadway, or on the pavements grey,
I hear it in the deep heart's core.

WB Yeats

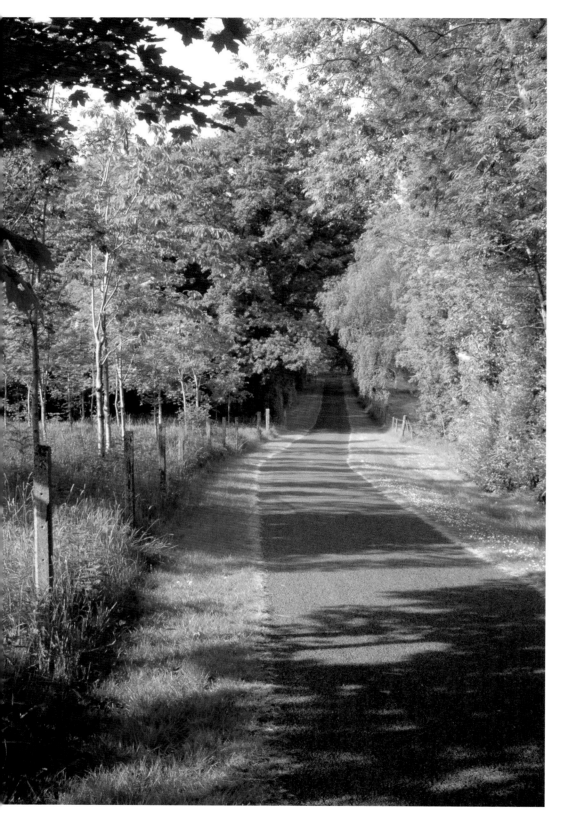

The Road Less Travelled

Two roads diverged in a yellow wood,
And sorry I could not travel both
And be one traveller, long I stood
And looked down one as far as I could
To where it bent in the undergrowth;

Then took the other, as just as fair,
And having perhaps the better claim,
Because it was grassy and wanted wear;
Though as for that the passing there
Had worn them really about the same.

And both that morning equally lay
In leaves no step had trodden black.
Oh, I kept the first for another day!
Yet knowing how way leads on to way,
I doubted if I should ever come back.

I shall be telling this with a sigh
Somewhere ages and ages hence:
Two roads diverged in a wood, and I –
I took the one less travelled by,
And that has made all the difference.

Robert Frost

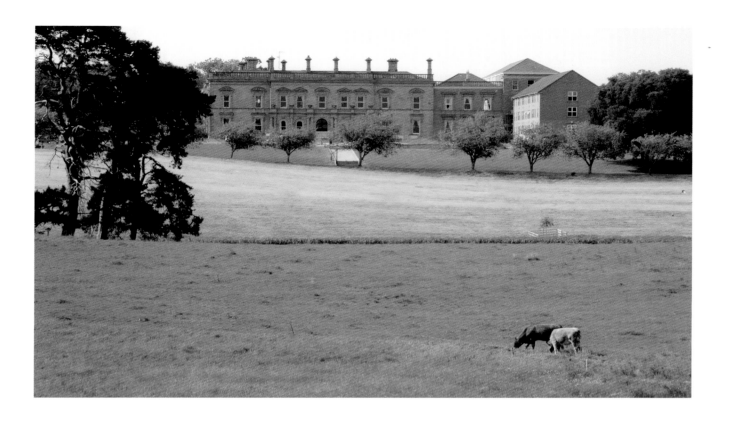

The path around the lake at Dromantine is a bucolic and peaceful walk, well-trodden over the years by a diversity of footsteps: clergy and laypersons, young and old, visitors and residents. All have benefited from the inspiration of its natural beauty and perhaps pondered which road in life they would take or reminisced about the joys of choosing a road less travelled.

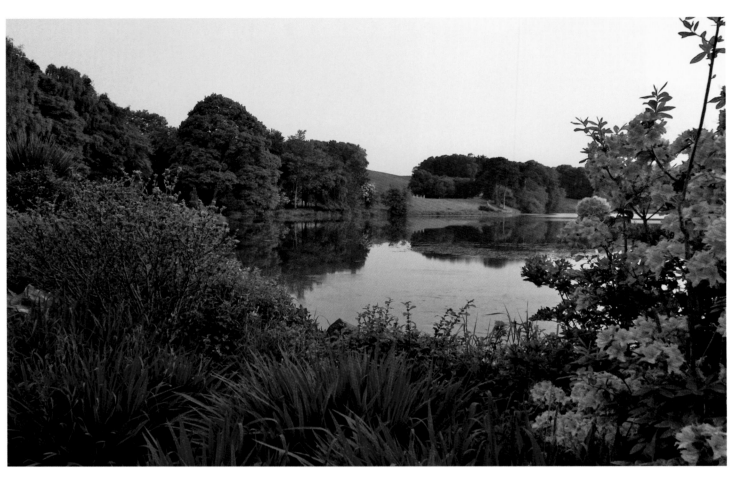

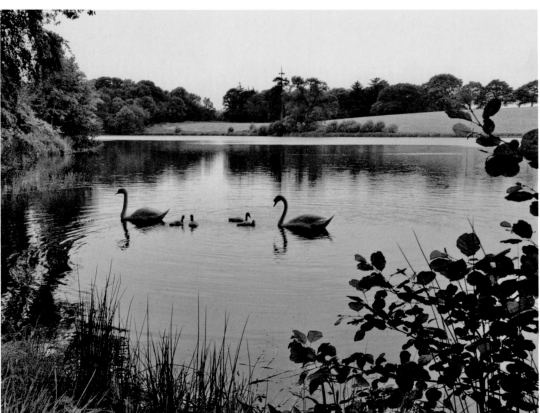

She Moved
Through the Fair

As she stepped away from me
and she moved through the fair
And fondly I watched her
move here and move there
And then she turned homeward
with one star awake
Like the swan in the evening
moves over the lake.

Padraic Colum

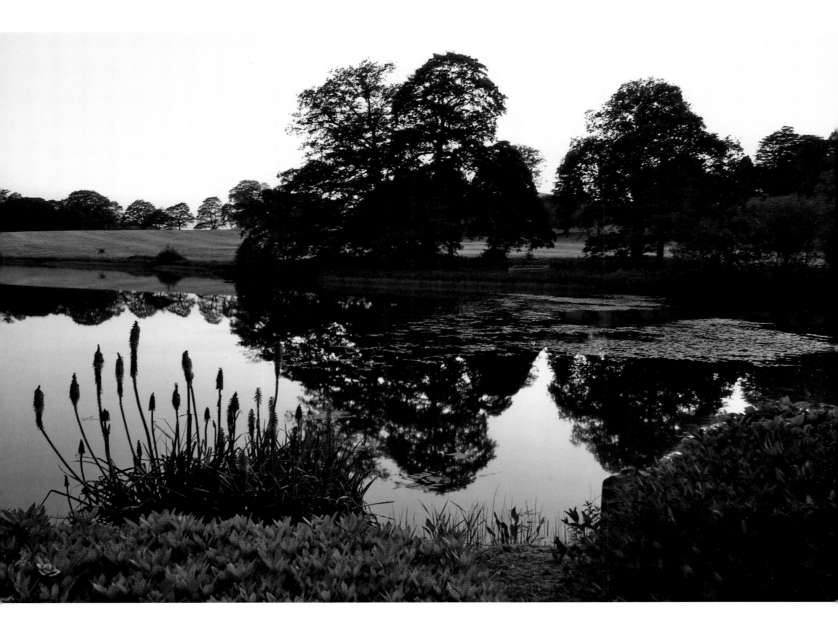

This small lake was of most value as a neighbour in the intervals of a gentle rain-storm in August, when, both air and water being perfectly still, but the sky overcast, mid-afternoon had all the serenity of evening, and the wood thrush sang around, and was heard from shore to shore. A lake like this is never smoother than at such a time; and the clear portion of the air above it being shallow and darkened by clouds, the water, full of light and reflections, becomes a lower heaven itself so much the more important.

Henry David Thoreau
Walden

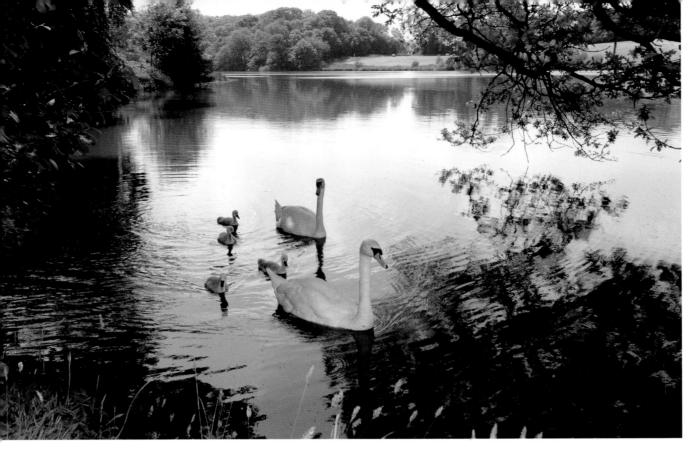
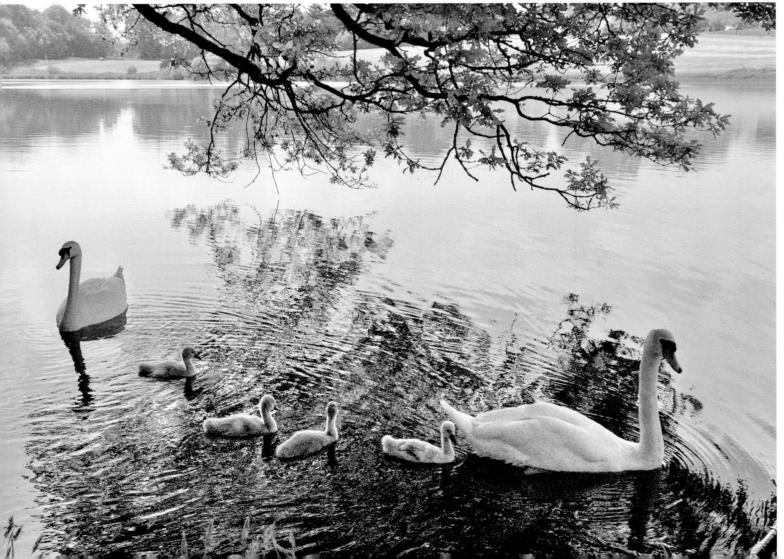

The Wild Swans at Coole

The Trees are in their autumn beauty,
The woodland paths are dry.
Under the October twilight the water
Mirrors a still sky;
Upon the brimming water among the stones
Are nine-and-fifty swans.

The nineteenth Autumn has come upon me
Since I first made my count;
I saw, before I had well finished,
All suddenly mount
And scatter wheeling in great broken rings
Upon their clamourous wings.

I have looked upon those brilliant creatures,
And now my heart is sore.
All's changed since I, hearing at twilight,
The first time on this shore,
The bell-beat of their wings above my head,
Trod with a lighter tread.

Unwearied still, lover by lover,
They paddle in the cold,
Companionable streams or climb the air;
Their hearts have not grown old;
Passion or conquest, wander where they will,
Attend upon them still.

But now they drift on the still water
Mysterious, beautiful;
Among what rushes will they build,
By what lake's edge or pool
Delight men's eyes, when I awake some day
To find they have flown away?

WB Yeats

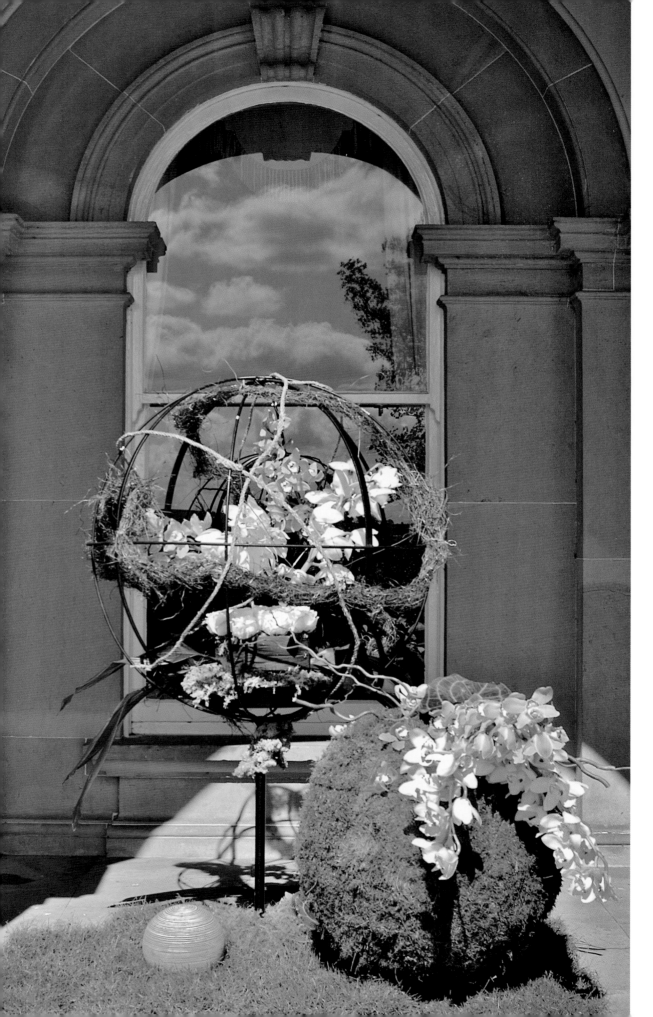

Ireland

MALCOLM KITT

Emerging From the Earth

Suspended within an open sphere, cymbidium orchids symbolize our dreams and aspirations that freely emerge out of the solid grounding of our earliest teachings and knowledge as represented by the solid moss-covered sphere. Our dreams can soar skyward but are anchored, in a global sense, to the wisdom of Mother Earth.

Dromantine House

Honorary Exhibits
Ireland, Northern Ireland and Around the World

Human beings are each a microcosm. Living here on Earth, we breathe the rhythms of a universe that extends infinitely above us. When resonant harmonies arise between this vast outer cosmos and the inner human cosmos, poetry is born.

The poetic spirit can be found in any human endeavour. It may be vibrantly active in the heart of a scientist engaged in research in the awed pursuit of truth. When the spirit of poetry lives within us, even objects do not appear as mere things; our eyes are trained on an inner spiritual reality. A flower is not just a flower. The moon is no mere clump of matter floating in the skies. Our gaze fixed on a flower or the moon, we intuitively perceive the unfathomable bonds that link us to the world.

Now more than ever, we need the thunderous, rousing voice of poetry. We need the poet's impassioned songs of peace, of the shared and mutually supportive existence of all things. We need to reawaken the poetic spirit within us, the youthful vital energy and wisdom that enable us to live to the fullest. We must all be poets.

Daisaku Ikeda

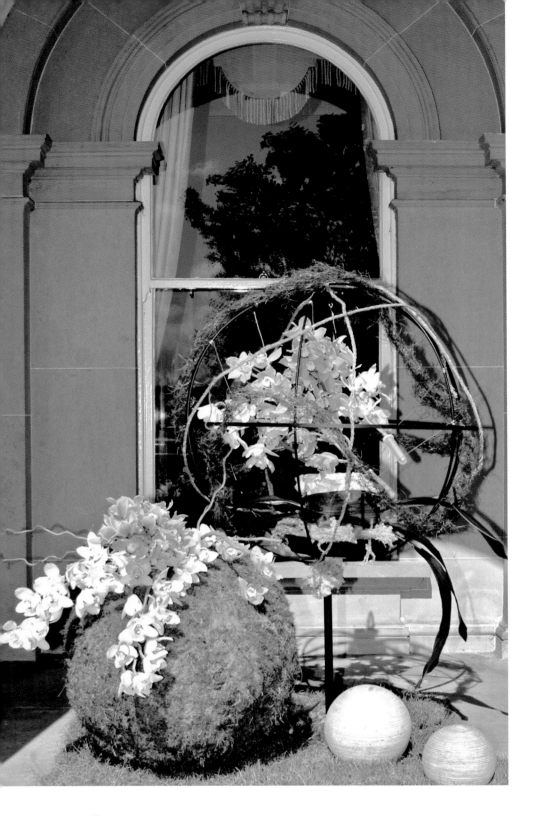

Ireland
Malcolm Kitt

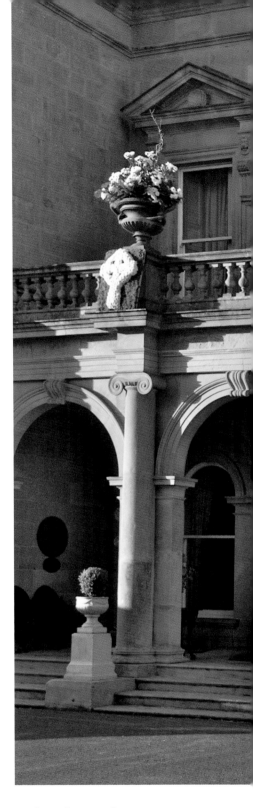

The Celtic Cross

Through storm and fire and gloom,
I see it stand
Firm, broad and tall,
The Celtic Cross that marks our Fatherland,
Amid them all!

Timothy Daniel Sullivan

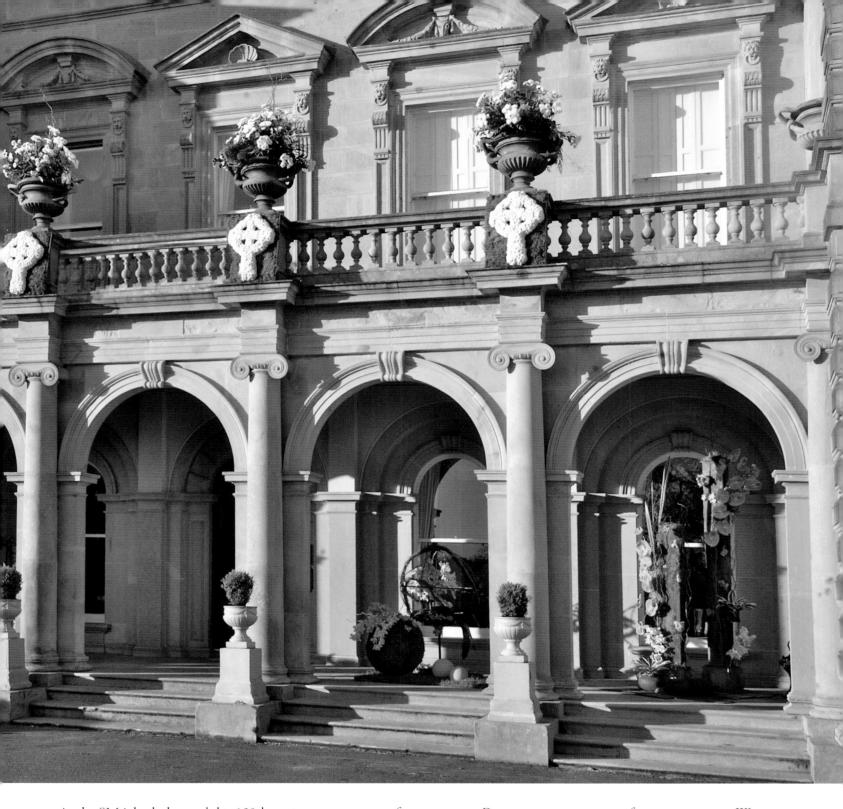

As the SMA looks beyond this 150th anniversary year to its future mission, Dromantine assumes significant importance. We see Dromantine not just as a beautiful house and grounds, but as a place of rest and a place of peace. And we want to use the facility of this magnificent structure as an agent of peace and reconciliation amongst communities. This flower festival is another occasion when the bonds of friendship and affection across communities and religious faiths are strengthened.

FR FACHTNA O'DRISCOLL SMA
Provincial Superior
Irish Province of the Society of African Missions

Northern Ireland

ANN TRAYNOR

MARY PEARSON

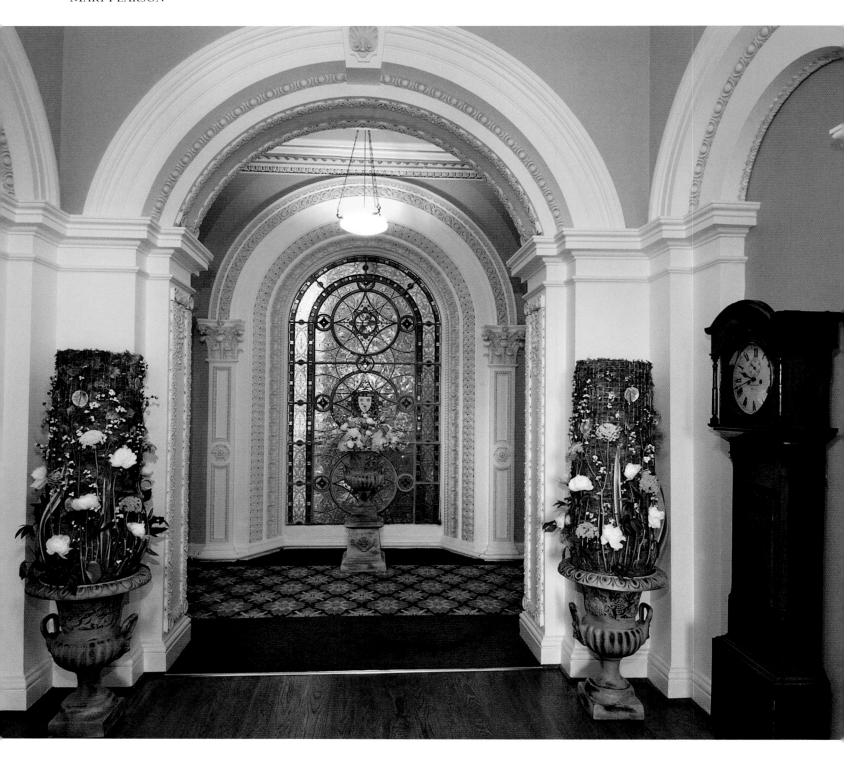

Dromantine House is a two-storey neo-classical building begun in 1806 and completed in 1810. The interior work of ornate cornices and mouldings was carried out later by Italian craftsmen who toured the country working in great Irish houses during the 19th century. Each room on the ground floor has different features, creating an atmosphere "where walls and ceilings are not silent barriers, but lively artistic expressions."

Ode on a Grecian Urn

Thou still unravish'd bride of quietness,
Thou foster-child of Silence and slow Time,
Sylvan historian, who canst thus express
A flowery tale more sweetly than our rhyme:
What leaf-fringed legend haunts about thy shape
Of dieties or mortals, or of both,
In Tempe or the dales of Arcady?
What men or gods are these? What maidens loth?
What mad pursuit? What struggle to escape?
What pipes and timbrels? What wild ecstasy?...

...O Attic shape! fair attitude! with brede
Of marble men and maidens overwrought,
With forest branches and the trodden weed;
Thou, silent form! dost tease us out of thought
As doth eternity. Cold pastoral!
When old age shall this generation waste,
Thou shalt remain, in midst of other woe
Than ours, a friend to man, to whom thou say'st,
'Beauty is truth, truth beauty – that is all
Ye know on earth, and all ye need to know.'

John Keats

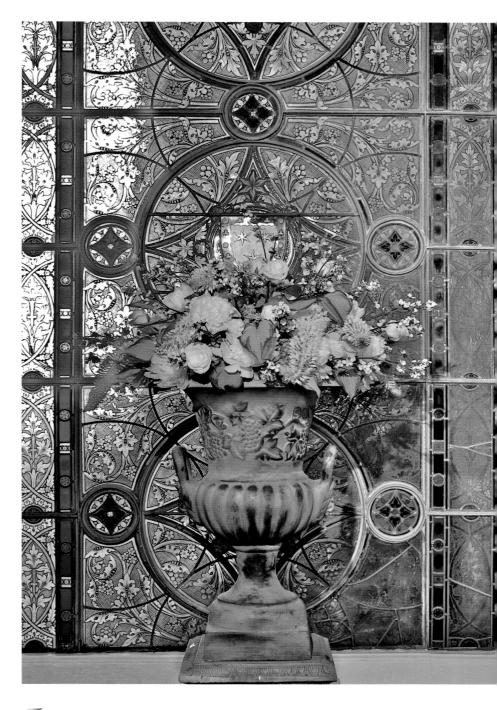

The stained glass window in the west wing reflects important symbols, including the motto "Be trustful" in the coat of arms of the Innes clan, the original owners dating back to 1741.

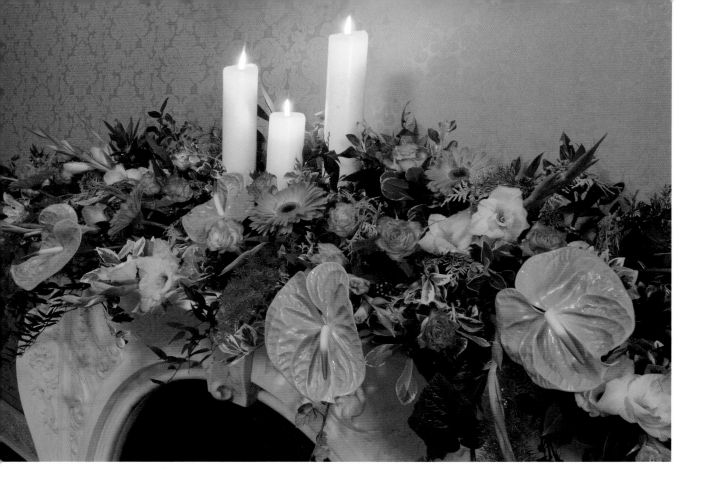

Northern Ireland

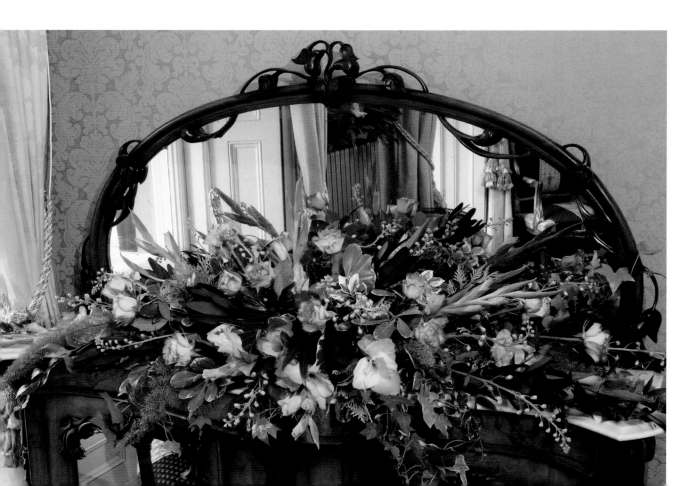

Beloved,
thou hast brought me many flowers
Plucked in the garden,
all the summer through
And winter, and it seemed as if they grew
In this close room,
nor missed the sun or showers.

Elizabeth Barrett Browning

REPRESENTATIVES OF
NIGFAS
Northern Ireland Group of
Flower Arranging Societies

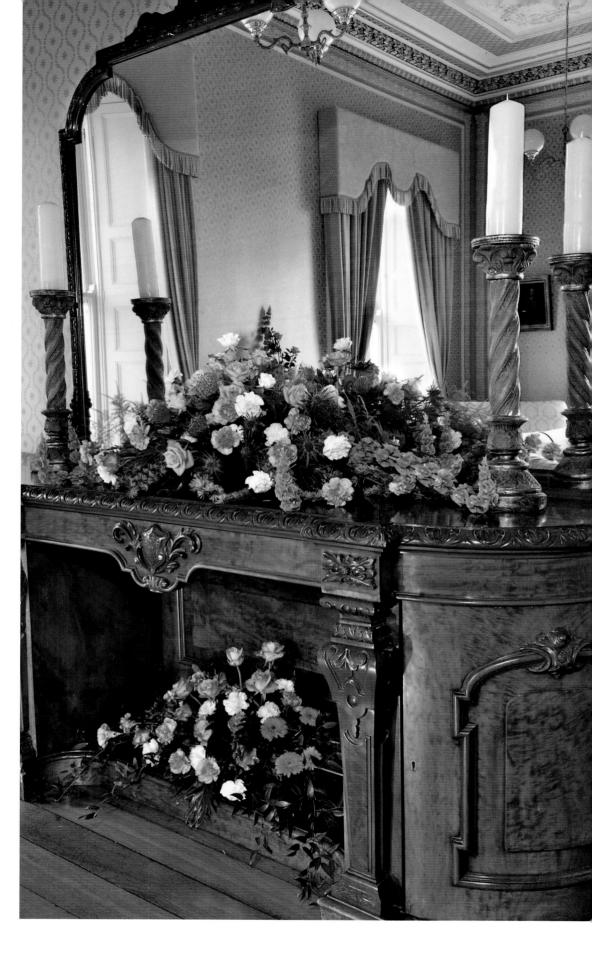

Northern Ireland

REPRESENTATIVES OF NIGFAS

Northern Ireland Group of Flower Arranging Societies

The Ballad of Father Gilligan

The old priest Peter Gilligan
Was weary night and day;
For half his flock were in their beds,
Or under green sods lay.

Once, while he nodded on a chair,
At the moth-hour of eve,
Another poor man sent for him,
And he began to grieve...

"I have no rest, nor joy, nor peace,
For people die and die",
And after cried he, "God forgive!
My body spake, not I!"

He knelt, and leaning on the chair
He prayed and fell asleep;
And the moth-hour went in from the fields,
And stars began to peep...

Upon the time of sparrow-chirp
When moths came once more,
The old priest Peter Gilligan
Stood upright on the floor.

Mavrone, Mavrone! the man has died
While I slept on the chair;
He roused his horse out of its sleep,
And rode with little care.

He rode now as he never rode,
By rocky lane and fen;
The sick man's wife opened the door;
"Father! you come again."...

"When you were gone, he turned and died
As merry as a bird."
The old priest Peter Gilligan
He knelt him at that word.

"He Who hath made the night of stars
For souls who tire and bleed,
Sent one of His great angels down
To help me in my need.

"He Who is wrapped in purple robes,
With planets in His care,
Had pity on the least of things,
Asleep upon a chair."

WB Yeats

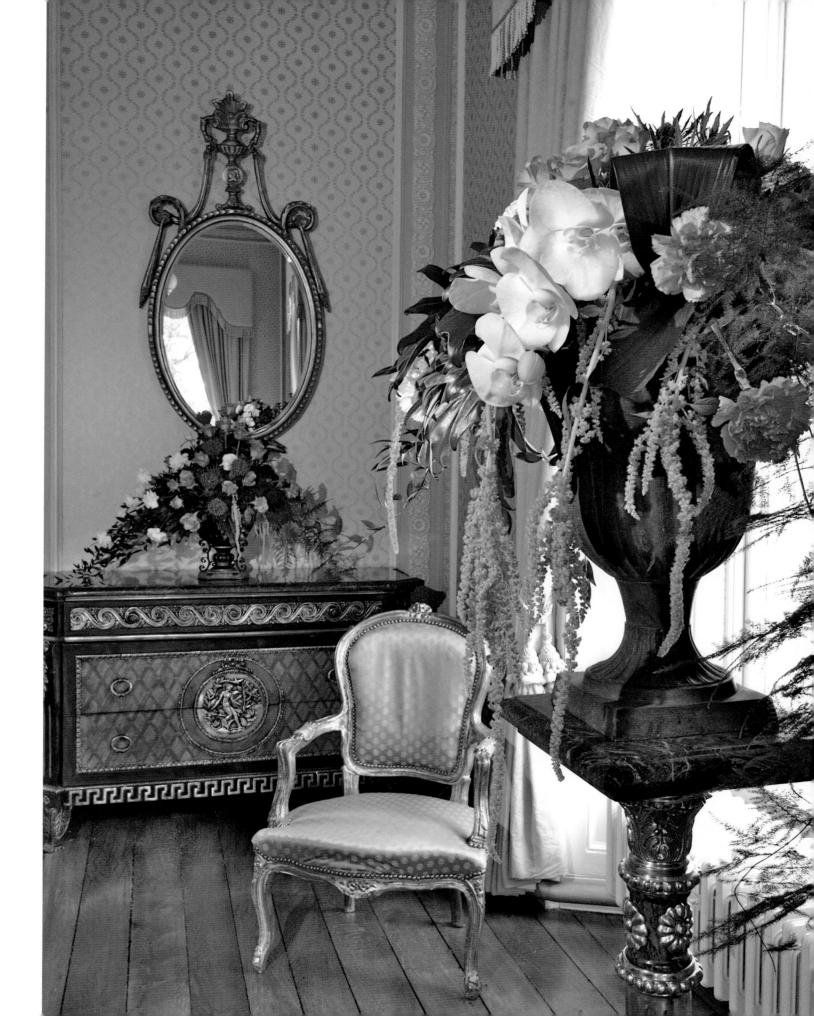

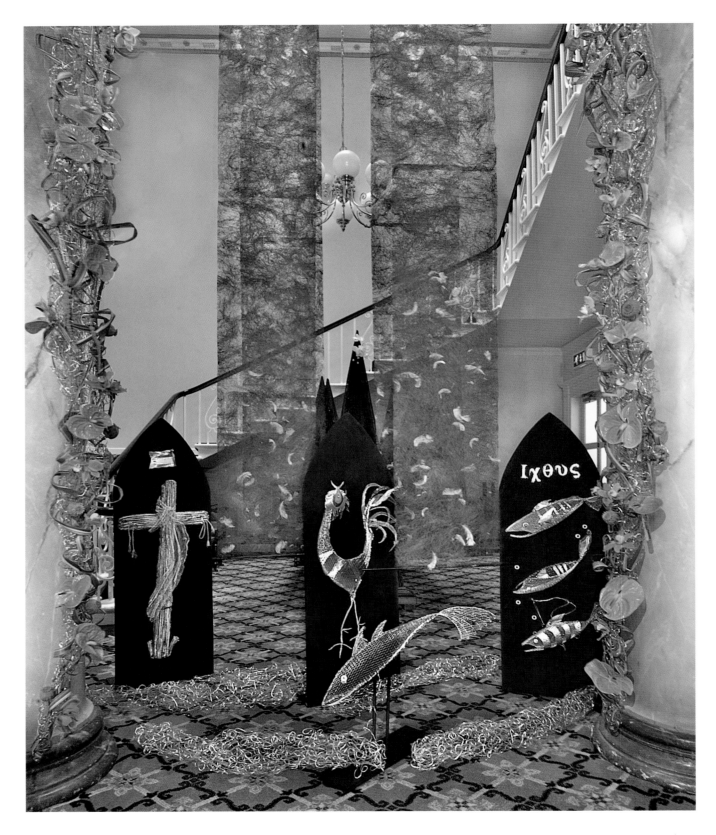

Architectural features from the Greco-Roman world such as Corinthian, Doric and Ionic columns are displayed in the exterior and interior of the house. The cantilevered staircase, constructed in the Great Hall during the renovations of the 1860s, was one of the first of its kind in Ireland.

Northern Ireland

Rev William McMillan MBE

Joan Lockhart

Pat Leahey

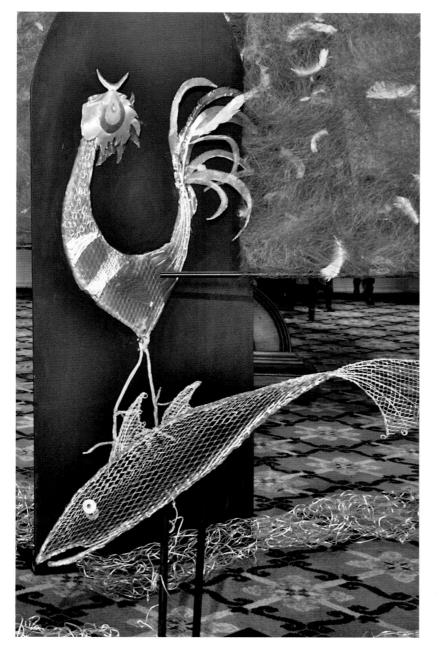

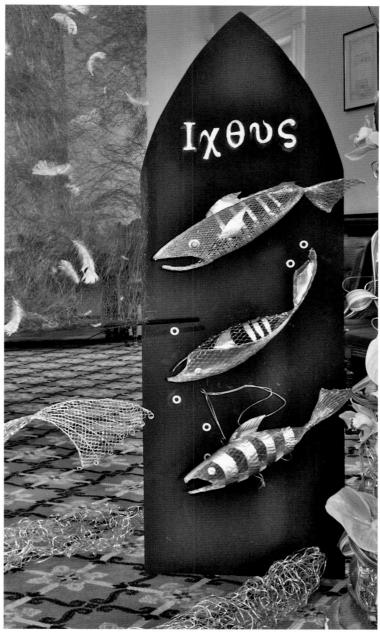

Man's life is warm, glad, sad, 'twixt love and graves,
Boundless in hope, honoured with pangs austere,
Heaven-gazing; and his angel-wings he craves–
The fish is swift, small-needing, vague yet clear,
A cold, sweet, silver life, wrapped in round waves
Quickened with touches of transporting fear.

James Henry Leigh Hunt

Northern Ireland
Rev William McMillan MBE
Assistants: Yolanda Campbell,
Mieko Obermuller and Ian McNeill

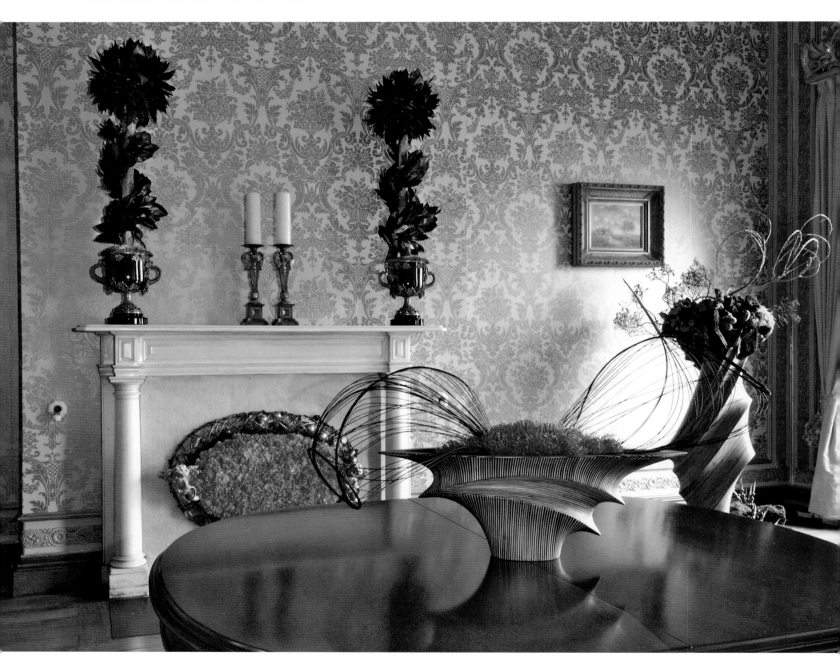

Africa and Ireland: The Rhythms of Africa, Earthiness of Ireland and Elegance of Dromantine

This striking combination of design creates a moving tribute to the SMA's mission in Africa while also honouring the strength and tradition of their Irish roots at Dromantine. Distinct hand-crafted containers made of strips of bamboo reflect African design. One is filled with bright red protea and hand-woven reeds that reflect the colours and rhythms of Africa. The other is topped with a heavy cluster of Irish potatoes, peet and native branches, creating a bold expression of the natural earthiness of Irish culture. Dromantine's elegance is captured in the beautiful urns garnished with topiaries of bronzed magnolia leaves.

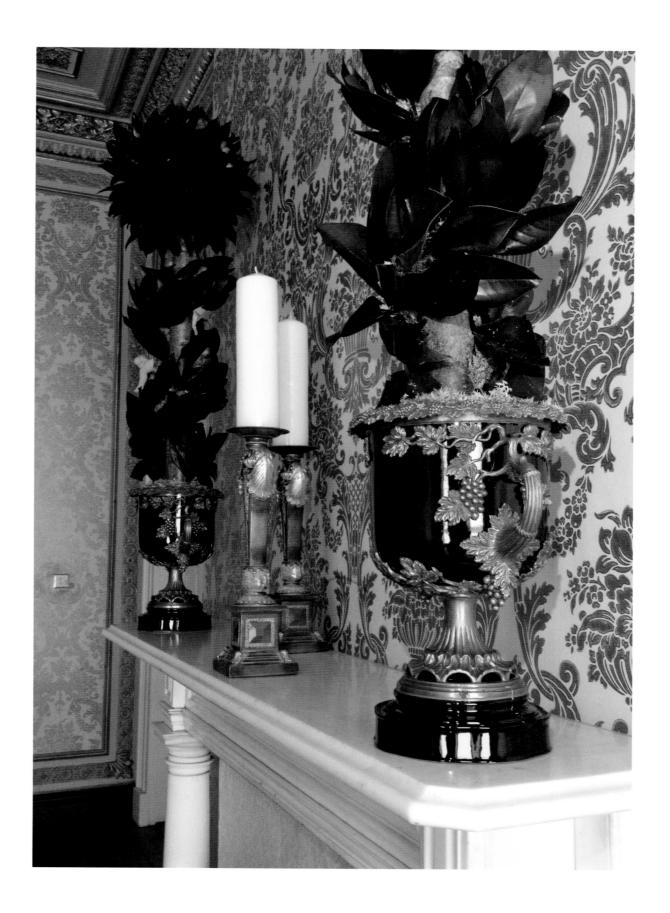

Northern Ireland

REV WILLIAM McMILLAN MBE
YOLANDA CAMPBELL

Digging

Between my finger and my thumb
The squat pen rests; as snug as a gun.

Under my window a clean rasping sound
When the spade sinks into gravelly ground:
My father, digging. I look down…

By God, the old man could handle a spade,
Just like his old man.

My grandfather could cut more turf in a day
Than any other man on Toner's bog.
Once I carried him milk in a bottle
Corked sloppily with paper. He straightened up
To drink it, then fell to right away
Nicking and slicing neatly, heaving sods
Over his shoulder, digging down and down
For the good turf. Digging.

The cold smell of potato mold, the squelch and slap
Of soggy peat, the curt cuts of an edge
Through living roots awaken in my head.
But I've no spade to follow men like them.

Between my finger and my thumb
The squat pen rests.
I'll dig with it.

Seamus Heaney

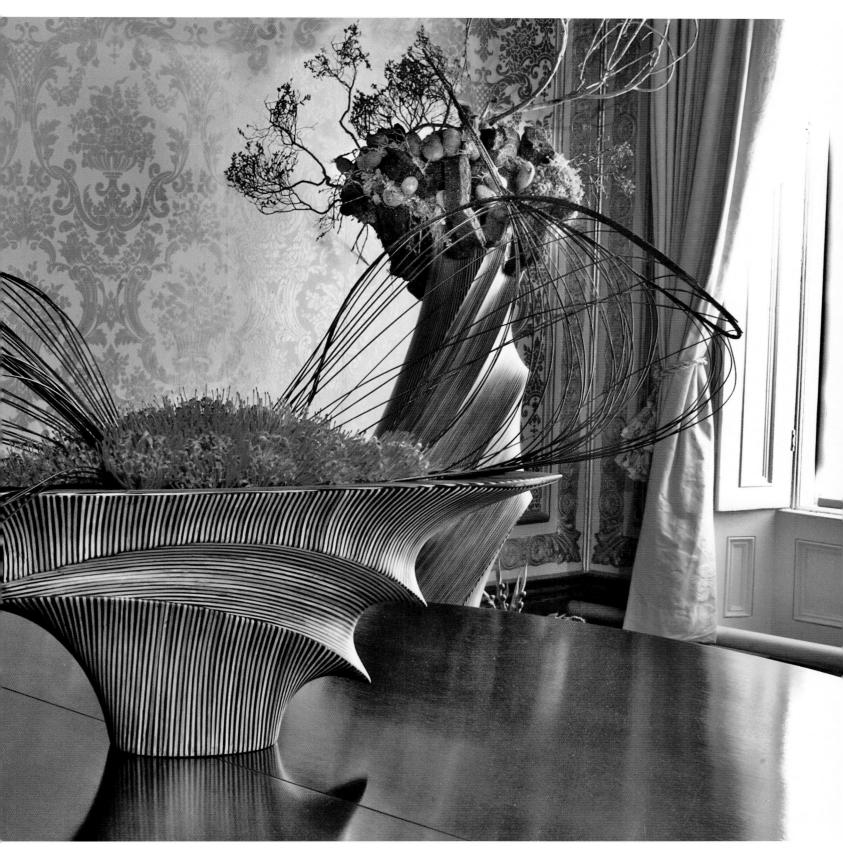

Ireland
RICHARD HASLAM, NDFS, AIFD

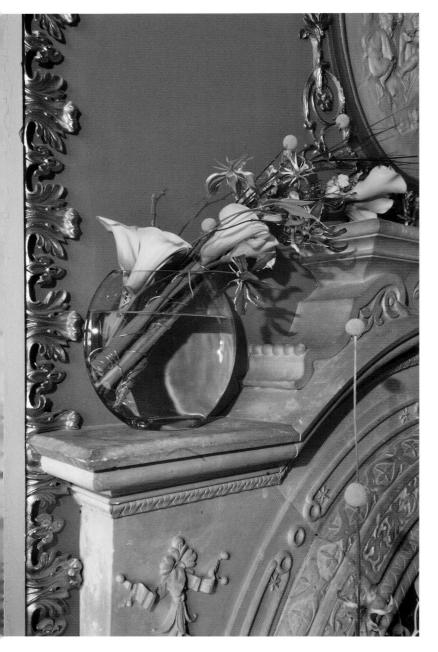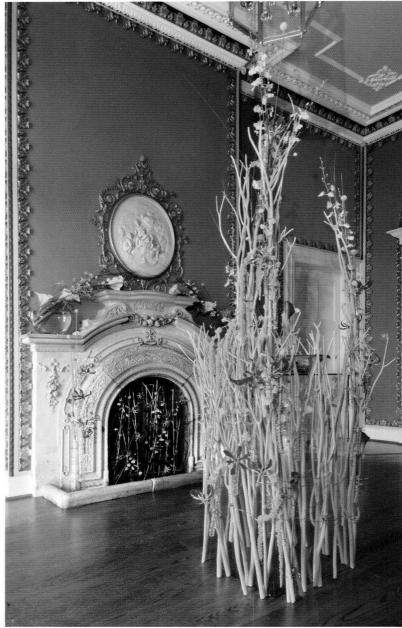

In the Pink: A Vibrant Contrast of Floral Simplicity and Ornate Decor

Dromantine's very ornate "pink room" is given a modern flair with a contemporary design based on glass, coloured canes and decorative wires. The use of minimal foliage places the emphasis on the open design of free-standing canes and fresh flowers presented in colours of shocking pinks and lemon yellows.

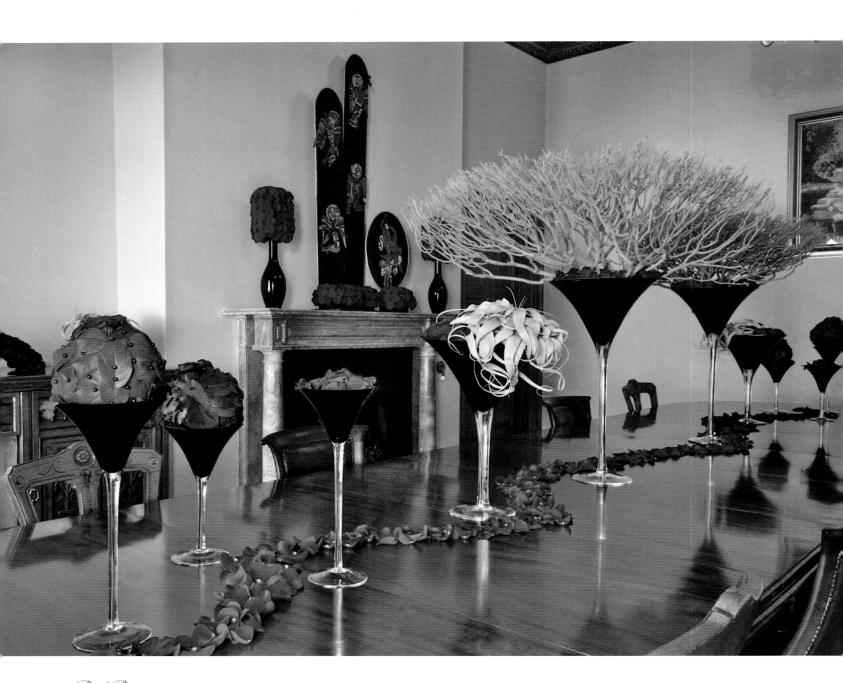

Red Rose, proud Rose, sad Rose of all my days!
Come near me while I sing the ancient ways:
Cuchulain battling with the bitter tide;
The Druid, grey, wood-nurtured, quiet-eyed,
Who cast round Fergus dreams, and ruin untold;
And thine own sadness, whereof stars, grown old
In dancing silver-sandalled on the sea,
Sing in their high and lonely melody.
Come near, that no more blinded by man's fate,
I find under the boughs of love and hate,
In all poor foolish things that live a day,
Eternal beauty wandering on her way...

Northern Ireland

REV WILLIAM MCMILLAN MBE

PAT LEAHEY

To the Rose upon the Rood of Time

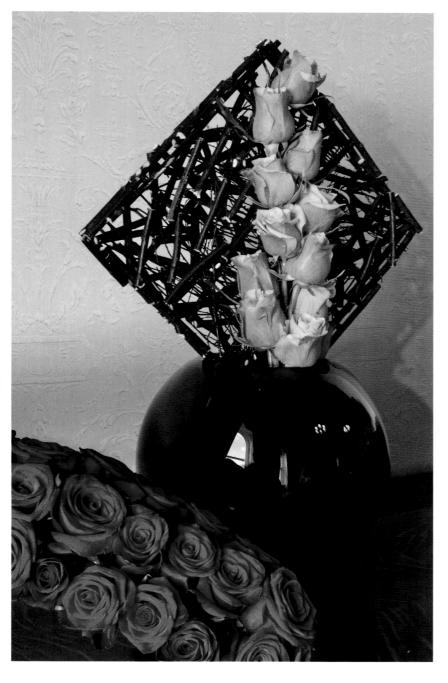

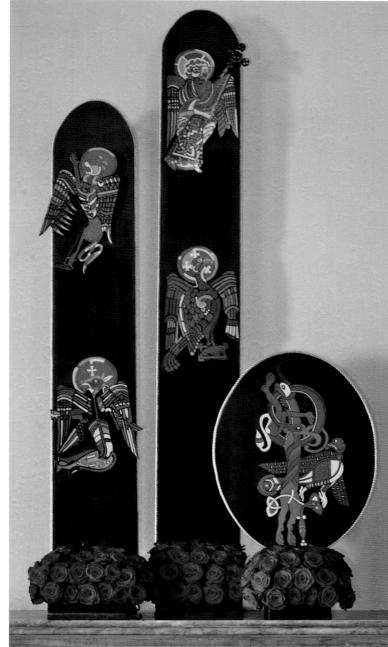

...Come near, come near, come near –
Ah, leave me still
A little space for the rose-breath to fill!
Lest I no more hear common things that crave;
The weak worm hiding down in its small cave,
The field-mouse running by me in the grass,
And heavy mortal hopes that toil and pass;
But seek alone to hear the strange things said
By God to the bright hearts of those long dead,
And learn to chaunt a tongue men do not know.
Come near; I would, before my time to go,
Sing of old Eire and the ancient ways:
Red Rose, proud Rose, sad Rose of all my days.

WB Yeats

United States of America

PENNY HORNE

Former Chairman, The Flower Arranging Study Group

The Great American Melting Pot

The bamboo represents the Pre-Columbian roots of the Americas, while the full spectrum of native and foreign flora represents the later multi-cultural evolution and blossoming of the United States.

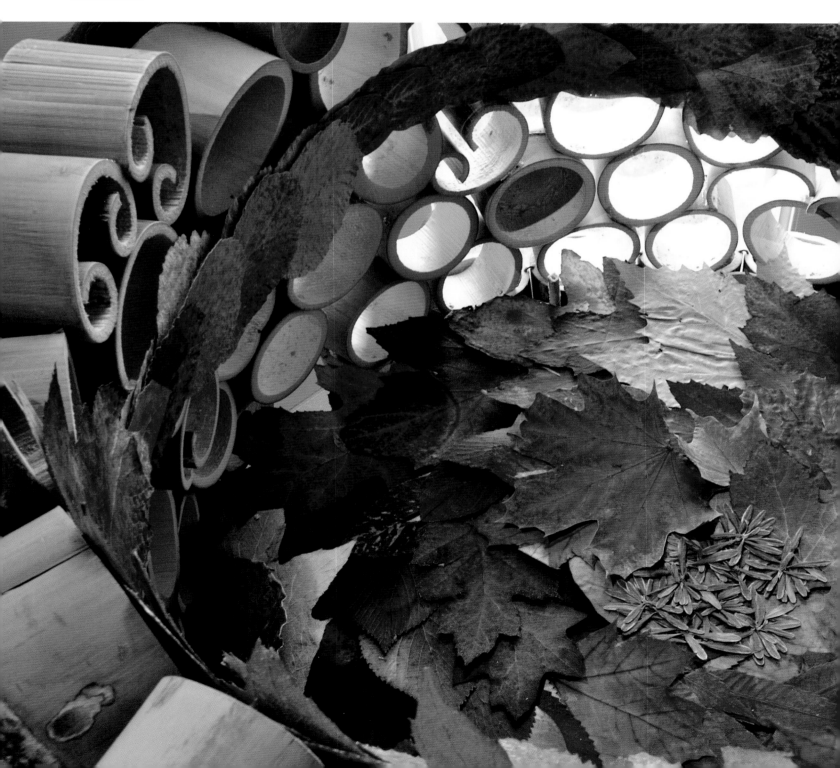

A World of Diversity

HONORARY EXHIBITS FROM AROUND THE WORLD

Our Old Feuillage

...Singing the song of These, my ever-united lands –
my body no more inevitably united, part to part,
and made out of a thousand diverse
contributions one identity, any more than
my lands are inevitably united
and made One identity;
Nativities, climates, the grass of the great pastoral Plains,
Cities, labours, death, animals, products, war,
good and evil–these me,
These affording, in all their particulars,
the old feuillage to me and to America,
how can I do less than pass the clew of
the union of them, to afford the like to you?
Whoever you are! how can I but offer you divine leaves,
that you also be eligible as I am?
How can I but as here chanting, invite you for yourself
to collect bouquets of the incomparable
feuillage of these States?

Walt Whitman

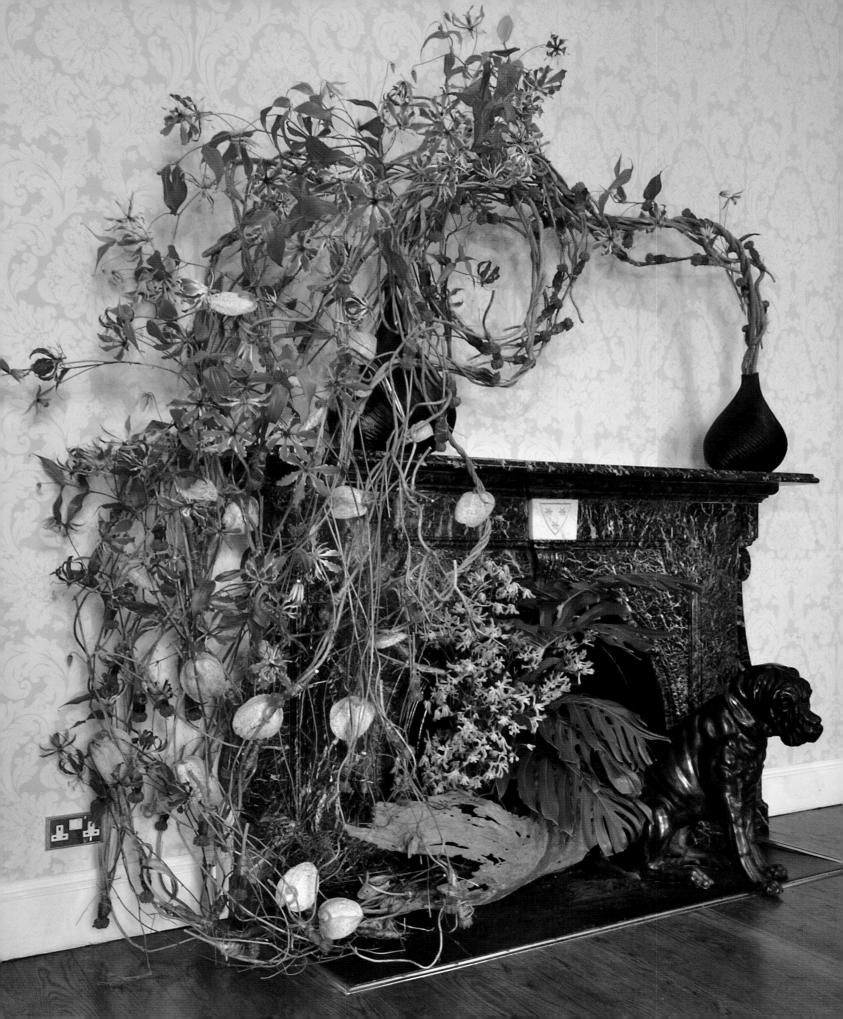

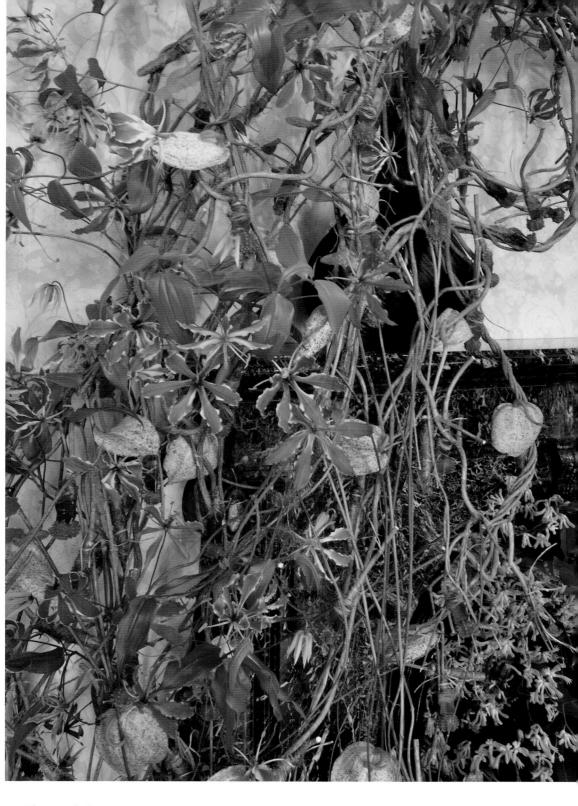

The Netherlands
Andreas Verheijen, AIFD
The Genie in the Bottle

Amidst a tangle of vines swirling forth from the genie's bottle, a profusion
of gloriosa lilies and rare anthuriums, meticulously tied to the branches,
cascade into an array of floral magic.

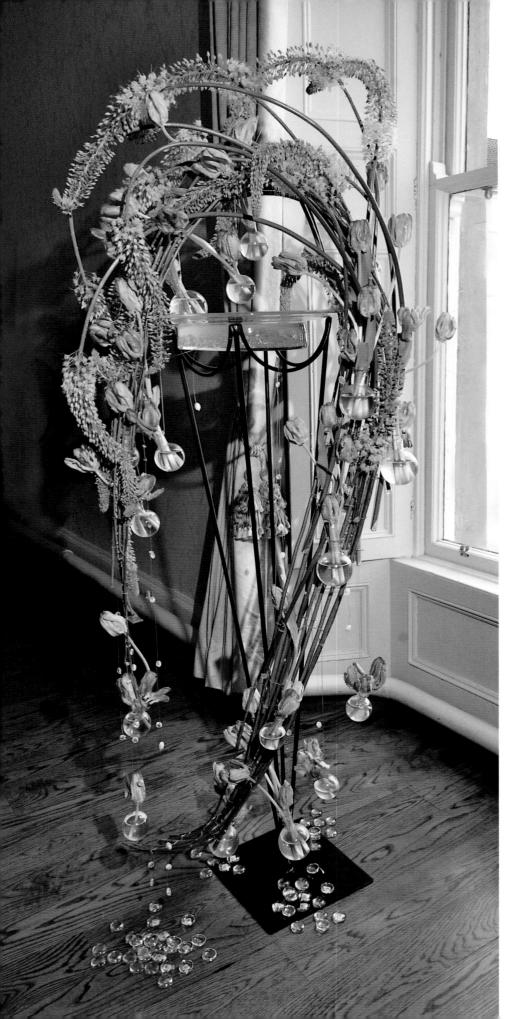

United States of America
FRANKIE McDONNELL PELTIERE, AIFD
Water: Our Precious Life-Source

A wave of foxtail lilies and tulips, bubbling with flasks of precious life-giving water, cascades over a crystal dish of clear water, caressing and honouring the precious life-source. Droplets of water fall from the wave like jewels upon the shore.

In the sea of ivy clothed Iwami
Near the cape of Kara,
The deep sea miru weed
Grows on the sunken reefs;
The jewelled sea tangle
Grows on the rocky foreshore,
Swaying like the jewelled sea tangle
My girl would lie with me,
My girl whom I love with a love
Deep as the miru growing ocean.

Hitomaro

Isle of Man

Annette Bratt
Leonore Fitton
Eileen Gill
Floreat Workgroup
An Isle of Man Landscape

Large sheets of native bark wrapped into cones
cradle a profusion of soft carousel illusion roses.
Autumn joy sedum reflects the rough texture and
colour of the container while the snakes of soft
Castlewellan gold leylandii, rambling through to a
softly mossed base of local stone, provide an element
of contrast so prevalent in the native landscape.

The Passionate Shepherd to His Love

Come live with me and be my Love,
And we will all the pleasures prove
That hills and valleys, dales and fields,
Or woods or steepy mountain yields.

And I will make thee a bed of roses
And a thousand fragrant posies;
A cap of flowers, and a kirtle
Embroider'd all with leaves of myrtle.

The shepherd's swains shall dance and sing
For thy delight each May morning:
If these delights thy mind may move,
Then live with me and be my Love.

Christopher Marlowe

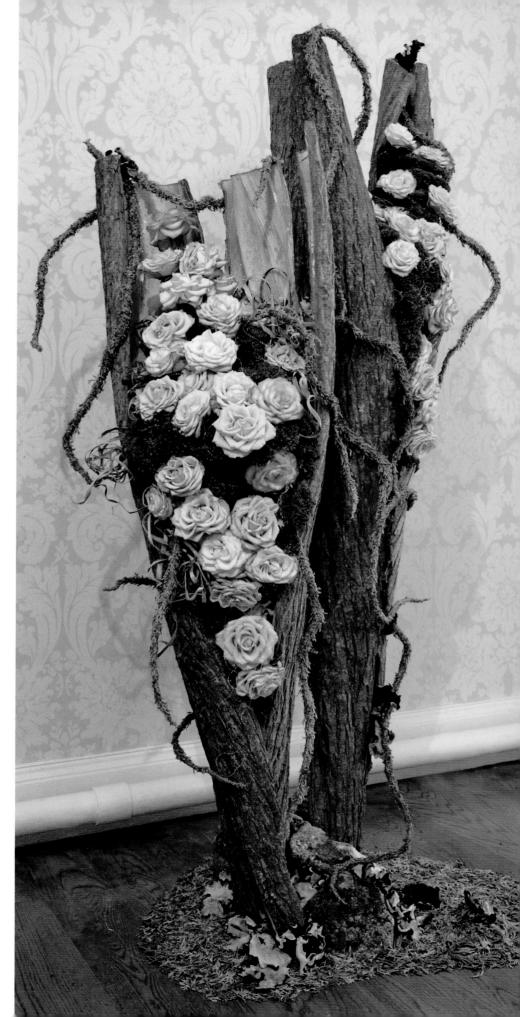

Belgium

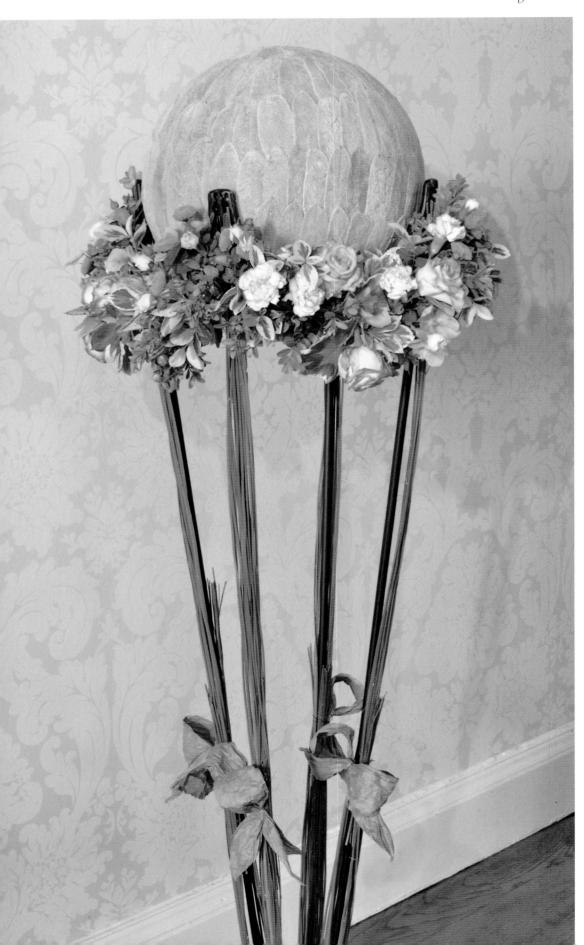

Salut au Monde!

My spirit has pass'd in compassion and
determination around the whole earth,
I have look'd for equals and lovers and
 found them ready for me in all lands,
I think some divine rapport has equalised
me with them.

Walt Whitman

France

NICOLE SIMÉON
École d'Art Floral de Versailles
SNHF
*Société Nationale
d'Horticulture de France*

*France,
The 18th Year of
These States*

...And I send these words to Paris
with my love,
And I guess some chansonniers
there will understand them,
For I guess there is latent music
yet in France, floods of it,
O I hear already the bustle of
instruments, they will soon be
drowning all that would
interrupt them,
O I think the east wind brings a
triumphal and free march,
It reaches hither, it swells me to
joyful madness,
I will run transpose it in words,
to justify,
I will yet sing a song for you
ma femme.

Walt Whitman

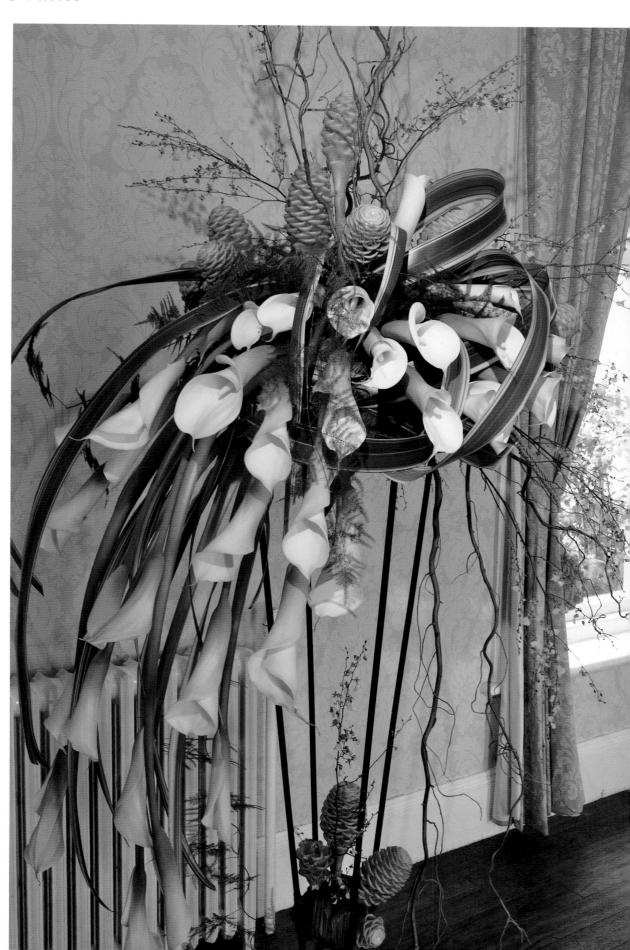

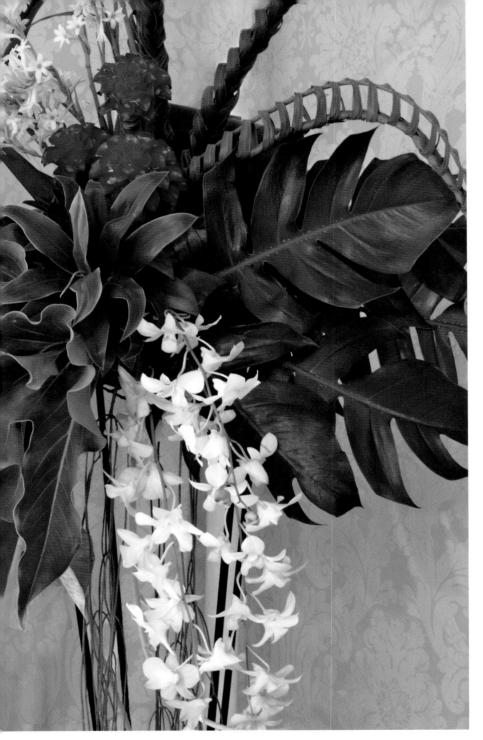

Trinidad
GEORGIA RAJ KUMAR
Flowers and Foliage, Flair and Colour

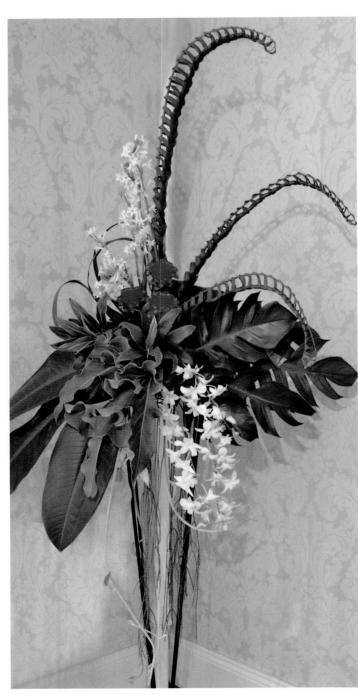

A flourish of tropical leaves, orchids and vibrant ginger, all grown in Trinidad's island paradise, are accentuated with a dramatic sweep of intricately braided grass reflecting the people of Trinidad and Tobago's love of flair and colour.

England

SUSAN ANN KEHOE

NAFAS

National Association of
Flower Arrangement Societies

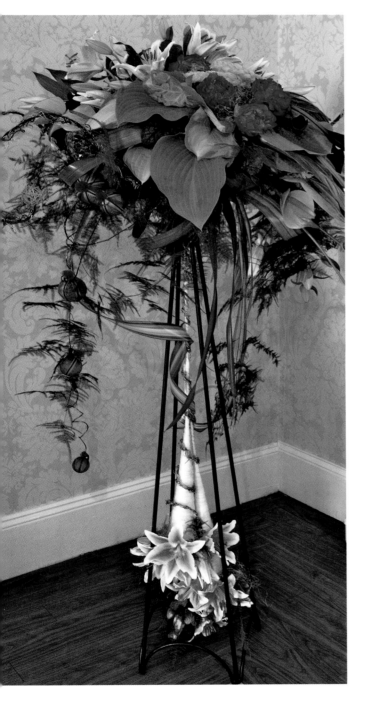

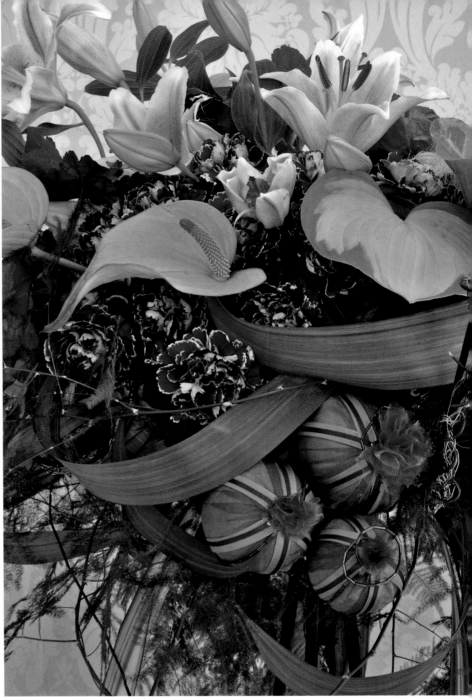

Mystic Ireland

Expressing the mystical quality of Ireland and her people, bright pinks, purples and greens are woven together to create a floral map of the country through colour, plant materials and decorative balls. Woven flax leaves bring the eye inward to the focal point of the arrangement while a reversed cone of vibrant lilies below completes the magic.

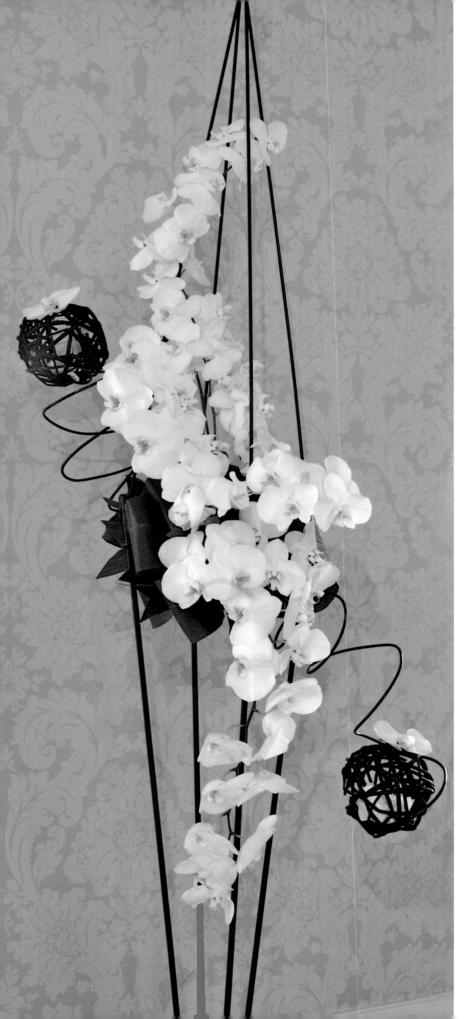

England

Knowle Garden Club

A Prayer in Spring

Oh, give us pleasure in the flowers today;
And give us not to think so far away
As the uncertain harvest; keep us here
All simply in the springing of the year.

Oh, give us pleasure in the orchard white,
Like nothing else by day, like ghosts by night;
And make us happy in the happy bees,
The swarm dilating round the perfect trees.

And make us happy in the darting bird
That suddenly above the bees is heard,
The meteor that thrusts in with needle bill,
And off a blossom in mid air stands still.

For this is love and nothing else is love,
The which it is reserved for God above
To sanctify to what far ends He will,
But which it only needs that we fulfil.

Robert Frost

Canada
BETH FROST
ASSISTANT: CLAUDETTE SMITH
The Seasonal Drama of Canada

Beautiful Casablanca lilies,
representing the snowy white
and cold of Canadian winters,
form a dramatic contrast with
the verdant foliage so prevalent
during the warm summers.

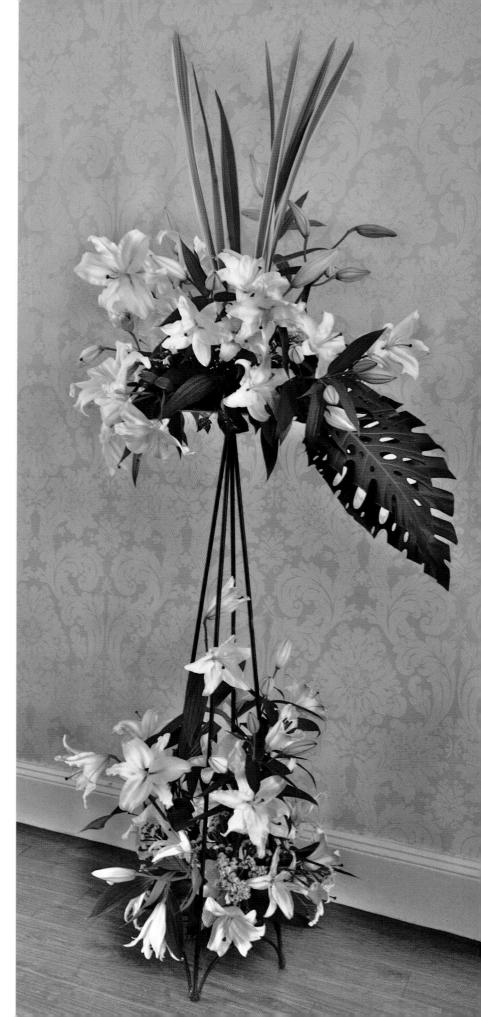

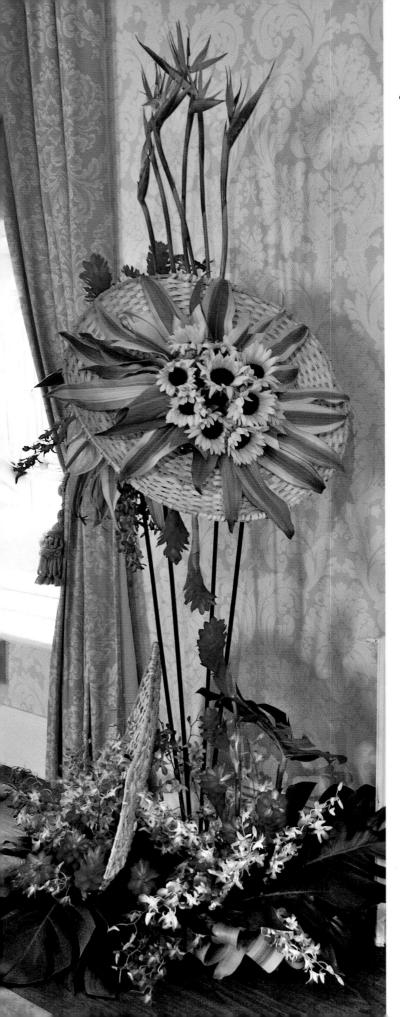

Jamaica
OLIVE ROSE HENRY
NOVLETTE PHILLIPS
Tropical Rhythm

Jamaica, island of perpetual sunshine and abundant
tropical flora, is represented by a basket medallion of
sunflowers and a profusion of native ginger, anthuriums
and orchids. Another basket depicts the breadbasket
of the country while the skyward reach of the bird of
paradise symbolizes the flight of the hummingbird,
national bird of Jamaica.

Legends say that hummingbirds float free of time, carrying our hopes for love, joy and celebration. The delicate grace of the hummingbird reminds us that life is rich, beauty is everywhere, every personal connection has meaning and that laughter is life's sweetest creation. The people of Jamaica approach life like the hummingbird, celebrating the joy of every day by savouring each moment as it passes and embracing all that life has to offer.

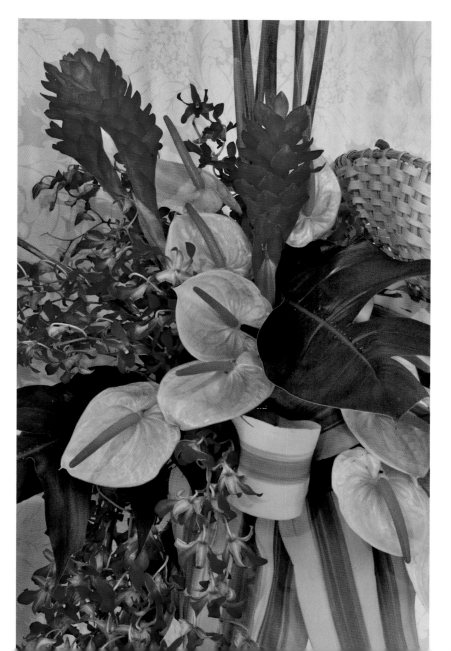

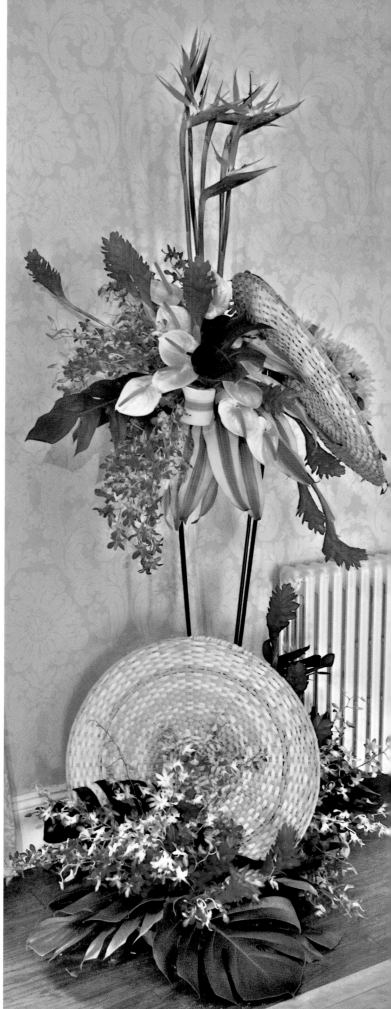

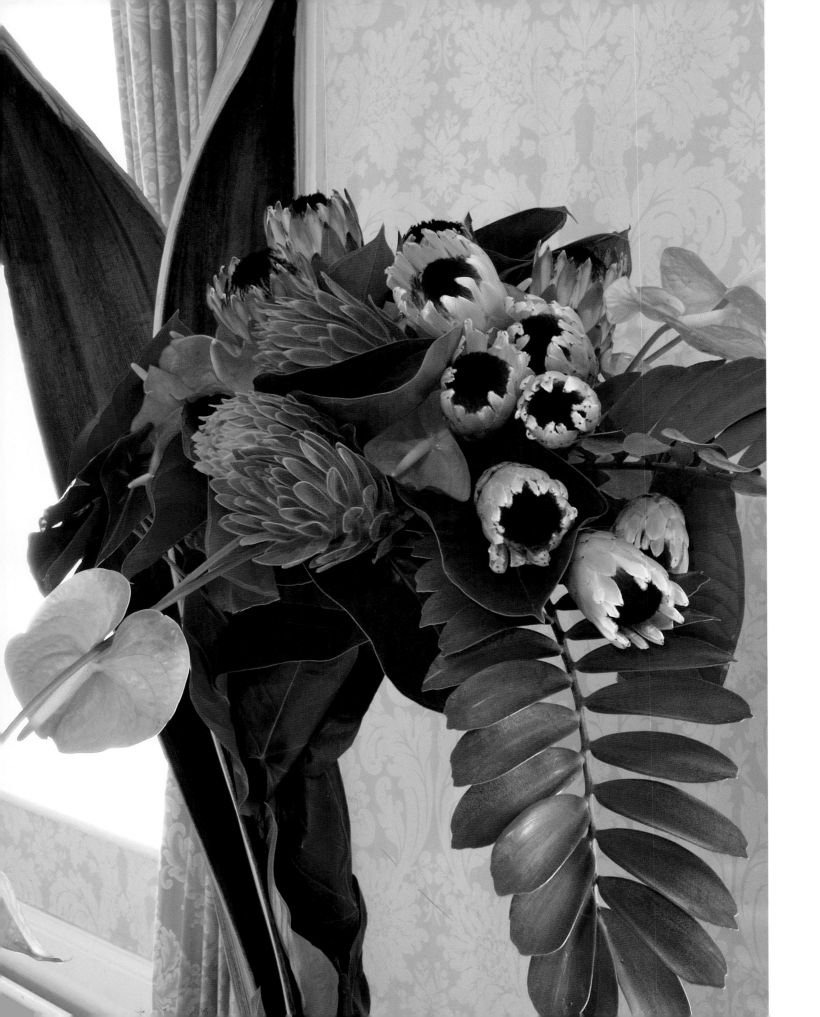

South Africa

ELBETH LIEBENBERG
MARJOLIJN MALAN
South African Flower Union

*A Strong Movement
Towards a New South Africa*

Indigenous plant material brought
from South Africa creates a
sweeping movement forward
that seems to defy gravity.
Cycad leaves, protea and
leucospermum enhanced by
anthuriums and anthurium leaves
combine to give credence and
beauty to new beginnings.

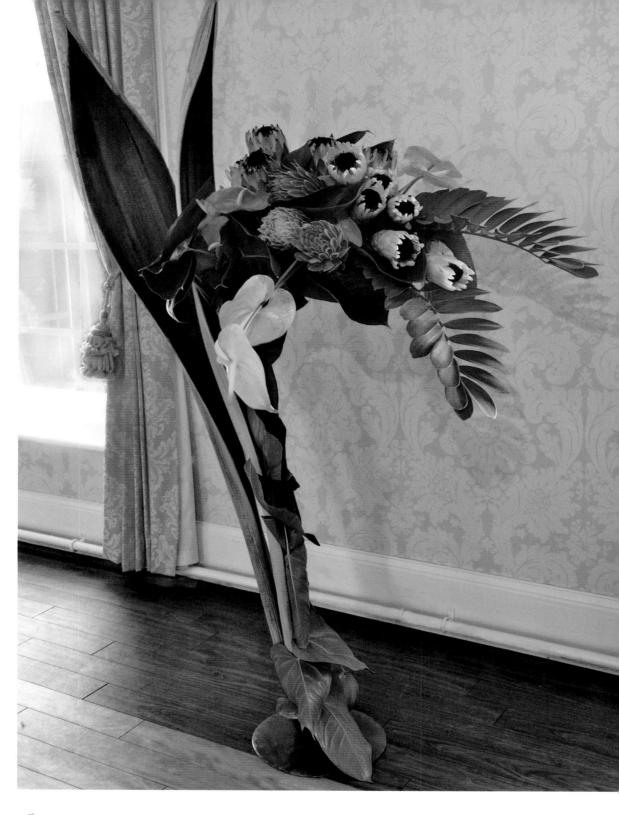

If there are dreams about a beautiful
South Africa, there are also roads that
lead to their goal. Two of these roads
could be named Goodness
and Forgiveness.

Nelson Mandela

Northern Ireland

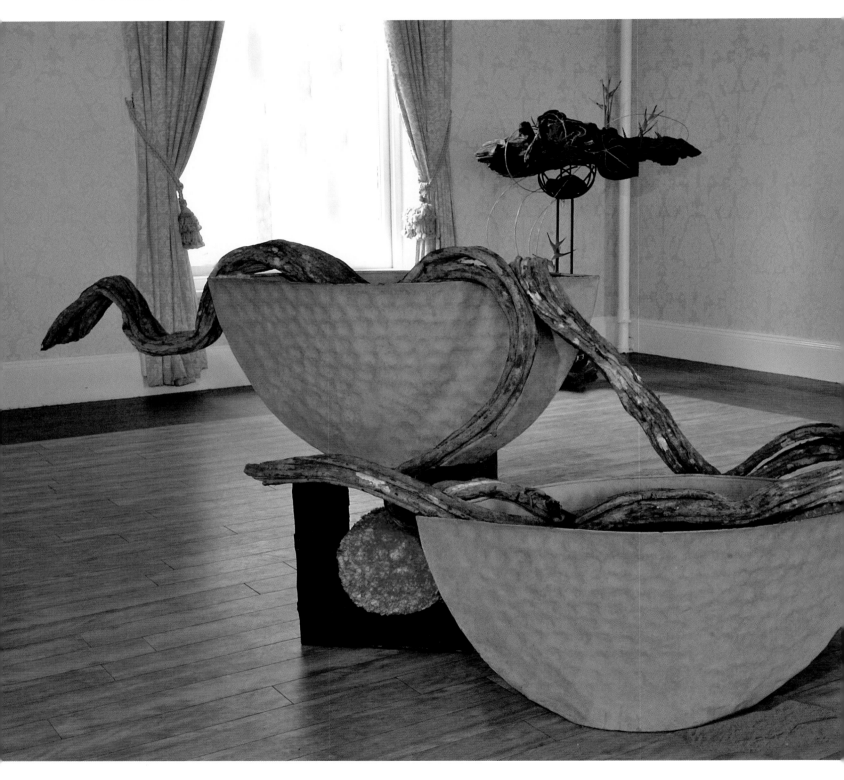

Rev William McMillan MBE
Ian McNeill

Angela and Steve Merryfield
NAFAS
National Association of Flower Arrangement Societies

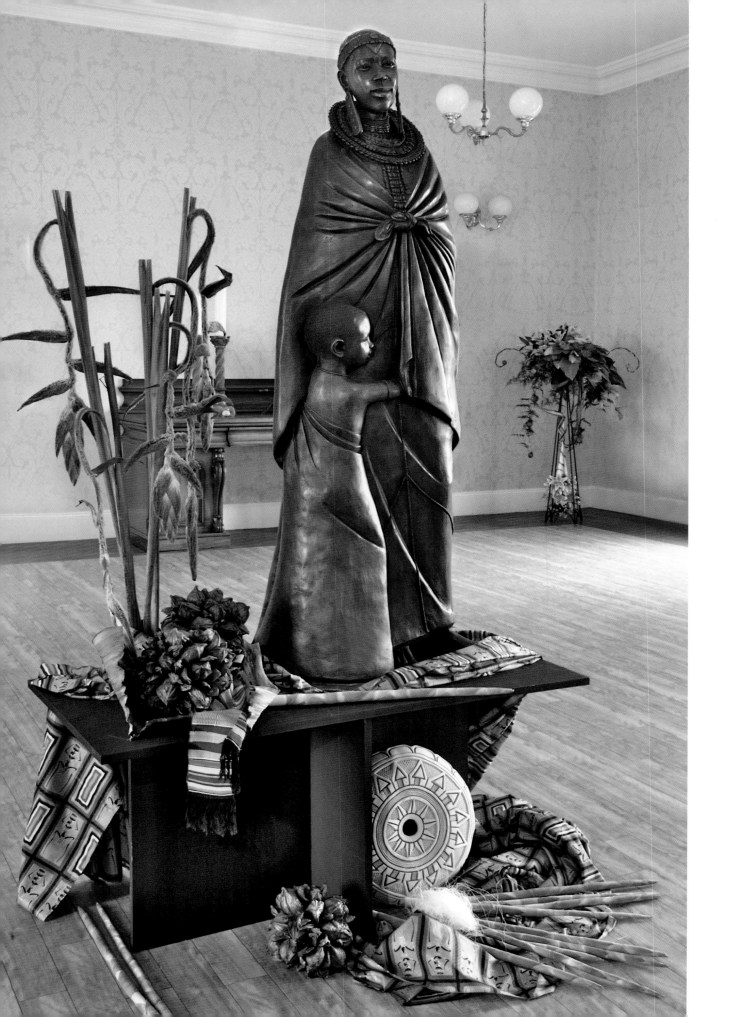

Northern Ireland

REV WILLIAM McMILLAN MBE

African Madonna, sculpture by Mr Gerard Olewe, b. 1963, Luo by tribe, Kisuma, Kenya

The Maasai woman representing the Madonna is in her traditional shawl (shuka) and distinctive earrings and neck adornments. Reflecting the uncertainties of early mortality in the Maasai tribe, the child is represented as five to six years into maturity, holding the promise that he will survive into adulthood.

Sonnets are full of love

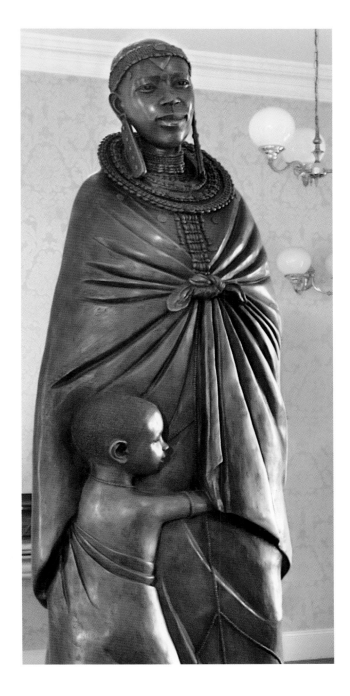

Sonnets are full of love, and this my tome
Has many sonnets: so here now shall be
One sonnet more, a love sonnet, from me
To her whose heart is my heart's quiet home,
To my first Love, my Mother, on whose knee
I learnt love-lore that is not troublesome;
Whose service is my special dignity,
And she my loadstar while I go and come
And so because you love me, and because
I love you, Mother, I have woven a wreath
Of rhymes wherewith to crown your
honoured name:
In you not fourscore years can dim the flame
Of love, whose blessed glow transcends the laws
Of time and change and mortal life and death.

Christina Rossetti

Northern Ireland
RAE DODDS
SUSAN TURLEY,
AND MEMBERS OF THE
DROMANTINE DESIGN TEAM
The Colours of Africa

Many hands came together
to create this vibrant topiary tapestry of African
colours and the striking pavé on the opposite
page of African design.

The Conference Centre

Céad Míle Fáilte

A Hundred Thousand Welcomes

'I am of Ireland,

And the Holy Land of Ireland,

And time runs on,' cried she.

'Come out of charity,

Come dance with me in Ireland.'

WB Yeats

Honorary Exhibits from Ireland and Around the World

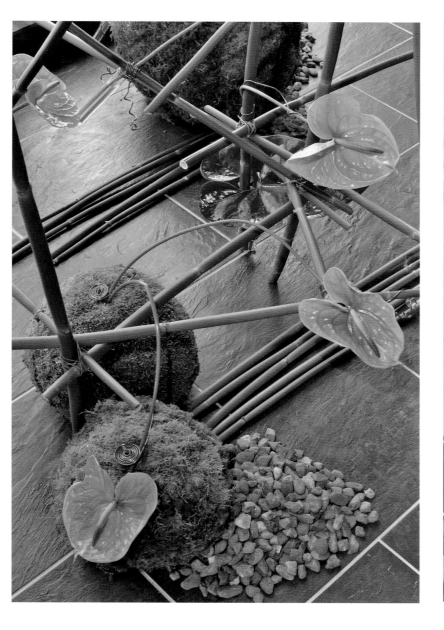

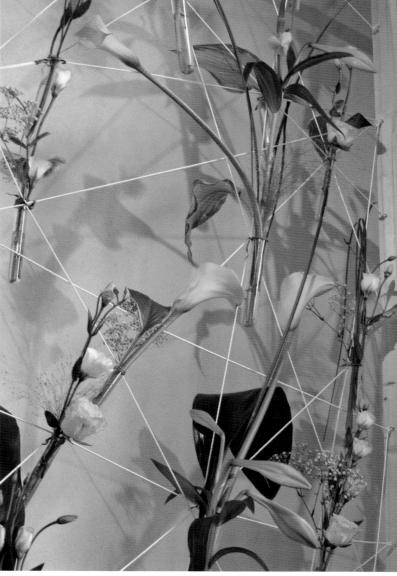

Winter

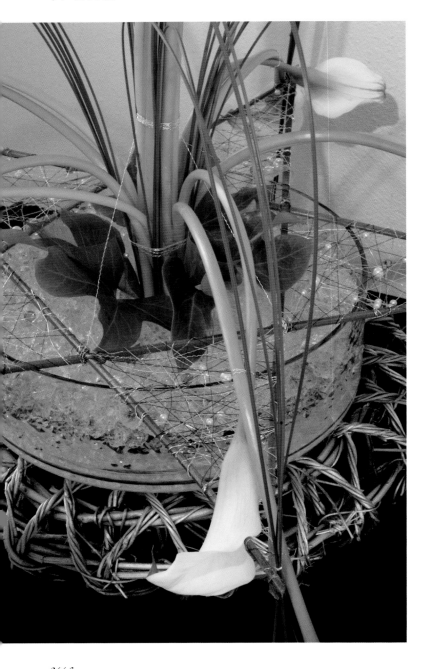

Spring

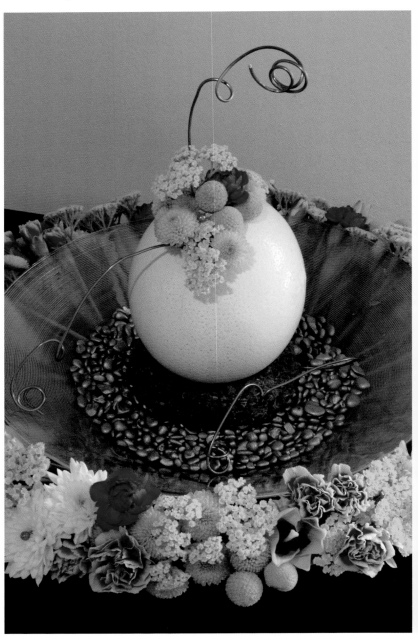

Winter garden
the moon thinned to a thread
insects singing.

Bashō

My heart rejoices
This day of spring.
To see the birds
That flock to play.

Ryōkan

Northern Ireland
INSPIRATIONS
A Specialist Group of Floral Designers

Summer

Autumn

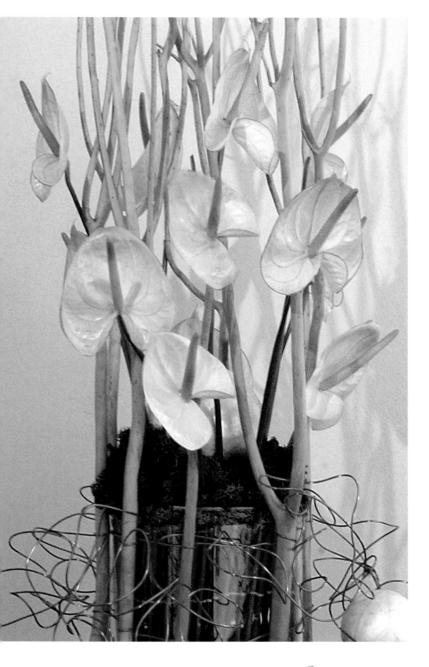

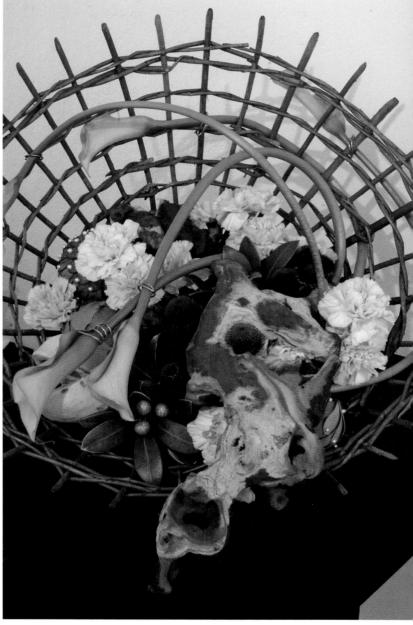

It's not like anything
they compare it to –
the summer moon.

Bashō

Autumn evening –
it's no light thing
being born a man.

Bashō

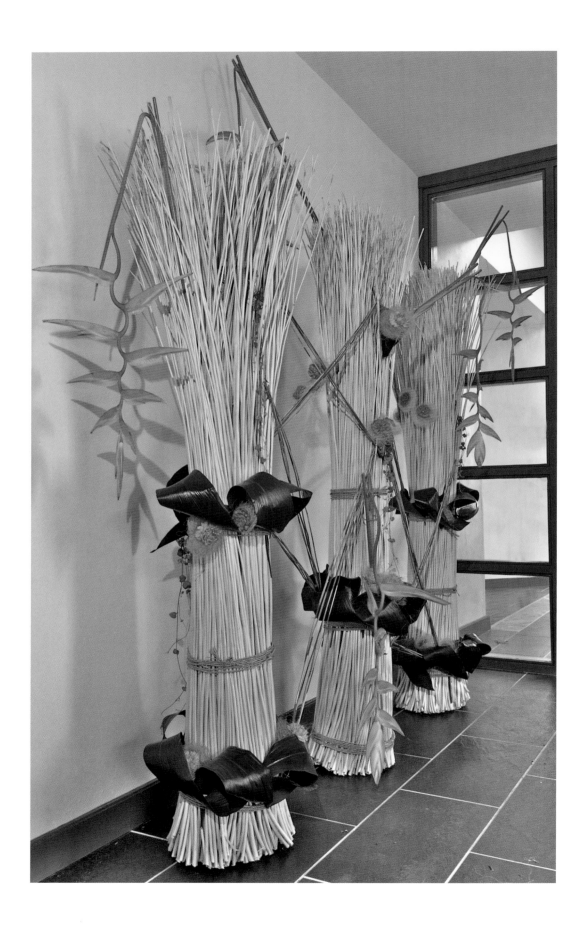

Northern Ireland

INSPIRATIONS

A Specialist Group of Floral Designers

The summer shower
Falls on the pinks,
So roughly.

Sampu

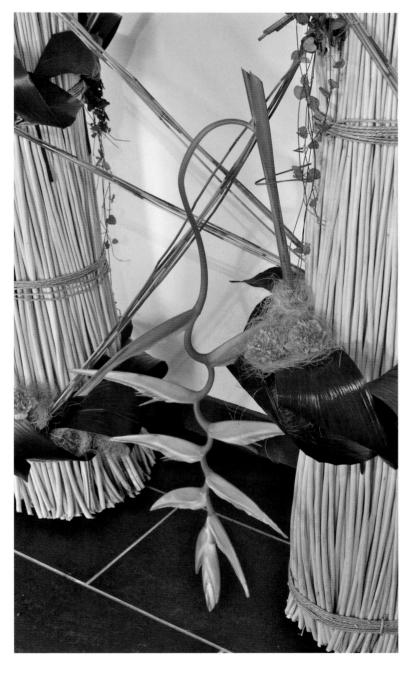

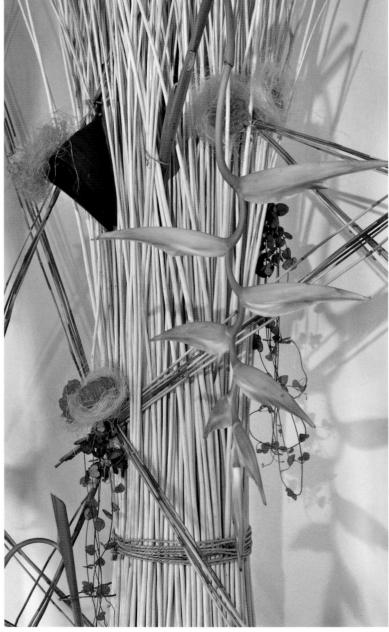

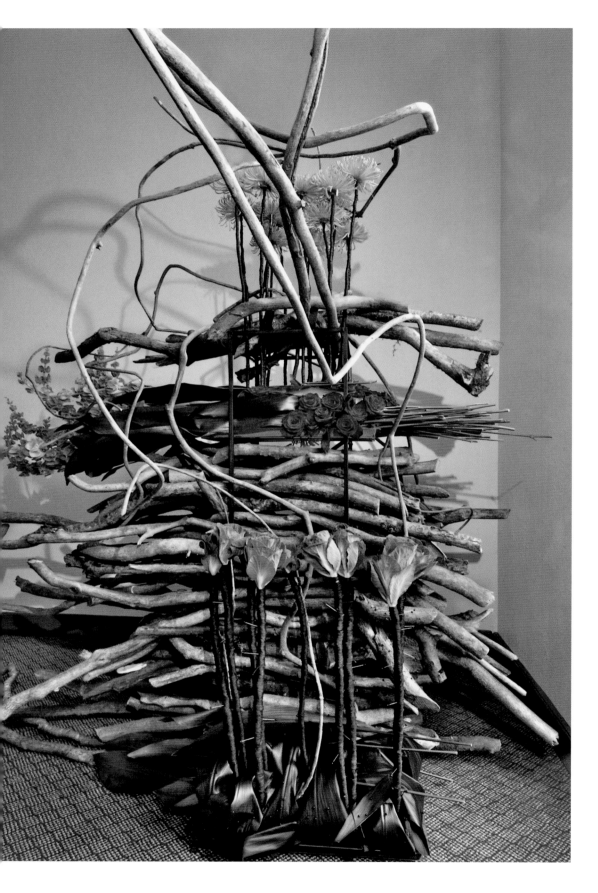

Hungary

ZOLTÁN KISS
FERENC KRUZSLICZ
The Strength of Life

A large stack of dead branches
represent a lack of respect for our Earth
through nature damaged by
environmental pollution.
Living flowers and leaves emerging from
the destruction symbolise the
power of nature to always renew
herself, while the swirling tangle of
branches upward expresses the new life
that arises after any kind of disaster,
whether natural or man-made.

On Not Saying Anything

This tree outside my window here,
Naked, umbrageous, fresh or sere,
Has neither chance nor will to be
Anything but a linden tree,
Even if its branches grew to span
The continent; for nature's plan
Insists that infinite extension
Shall create no new dimension,
From the first snuggling of the seed
In earth, a branchy form's decreed.

Cecil Day-Lewis

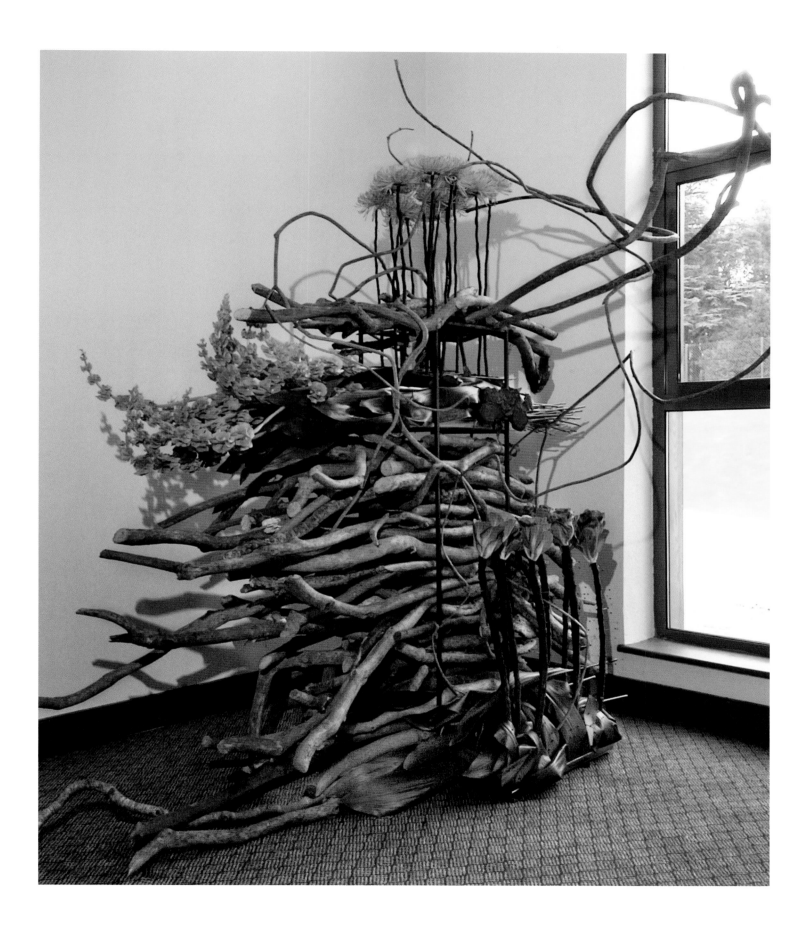

Zimbabwe

MORAG FLIGHT
LYNDA GRACE
MARGARET ANNE SHATTOCK
National Association of Garden Clubs

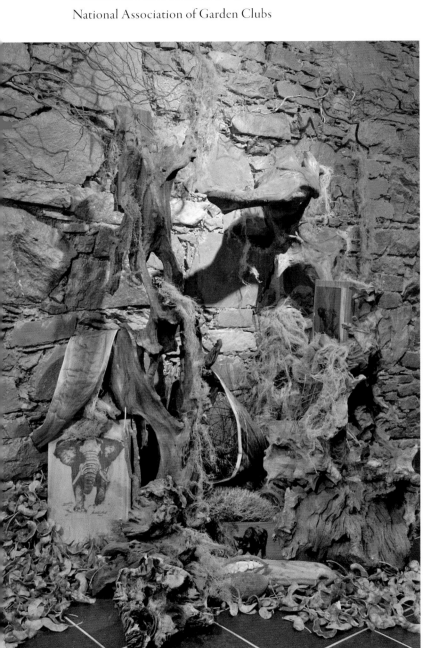

The Zimbabwean Bush

An array of natural plant material, including a number of varieties of seed pods from indigenous tree species, gives a dramatic portrayal of the Zimbabwean bush. The wood burnings of the beautiful native fauna were hand-created from drawings by Margaret Anne Shattock.

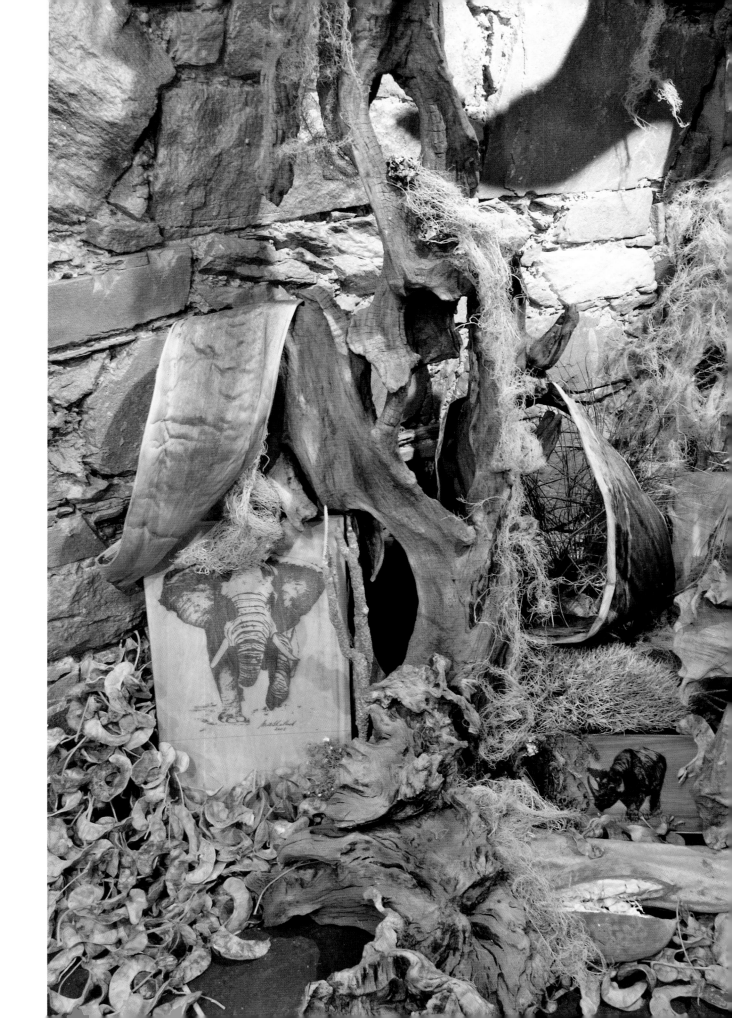

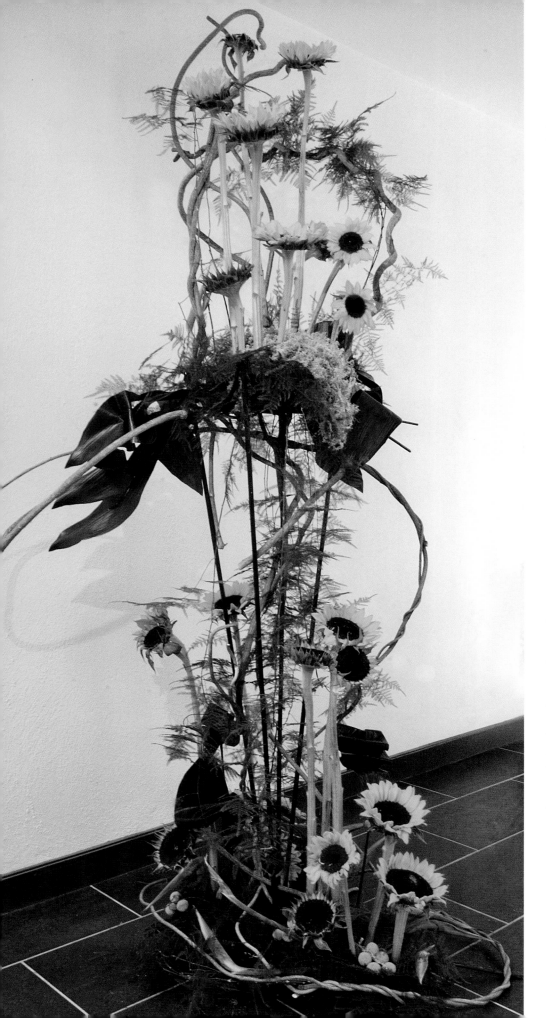

Uruguay

Rosemarie Symond Chilibroste
Magdalena Sienra de Pacheco
The Garden Clubs of Uruguay
The Land of the Sun and the Nice People

Ah Sun-flower

Ah Sun-flower! weary of time,
Who countest the steps of the Sun,
Seeking after that sweet golden clime
Where the traveller's journey is done;

Where the Youth pined away with desire,
And the pale Virgin shrouded in snow,
Arise from their graves and aspire,
Where my Sun-flower wishes to go.

William Blake

Swaziland

MARGARET DEAN SMITH

SANDRA FORBES

To the Daisy

Bright Flower! whose home is everywhere,
Bold in maternal Nature's care,
And all the long year through the heir
Of joy or sorrow;
Me thinks that there abides in thee
Some concord with humanity,
Given to no other flower I see
The forest thorough!

William Wordsworth

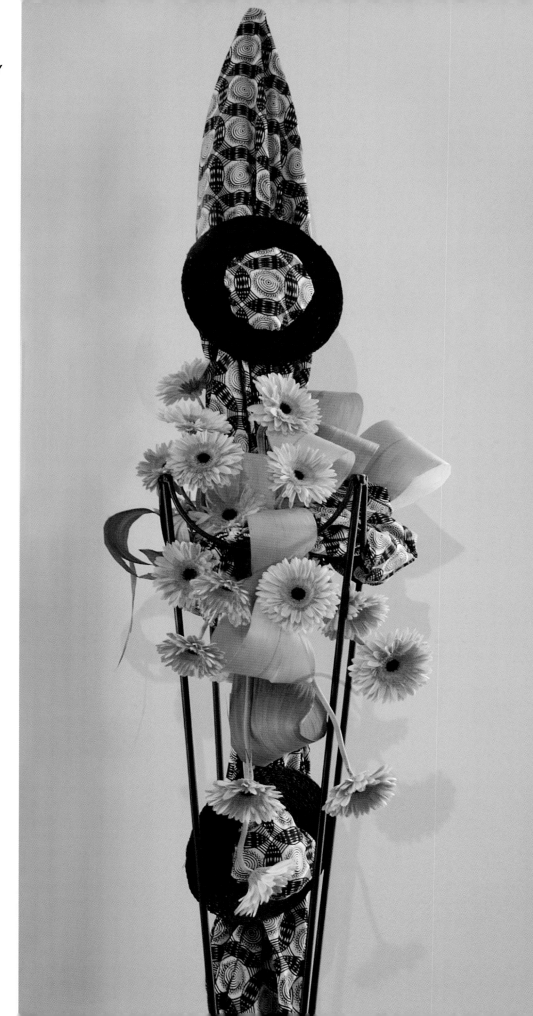

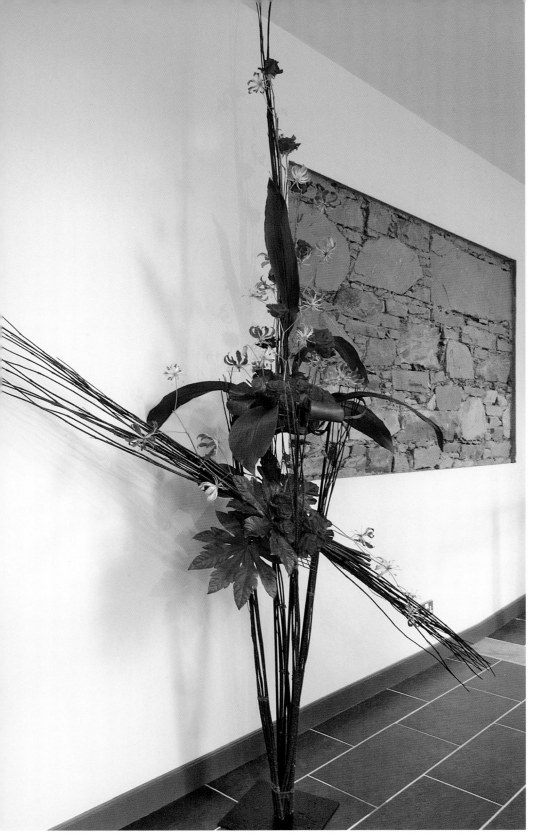

England

IRENE ANN PARKER

ANNE CODD

The White Rose

The red rose whispers of passion
And the white rose breathes of love.
O the red rose is falcon,
And the white rose is a dove.

But I send you a cream-white rosebud
With a flush on its petal tips;
For the love that is purest and sweetest
Has a kiss of desire on the lips.

John Boyle O'Reilly

England
SUSAN PHILLIPS
A Tranquil Rain Forest of Green and White

The aim of this exhibit was to balance a strong geometric outline with a delicacy of plant material. The tranquillity of the green and white colour scheme and the layering of foliage and flowers suggest a rain-forest atmosphere, enhanced by large monstera leaves, that add a canopy to the geometric form of the cube.

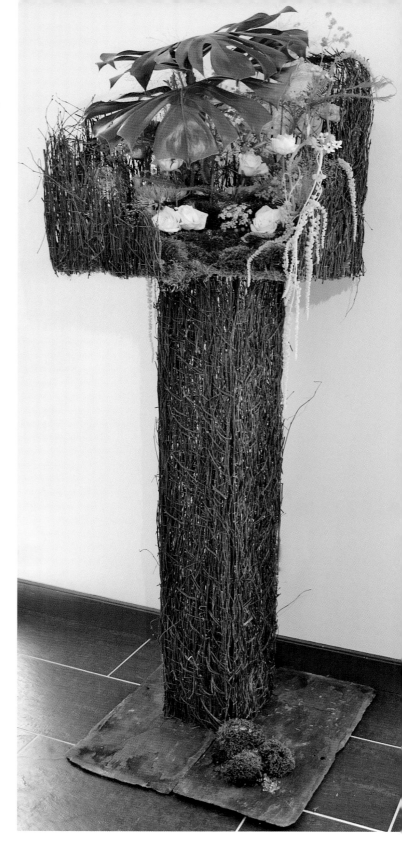

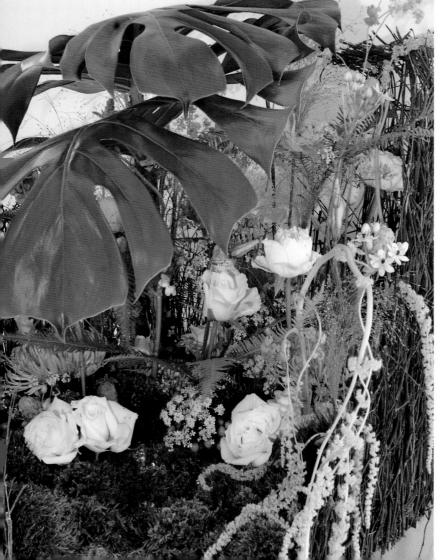

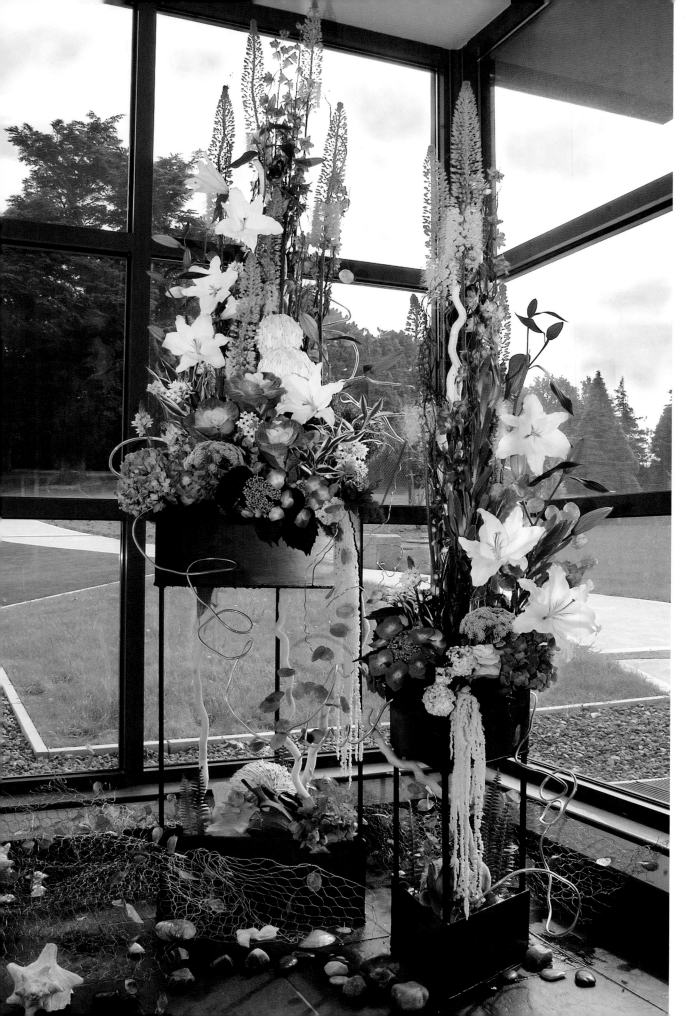

A wild sea –
and flowing
out towards
Sado Island
the Milky Way.

Bashō

Along the shore
mixed with small
shells, petals of
bush clover.

Bashō

Japan
YASUKO MANAKO
School Master, Manako Flower Academy
President, Manako-JAFAS
Japanese Association of Flower Arranger Societies

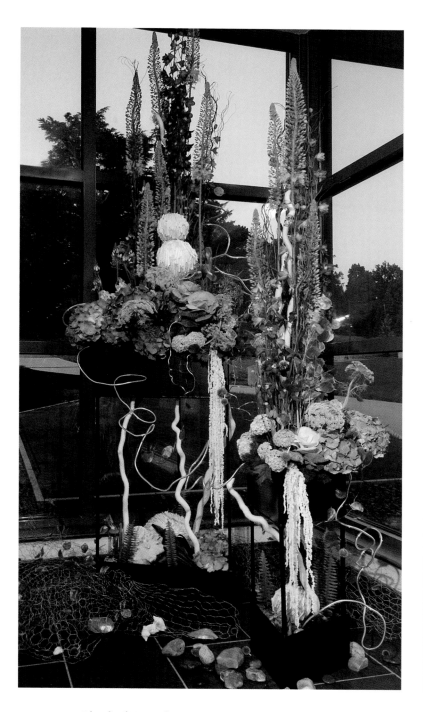

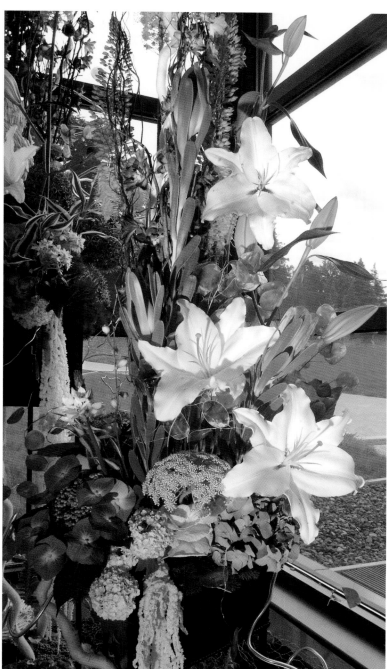

Islands of Natural Beauty

Surrounded by the beauty and strength of an ever-changing blue sea, Japan is a group of mountainous islands abounding with a variety of plants and flowers, rushing rivers and streams, and magnificent seasonal landscapes. This diverse beauty is dramatically portrayed in an arrangement that also harmonizes with the lush greenery of the Irish landscape beyond.

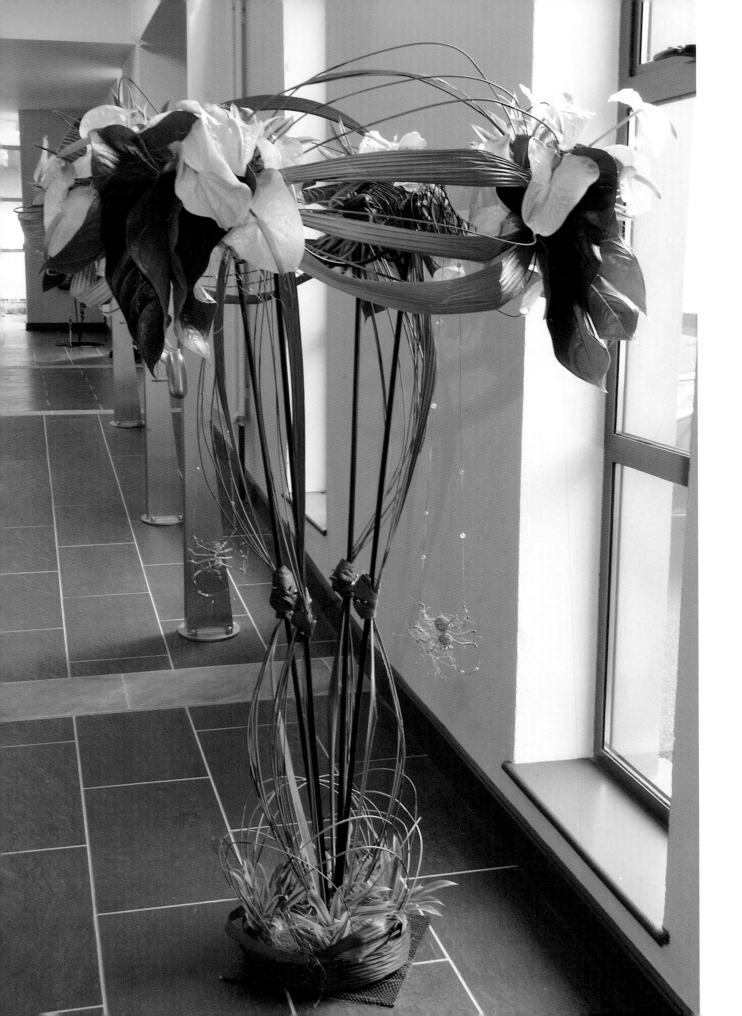

South Africa
BEVERLEY WESTHOF

This special hand-beaded and
hand-molded wire spider is one
of many made by local Africans
who are part of a self-help project.
Working in groups all day long to
make these beautiful pieces, they
offer them for sale in order to feed
themselves, their families and
those around them.

The Spider holds a Silver Ball
In unperceived Hands –
And dancing softly to Himself
His Yarn of Pearl – unwinds –

He plies from Nought to Nought –
In unsubstantial Trade –
Supplants our Tapestries with His –
In half the period –

An Hour to rear supreme
His Continents of Light –
Then dangle from the Housewife's Broom –
His Boundaries – forgot –

Emily Dickinson

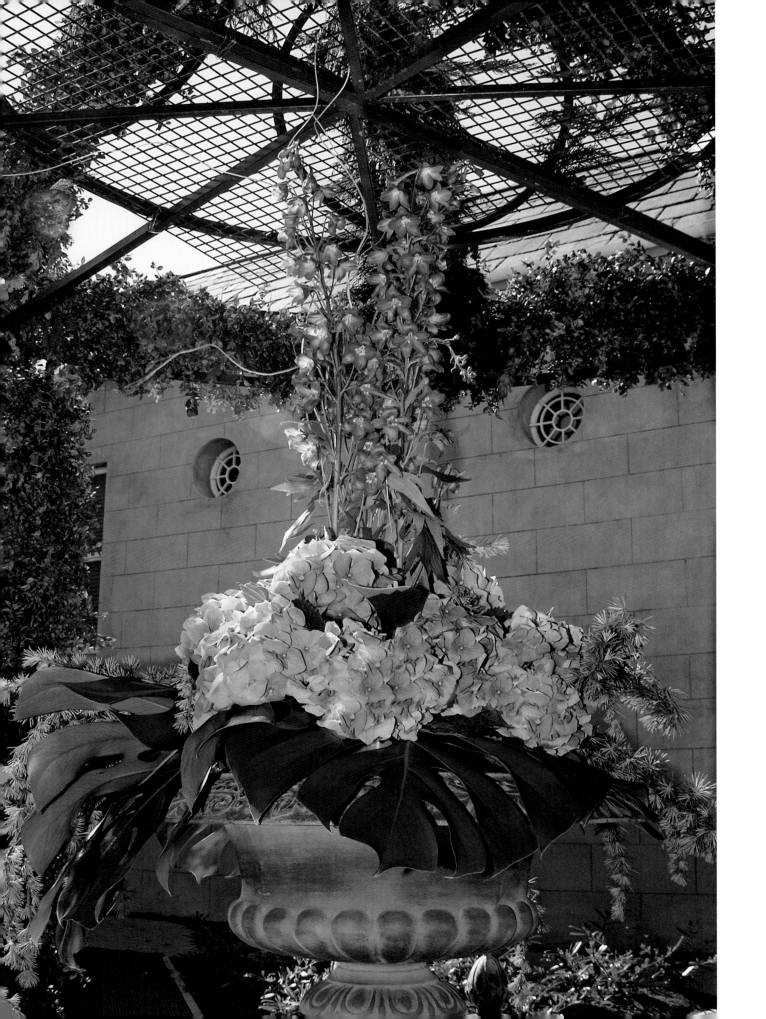

The Courtyard

Ireland
CHRISTOPHER WHITE
Naul Gardening Club

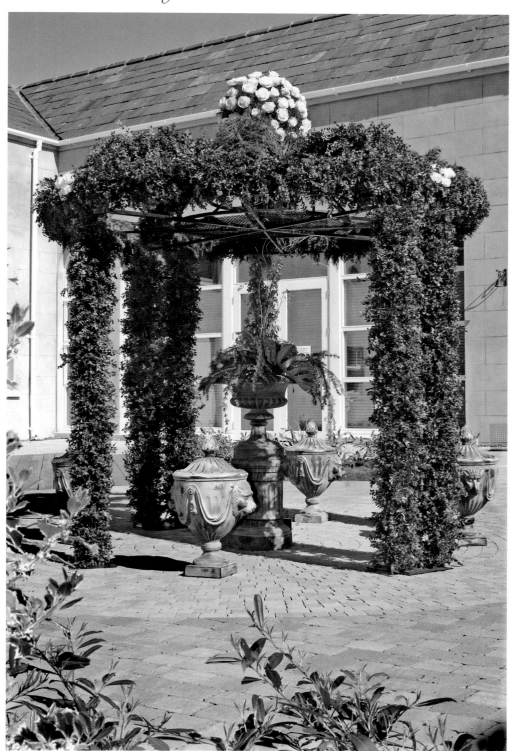

Blue! 'Tis the life of heaven, the domain
 Of Cynthia, the wide palace of the sun,
 The tent of Hesperus and all his train.
 The bosomer of clouds, gold, grey, and dun.

 Blue! Gentle cousin of the forest-green,
Married to green in all the sweetest flowers–
Forget-me-not, the blue bell, and that queen
Of secrecy, the violet! What strange powers
Hast thou as a mere shadow! But how great,
 When in an eye thou art alive with fate!

 John Keats

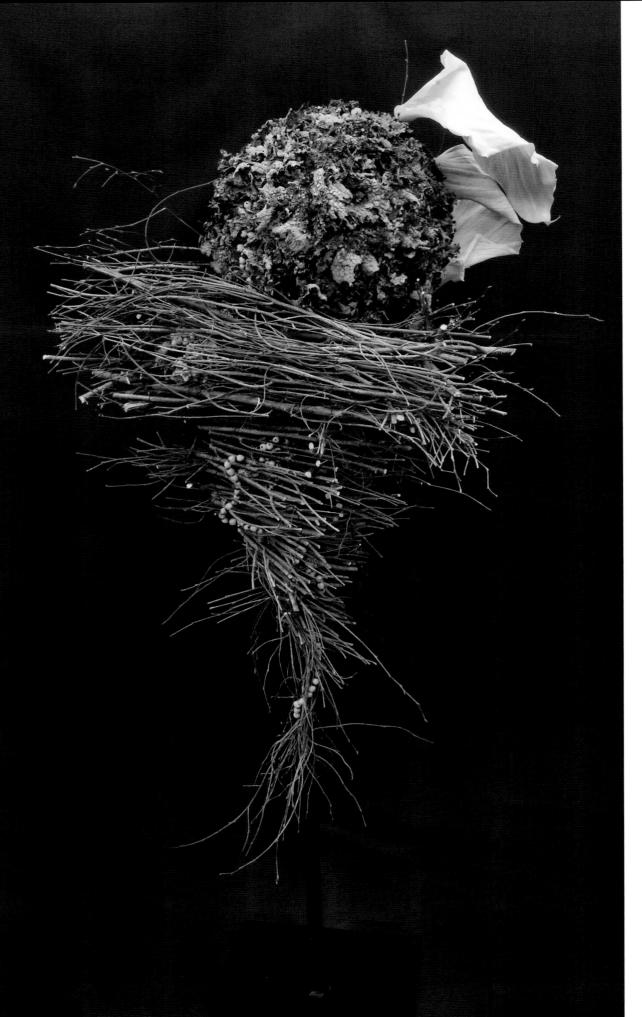

Life Force

FIRST PLACE AND
BEST IN SHOW

England
SUSAN PHILLIPS

Poetry

...and suddenly I saw
the heavens
unfastened
and open,
planets,
palpitating plantations,
shadow perforated,
riddled
with arrows, fire and flowers,
the winding night, the universe

And I, infinitesimal being,
drunk with the great starry
void,
likeness, image of
mystery,
felt myself a pure part
of the abyss,
I wheeled with the stars,
my heart broke loose on the wind.

Pablo Neruda

The Competitions

The flower-arranging competition at Dromantine consisted of eight classes and 78 entries that were staged in three rooms:

> Hannon Hall: *Life Force, Transparency, Encircled* and *Timeless*
> Mulhern Room: *Delicate Balance, Tread Softly* and *Entwined*
> Donaghmore Room: *Daring Composition*

From the Arranger's Point of View

His or her individual selection was a matter of inspirational appeal arising from the information in the schedule. A choice was made for one of the class titles which fall into the following categories: a standard exhibit, a petite exhibit or a craft class. Within each class were further requirements and restrictions regarding size and preparation that influenced an arranger's decision. Only the two craft classes, *Tread Softly* and *Entwined,* allowed the exhibit to be submitted fully prepared. All other classes were to be done in situ in the time allotted, which was five hours beginning at 6:00 am on the day of judging. The arrangers were to follow the show's six rules:

1. An exhibit consists of plant material, with or without accessories, within a space specified in the schedule.
2. Plant material must predominate over all other components.
3. The use of artificial plant material is forbidden.
4. Fresh plant material must be in water or water retaining substance, unless such plant material remains turgid for the duration of the event.
5. Painted and/or artificially coloured plant material may be used.
6. Nothing may be attached to the background in any class.

From the Judges' Point of View

Three international judges – from Belgium, Ireland and the United States – were invited to judge the 78 entries. Each of these judges is a very experienced judge in their own country as well as being an international judge. The judges first viewed all the exhibits in the entire show individually and later conferred and discussed each of the entries by class. Each judge named her top three to five choices for the awards of first, second and third place. A consensus was reached and in the case of Dromantine, almost every decision was immediately unanimous.

Judging was based on the elements and principles of design: originality, creativity and interpretation of the class title. The judges' final assignment of the day was to select from among the first-place winners a Best in Show and a Judges' Choice. Finally the next morning, all three judges met in person with the arrangers to discuss their decision in each class.

PENNY HORNE
International Judge, United States of America

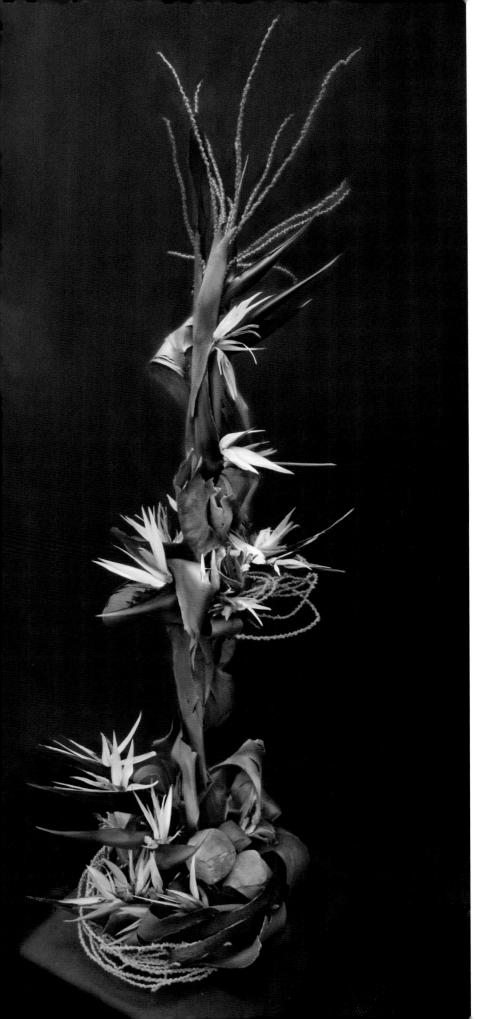

Life Force

An Exhibit
*Staged on a metal stand
that was provided for
the competition.*

SECOND PLACE

South Africa
CAROLYNNE SPIERS
Dynamic Energy

The polarity of the near-complementary
colours purple and orange depicts a
feeling of force and tension, while
the circular patterns and vertical lines
give the design movement and
projection. Combined with the
explosive quality of the strelitzia
flowers, the work portrays the dynamic
energy of Life Force.

Trinidad

JOYCE MUNGAL

Rise Like the Phoenix

Out of a dry tangled vine
comes a new life force of
beautiful flowers
and foliage.

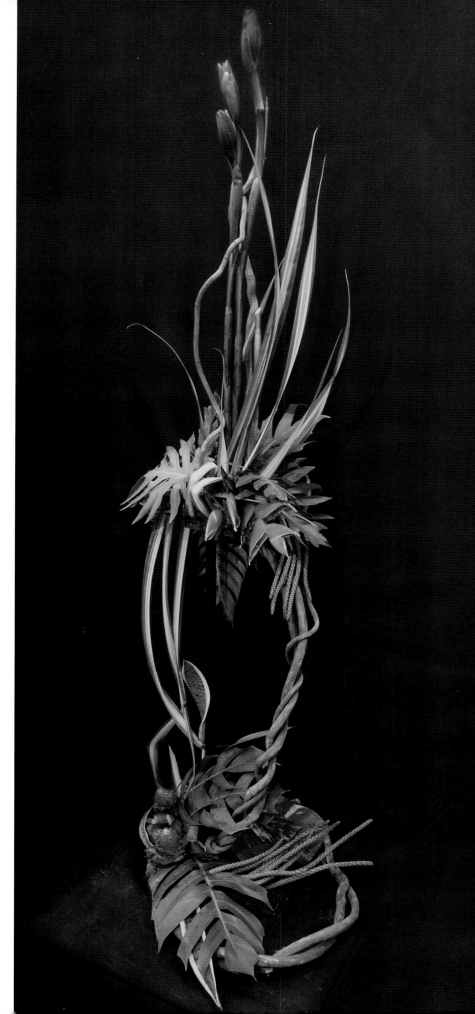

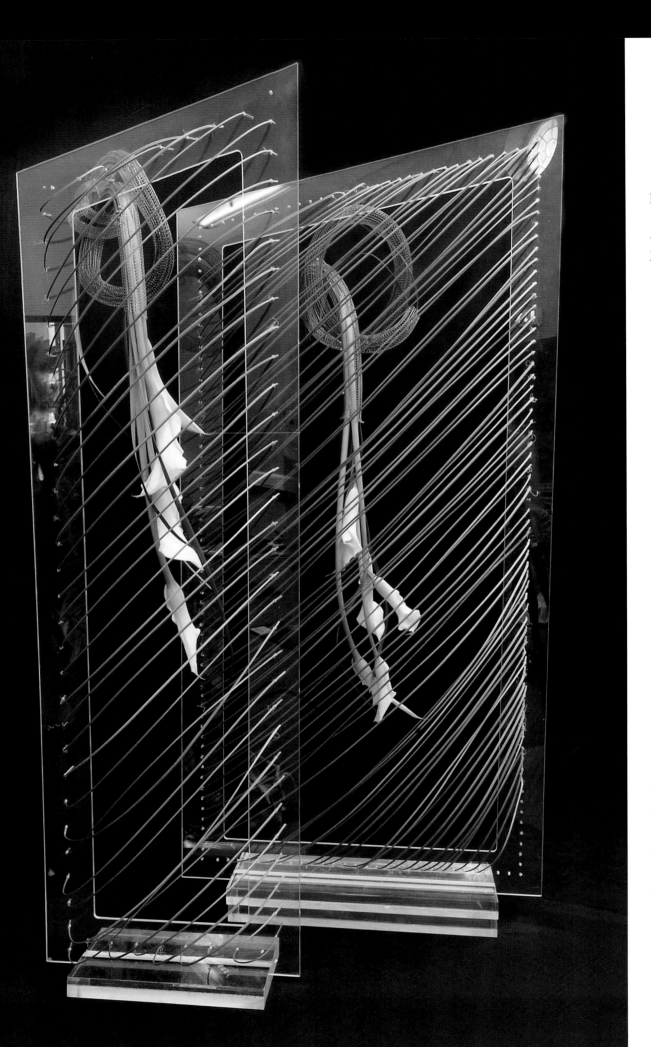

For now we see
through a glass, darkly;
but then face to face:
now I know in part;
but then shall I know
even as also I am known.

1 Corinthians 13:12

Transparency

An Exhibit
Staged on a base at floor level.
To be viewed all round,
judged from the front.

SECOND PLACE

Northern Ireland

ROSSLIND McGOOKIN

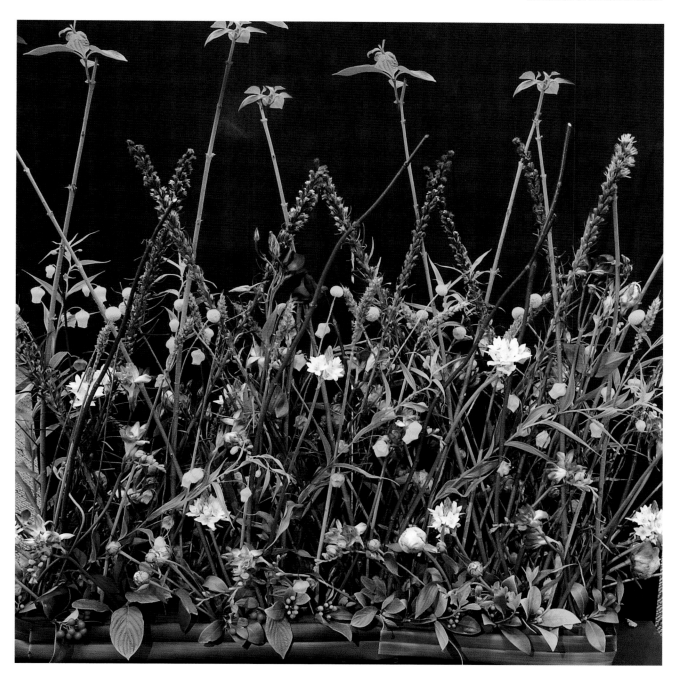

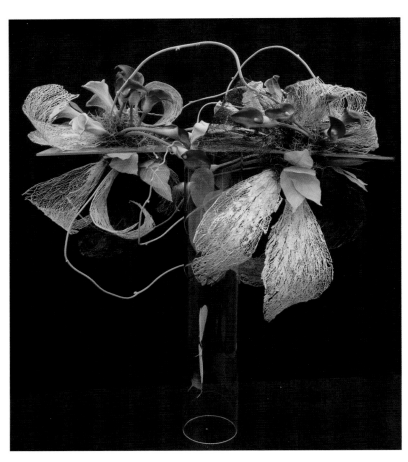

Transparency

THIRD PLACE

South Africa
VAUGHN HARRINGTON

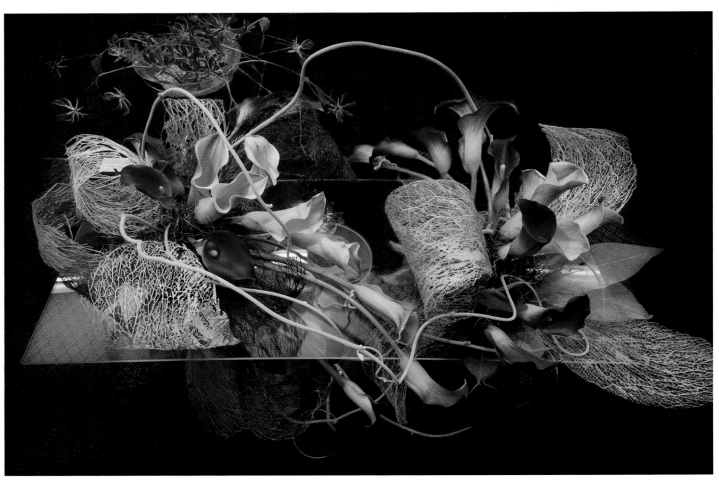

this is the garden: colours come and go

this is the garden: colours come and go,
frail azures fluttering from night's outer wing
strong silent greens serenely lingering,
absolute lights like baths of golden snow.
This is the garden: pursed lips do blow
upon cool flutes within wide glooms, and sing
(of harps celestial to the quivering string)
invisible faces hauntingly and slow.

This is the garden. Time shall surely reap
and on Death's blade lie many a flower curled,
in other lands where other songs be sung;
yet stand They here enraptured, as among
The slow deep trees perpetual of sleep
some silver-fingered fountain steals the world.

e e cummings

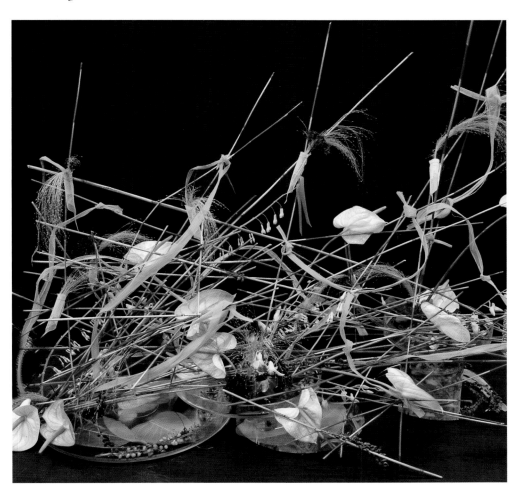

Northern Ireland

ELIZABETH REA

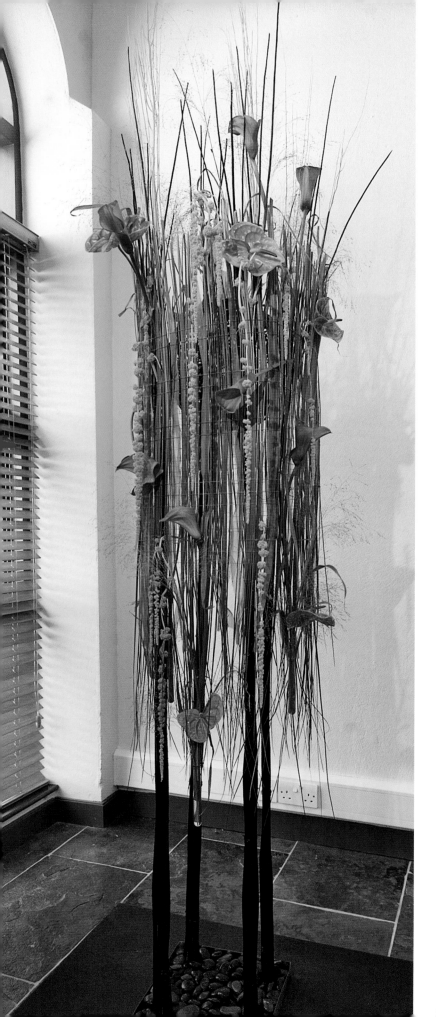

Daring Composition

An Exhibit
Staged on a base at floor level.
To be viewed all round, judged from the front.

FIRST PLACE AND
JUDGES' CHOICE

England
EILEEN BARRACLOUGH

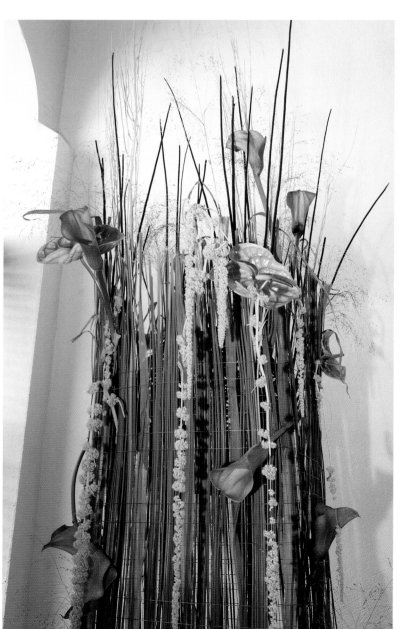

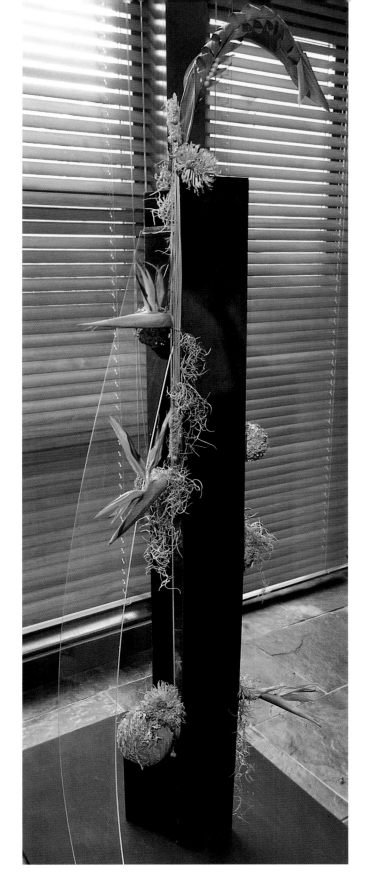

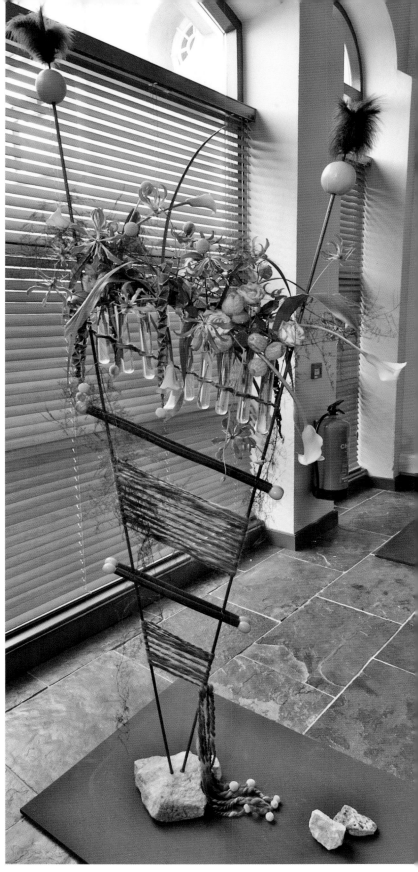

SECOND PLACE

South Africa

HELEN BARNARD

THIRD PLACE

Scotland

HEATHER BARR

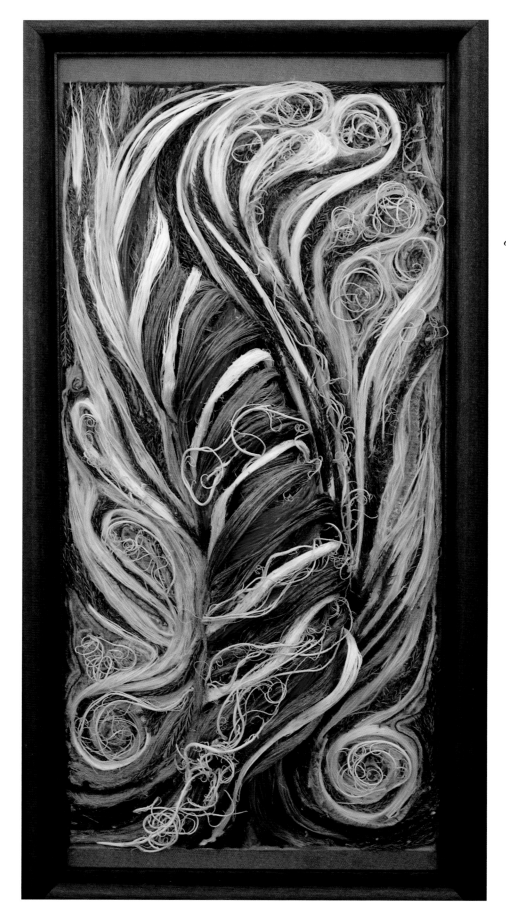

Entwined

Craft Class
A Collage Exhibit
*Dried/preserved plant material
staged on a vertical surface.*

FIRST PLACE

Japan
SETSU SHIMOZAWA

Believe me, if all those endearing
young charms
Which I gaze on so fondly today,
Were to change by tomorrow and fleet
in my arms,
Like fairy gifts fading away
Thou wouldst still be adored as this
moment thou art,
Let thy loveliness fade as it will,
And around the dear ruin each wish of
my heart
Would entwine itself verdantly still...

Thomas Moore

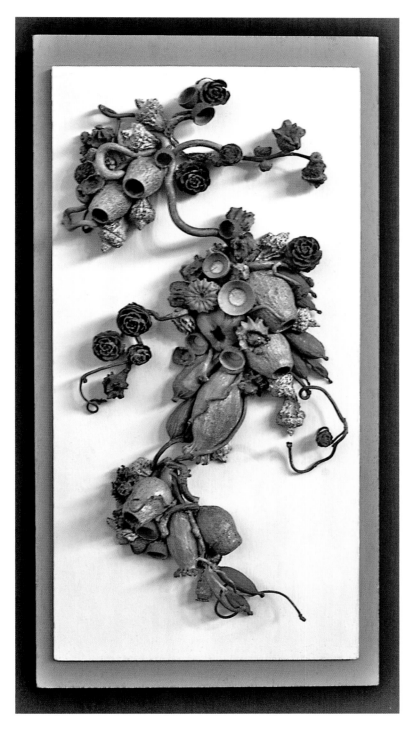

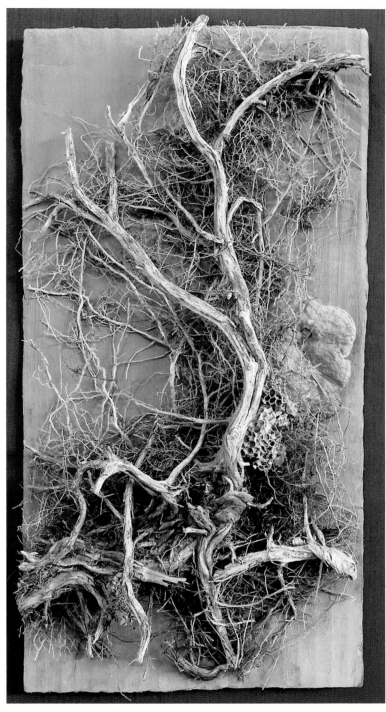

SECOND PLACE

Northern Ireland

JOAN JOHNSTON

THIRD PLACE

Zimbabwe

MORAG FLIGHT

Tread Softly

Craft Class
*An item of decorated footwear
staged on shelving at various levels.*

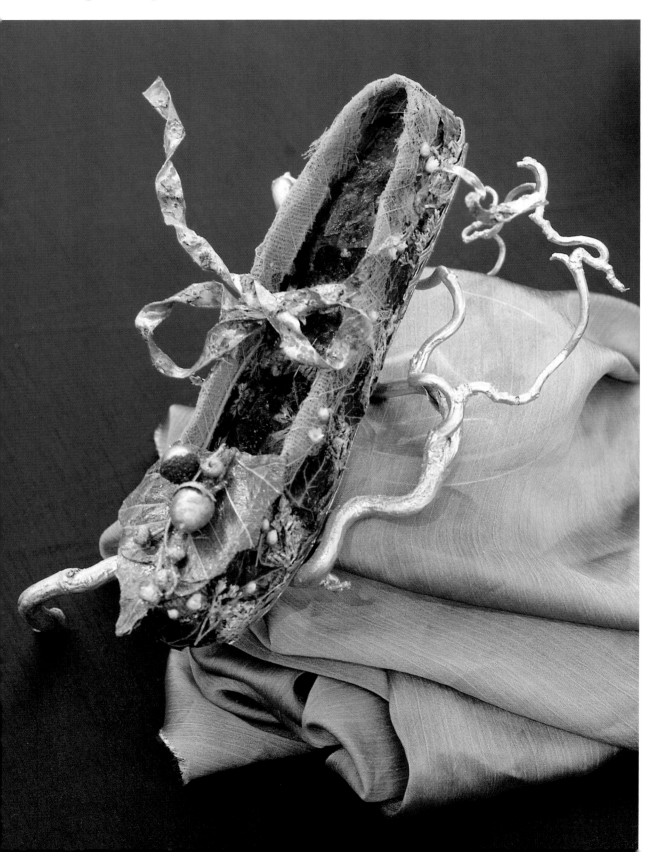

He Wishes for the Cloths of Heaven

Had I the heavens' embroidered cloths,
Enwrought with golden and silver light,
The blue and the dim and the dark cloths
Of night and light and half-light,
I would spread the cloths under your feet;
But I, being poor, have only my dreams;
I have spread my dreams under your feet;
Tread softly because you tread on my dreams.

WB Yeats

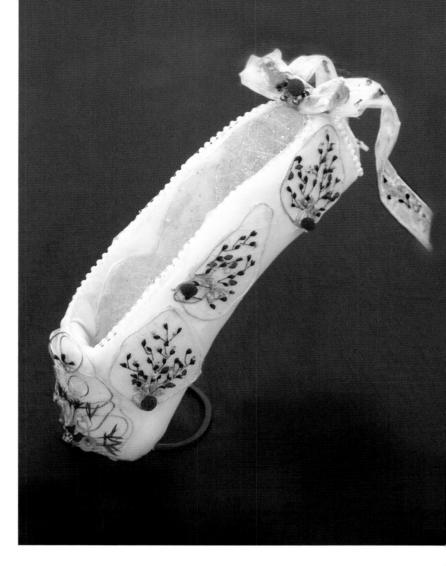

THIRD PLACE

England

LINDA TAYLOR

SECOND PLACE

England

SUSAN ANN KEHOE

NAFAS

*National Association of
Flower Arrangement Societies*

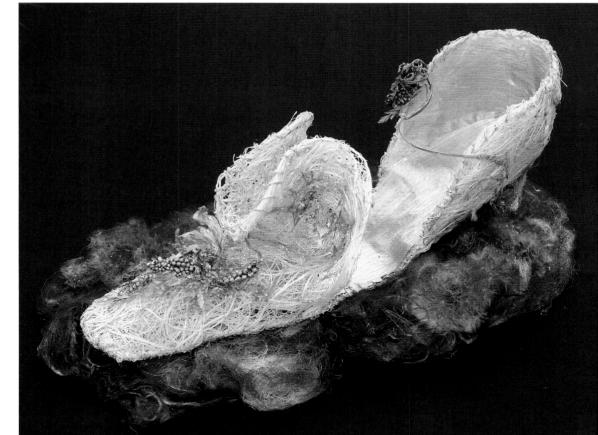

Delicate Balance

A Petite Class
Staged on 25-centimetre circular bases
at various eye levels.

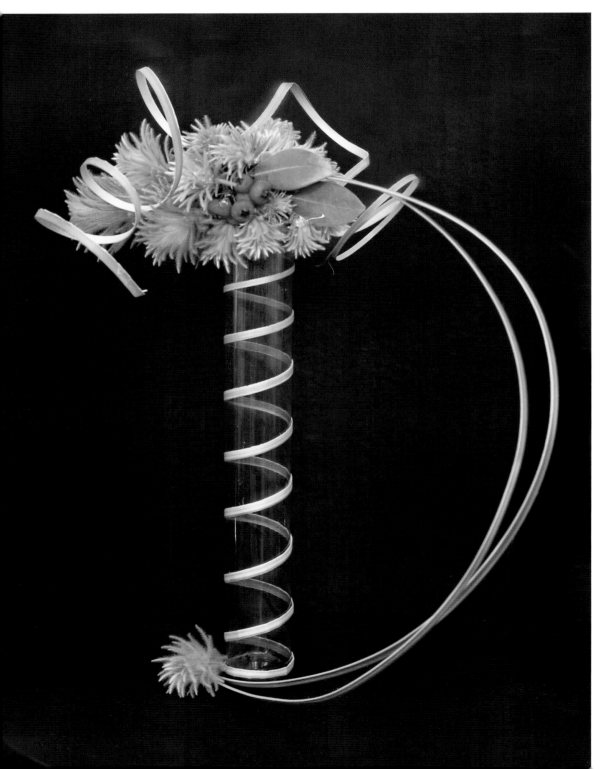

FIRST PLACE

South Africa

YVONNE EIJLERS
KwaZulu Panel
of Floral Art Judges

An Irish Airman
Foresees His Death

I balanced all, brought all to mind,
The years to come seemed waste of breath,
A waste of breath the years behind
In balance with this life, this death.

WB Yeats

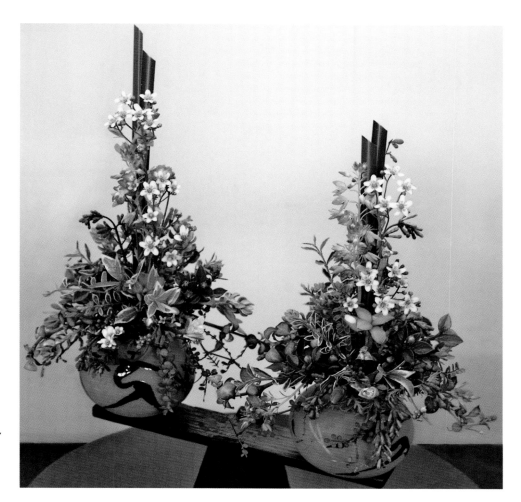

Encircled

An Exhibit
*Staged on a two-centimetre thick circular base
raised 45 centimetres from the floor.
To be viewed all round.*

FIRST PLACE

South Africa
LINDA LARRATT
Durban Floral Art Club
South African Flower Union

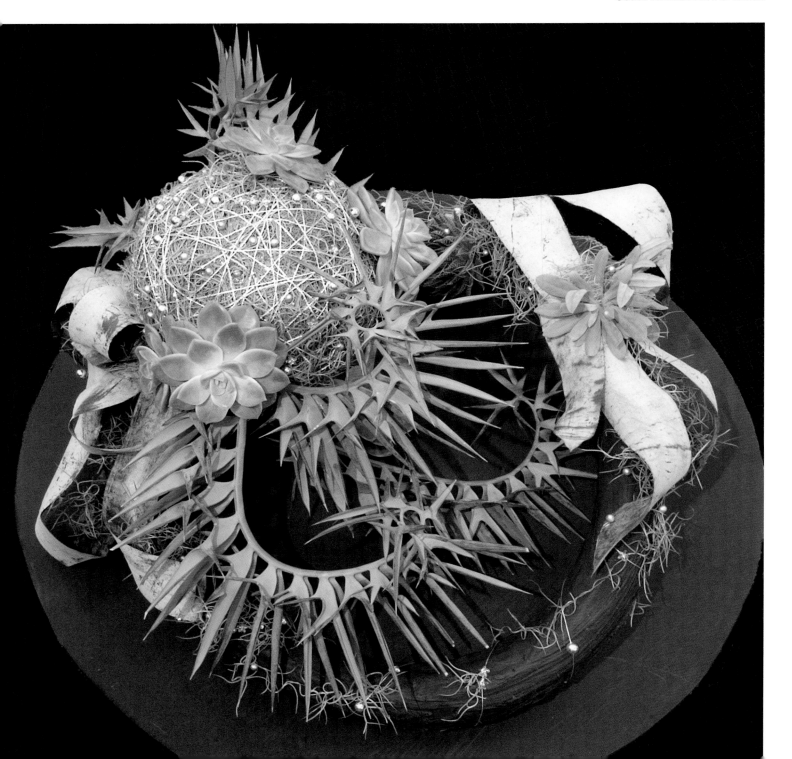

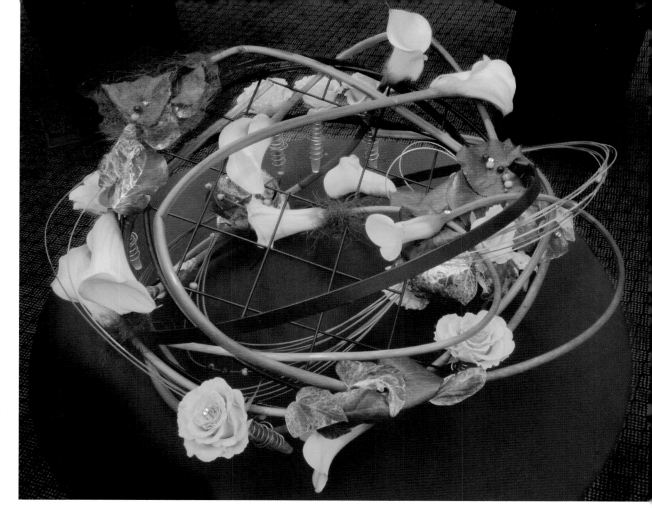

SECOND PLACE

England
VAL SEED

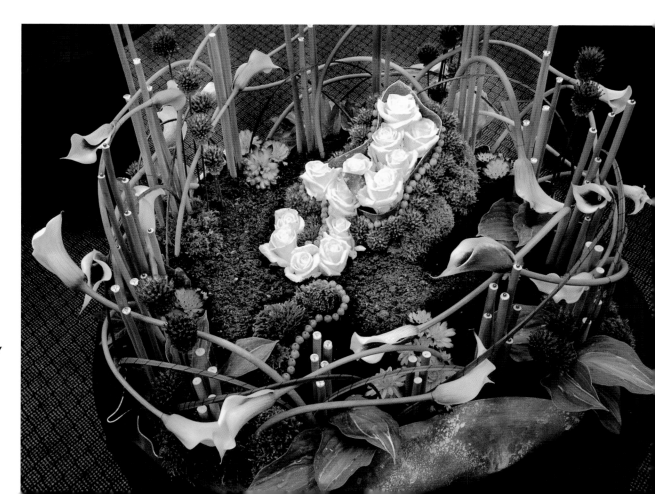

THIRD PLACE

England
SUSAN FAIRHURST

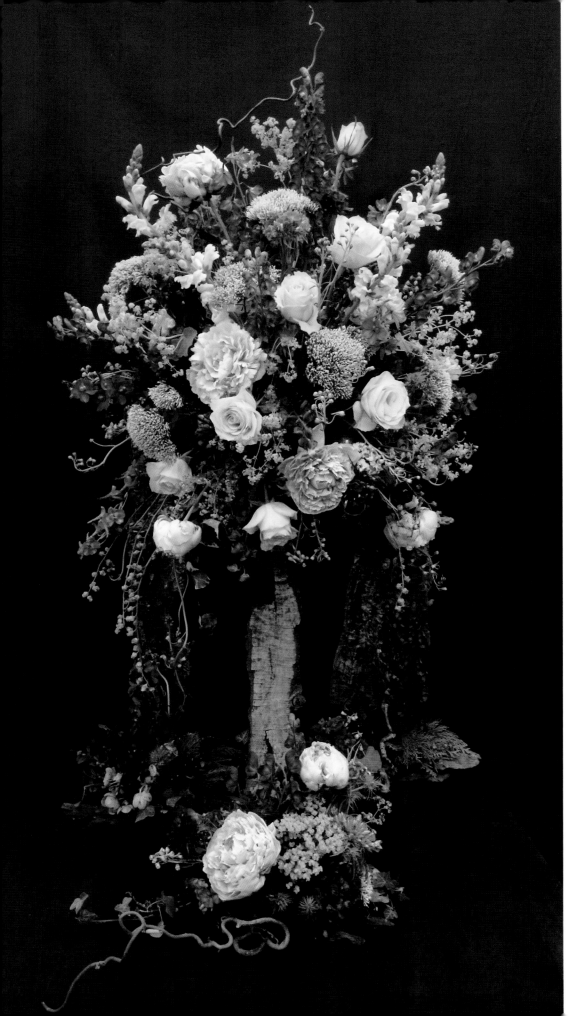

Timeless

An Exhibit
*Staged on tabling 75 centimetres
from the floor. To be viewed and
judged from the front.*

FIRST PLACE

Ireland
BRIDIE DOWLING

Let me not to the marriage of true minds
Admit impediments. Love is not love
Which alters when it alteration finds,
Or bends with the remover to remove:
O no! it is an ever-fixed mark
That looks on tempests and is never shaken;
It is the star to every wandering bark,
Whose worth's unknown,
 although his height be taken.
Love's not Time's fool,
 though rosy lips and cheeks
Within his bending sickle's compass come:
Love alters not
 with his brief hours and weeks,
But bears it out even to the edge of doom.
If this be error and upon me proved,
I never writ, nor no man ever loved.

William Shakespeare

SECOND PLACE

Northern Ireland

MARIE GILLANDERS

THIRD PLACE

Northern Ireland

ELIZABETH ALLEN

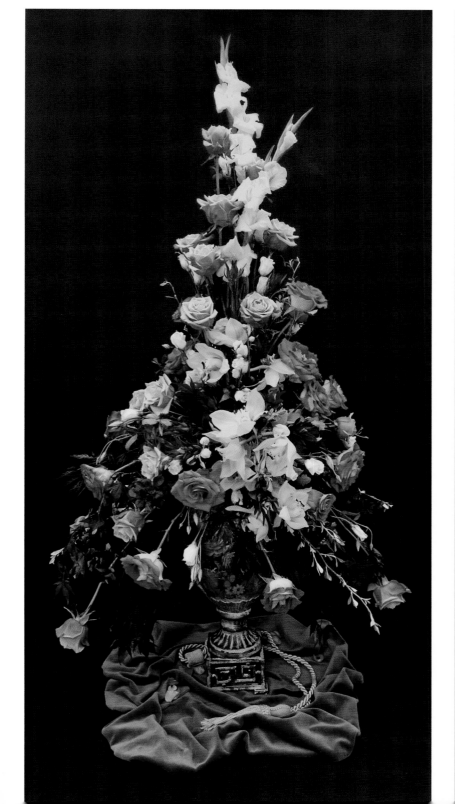

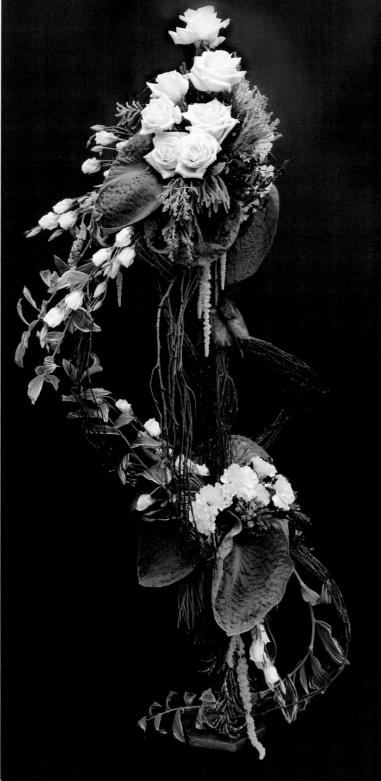

A River of Roses

Northern Ireland

Five thousand roses were flown in to Northern Ireland
from Zambia under fair-trade
conditions. From this glorious bounty of floral beauty,
visitors were invited to participate in
creating "A River of Roses," winding its way
through the lawn along the path to the chapel.

Roses were placed in the "river" in memory of a loved
one, and at the end of the week a
special prayer service of thanksgiving was held in the
chapel for the thousands of loved ones
so reverently honoured in
"A River of Roses" at Dromantine.

Fr P J Gormley SMA
Rev William McMillan MBE
Susan and Hugh Turley

Esquire Roses, Zambia,
ZEGA, Zambia
CML Ltd, UK
British Airways
Kelly Flowers, UK

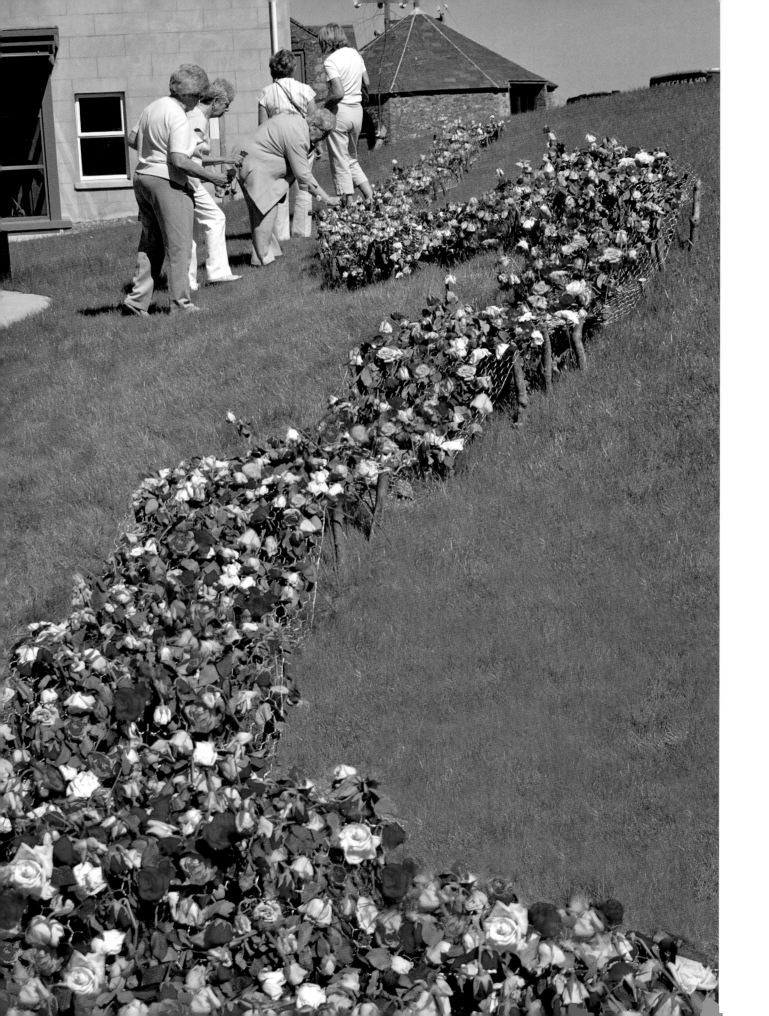

A River of Roses... creating a River of Remembrance

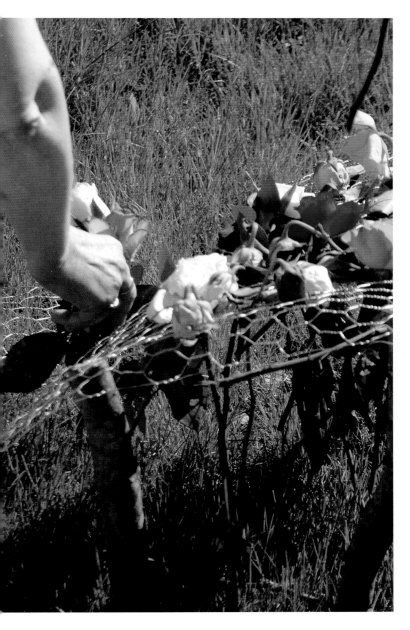

Strings in the earth and air
Make music sweet;
Strings by the river where
The willows meet.

There's music along the river
For Love wanders there,
Pale flowers on his mantle,
Dark leaves on his hair.

All softly playing,
With head to the music bent,
And fingers straying
Upon an instrument.

James Joyce

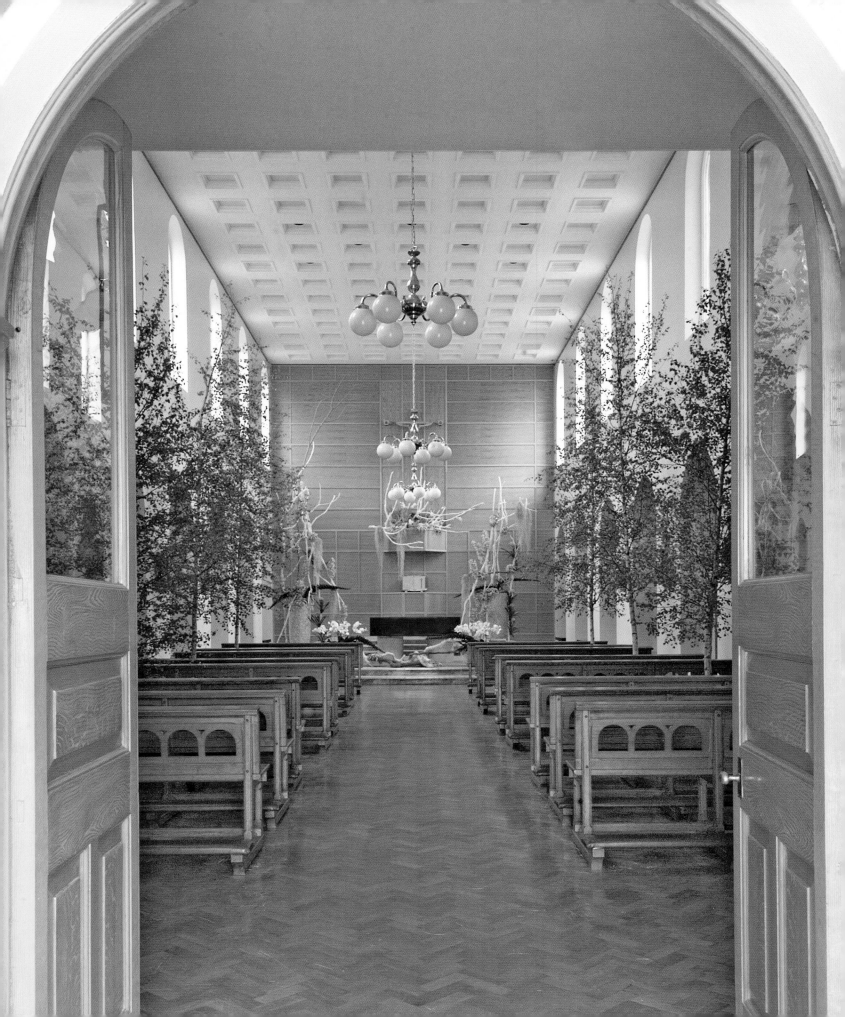

The Chapel

Light of Life

You pray in your distress and in your need;

would that you might pray also in the fullness of your joy and in your days of abundance.

For what is prayer but the expansion of yourself into the living ether?

And if it is for your comfort to pour your darkness into space,

it is also for your delight to pour forth the dawning of your heart.

And if you cannot but weep when your soul summons you to prayer,

she should spur you again and yet again, though weeping, until you shall come laughing.

When you pray you rise to meet in the air those who are praying at that very hour,

and whom save in prayer you may not meet.

Therefore let your visit to that temple invisible be for naught but ecstasy and sweet communion.

For if you should enter the temple for no other purpose than asking you shall not receive.

And if you should enter into it to humble yourself you shall not be lifted:

Or even if you should enter into it to beg for the good of others you shall not be heard.

It is enough that you enter the temple invisible.

Kahlil Gibran

The Chapel Exhibits

An International Creation of Spiritual Beauty

The Netherlands
Andreas Verheijen, AIFD

Northern Ireland
Rev William McMillan MBE
Fr Sean McEvoy
Neill Strain

United States of America
Frankie McDonnell Peltiere, AIFD
Tasha Tobin

Intimations of Immortality from Recollections of Early Childhood

...But for those first affections,
Those shadowy recollections,
Which, be they what they may,
Are yet the fountain-light of all our day,
Are yet a master-light of all our seeing;
Uphold us, cherish, and have power to make
Our noisy years seem moments in the being
Of the eternal Silence: truths that wake,
To perish never:
Which neither listlessness, nor mad endeavour,
Nor Man nor Boy,
Nor all that is at enmity with joy,
Can utterly abolish or destroy!...

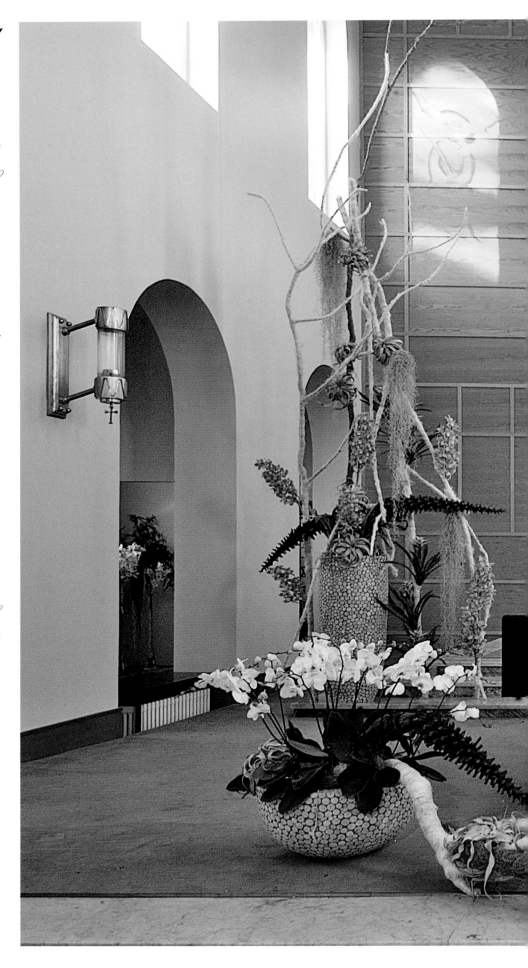

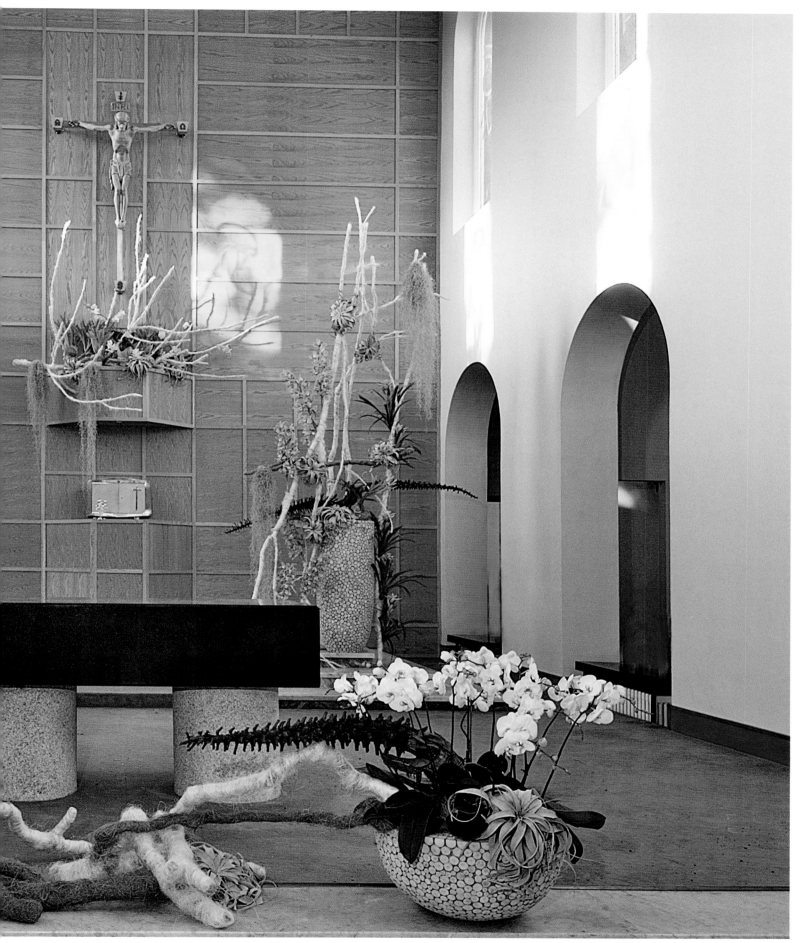

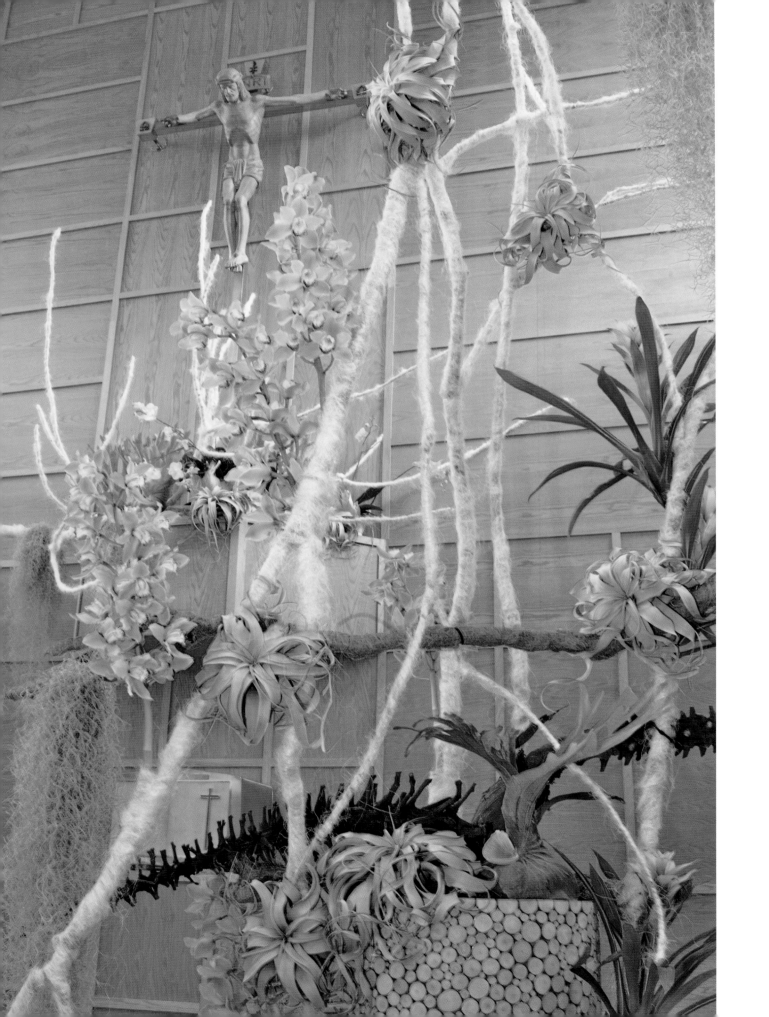

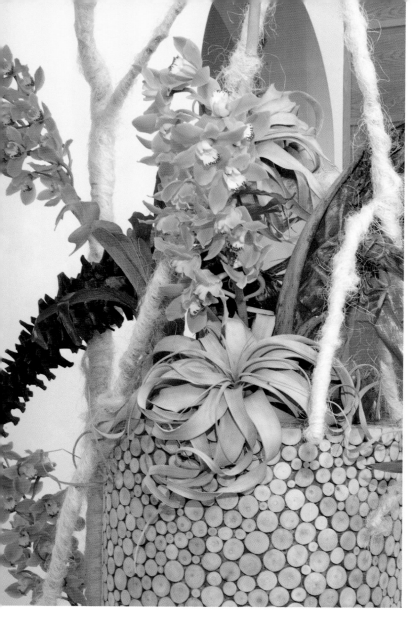

...What though the radiance which was once so bright
Be now for ever taken from my sight,
Though nothing can bring back the hour
Of splendour in the grass, of glory in the flower;
We will grieve not, rather find
Strength in what remains behind;
In the primal sympathy
Which having been must ever be;
In the soothing thoughts that spring
Out of human suffering;
In the faith that looks through death,
In years that bring the philosophic mind.

William Wordsworth

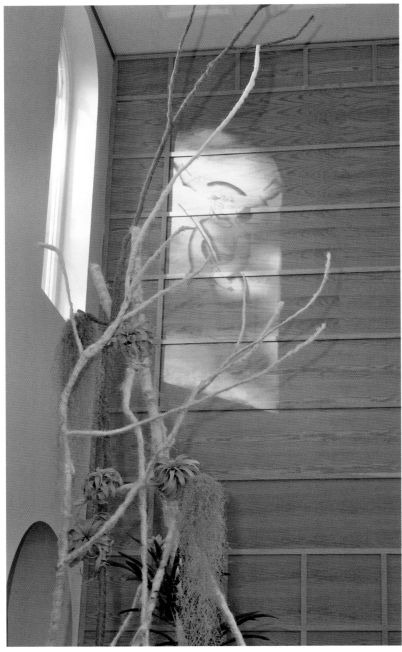

So we saunter toward the Holy Land, till one day the
sun shall shine more brightly than ever he has done,
shall perchance shine into our minds and hearts,
and light up our whole lives with a great awakening light,
as warm and serene and golden as on a bankside in autumn.

Henry David Thoreau

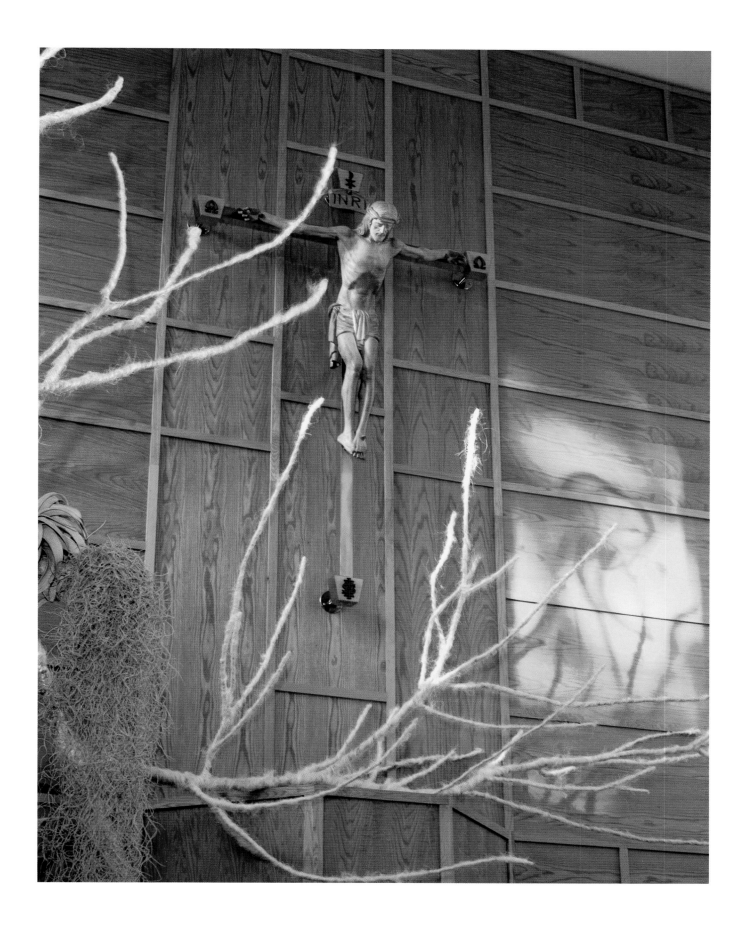

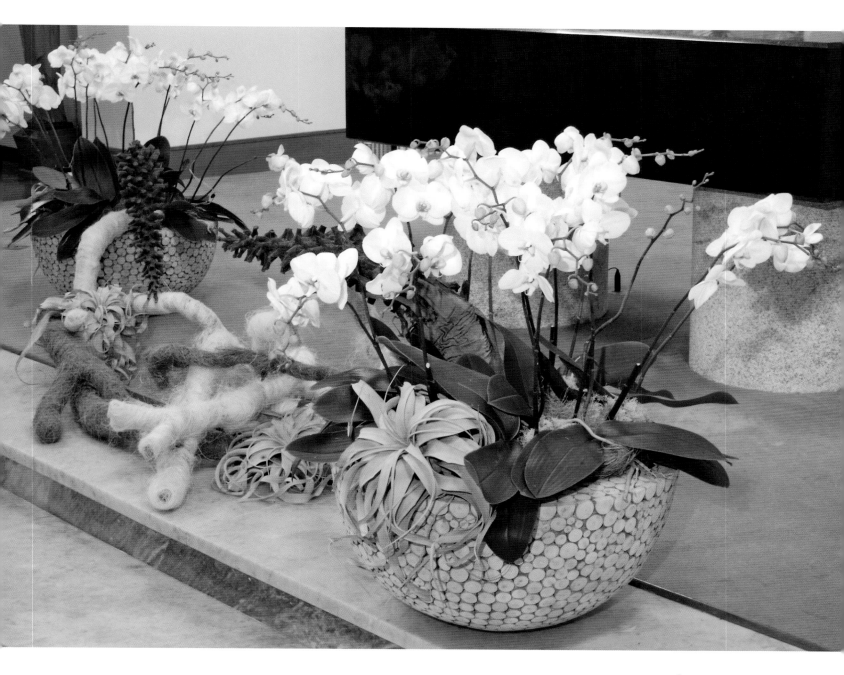

As I dig for wild orchids
In the autumn fields,
It is the deeply-bedded root
That I desire
Not the flower.

Izumi Shiki

The Side Chapels

How aware are we of our own inner life, our spirituality–something so intangible yet so priceless? How much effort do we make to perceive that which is not obvious, which can neither be seen nor heard? I believe the exploration and enrichment of the human spirit is what determines our very humanity. Such enrichment provides an inner compass that can lead civilisations to greatness.

Daisaku Ikeda

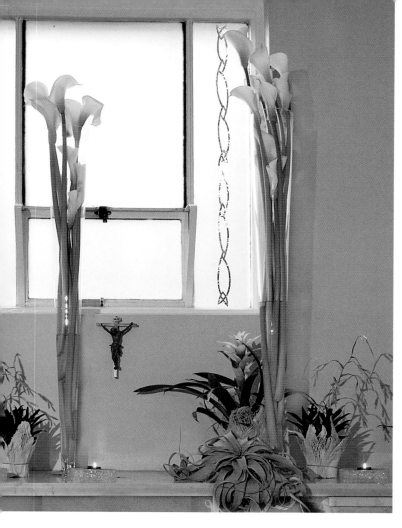

Prayer is not asking.
It is a longing of the soul.
It is better in prayer to have a heart
without words
than words without a heart.

Mahatma Gandhi

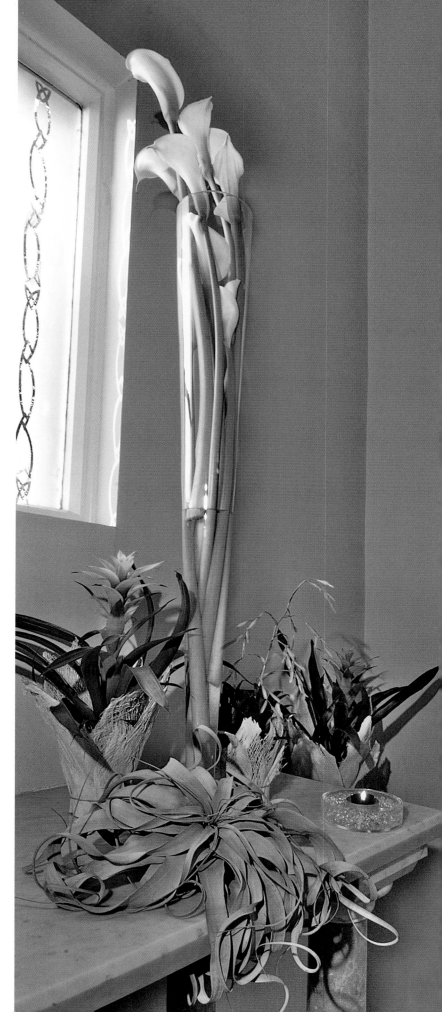

Faith is Light.
The hearts of those with strong
faith are filled with light. A radiance
envelops their lives.

People with unshakeable conviction
in faith enjoy a happiness that is as
luminous as the full moon on a dark
night, as dazzling as the sun on a
clear day.

Daisaku Ikeda

Lead, Kindly Light

Lead, Kindly Light,
amid the encircling gloom,
Lead Thou me on!
The night is dark, and I am far from home –
Lead Thou me on!
Keep Thou my feet; I do not ask to see
The distant scene – one step enough for me.

I was not ever thus, nor pray'd that Thou
Shouldst lead me on;
I lov'd to choose and see my path; but now
Lead Thou me on!
I loved the garish day, and, spite of fears,
Pride rul'd my will: remember not past years.

So long Thy power hath bless'd me, sure it still
Will lead me on,
O'er moor and fen, o'er crag and torrent, till
The night is gone;
And with the morn those angel faces smile
Which I have lov'd long since, and lost awhile.

John Henry Newman

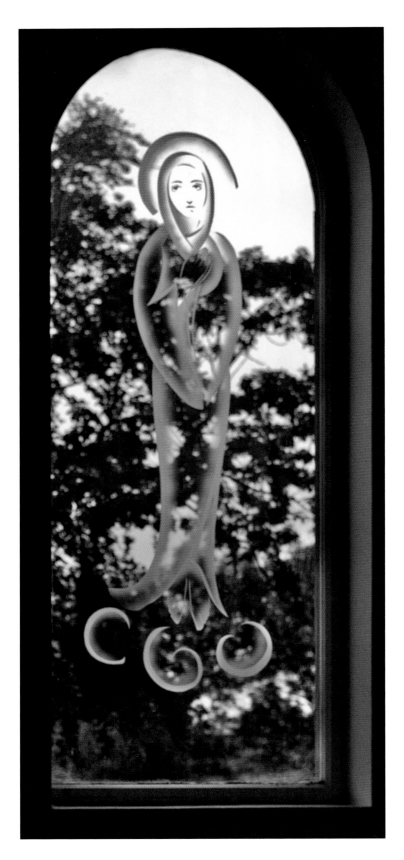

The Teacher's Prayer

...Let me be more mother than the mother herself
in my love and defence of the child
who is not flesh of my flesh.

Help me to make one of my children
my most perfect poem
and leave within him or her
my most melodious melody from that day
when my own lips no longer sing...

Gabriela Mistral

It is not Growing Like a Tree

It is not growing like a tree
In bulk doth make Man better be;
Or standing long an oak,
three hundred year,
To fall a log at last, dry, bald, and sere:
A lily of a day
Is fairer far in May,
Although it fall and die that night—
It was the plant and flower of light.
In small proportions we just beauties see;
And in short measures life may perfect be.

Ben Jonson

Irish Blessing

May the blessing
of light be upon you.
Light on the outside
Light on the inside.

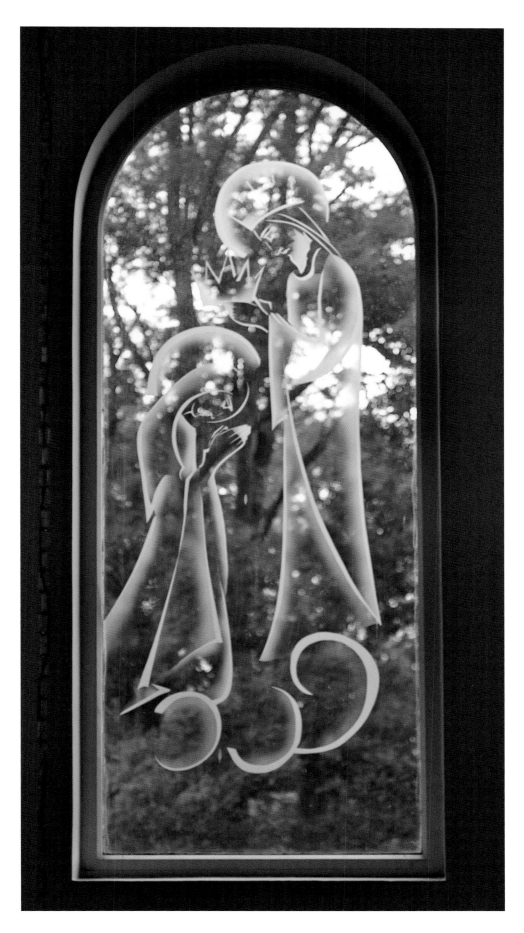

Lord, make me an
instrument of your peace;
where there is hatred, let me sow love;
where there is injury, pardon;
where there is doubt, faith;
where there is despair, hope;
where there is darkness, light;
and where there is sadness, joy.

St Francis of Assisi

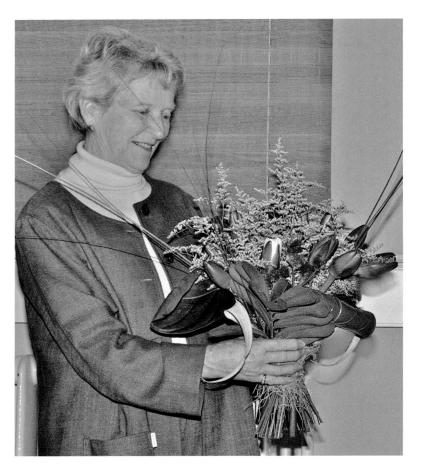

Ireland

Lorna MacMahon

Ardcarraig Garden, Galway

Lorna MacMahon began Ardcarraig Garden in 1971. Her captivating lecture led us on a personal journey of the garden's humble beginnings to its present-day grandeur as one of Ireland's horticultural treasures. With nothing more to begin with than an untidy wasteland of granite rocks with no topsoil, she has created over the years a masterwork of gardening eloquence that now extends over four acres and comprises 17 separate garden areas. Each garden contains plantings that thrive in harmony with the soil and moisture conditions of that particular area. All 17 gardens bear names referring to either the garden's location, the plantings or to the memory of someone special, as shown below in Harry's Garden in memory of her husband. The main Japanese section in the image on the opposite page is in the Japanese "hill and pool" style with a focal point of a genuine *yukimi* (snow-viewing) lantern.

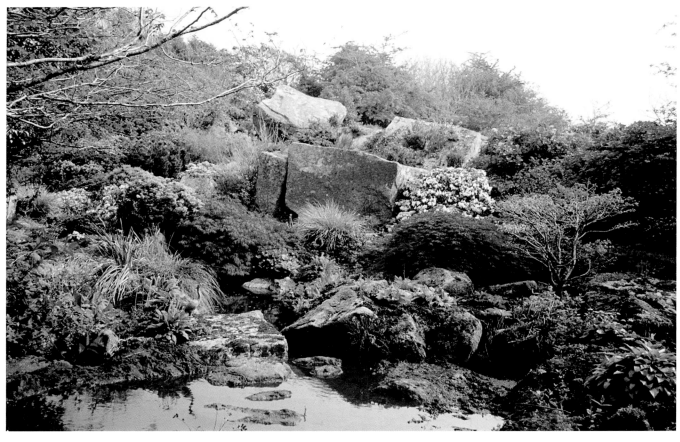

Lectures and Demonstrations at Dromantine

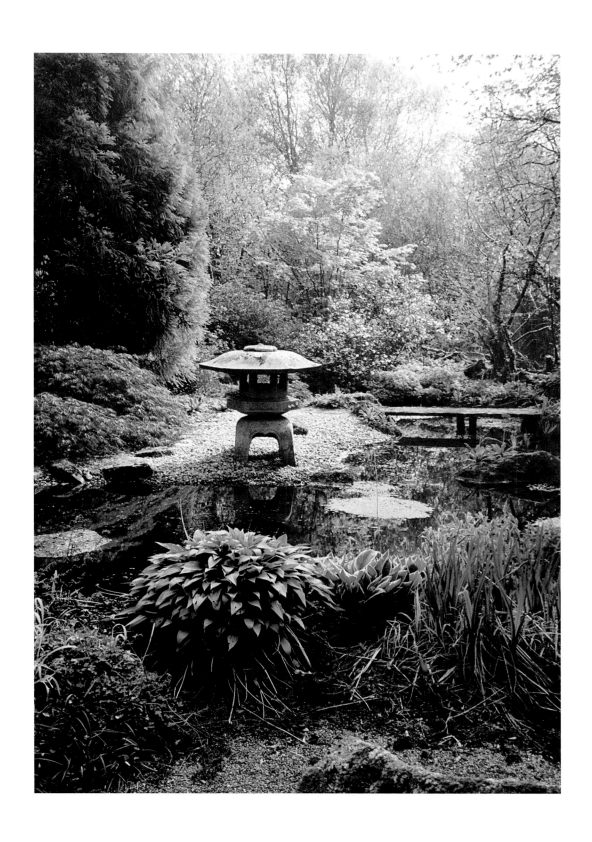

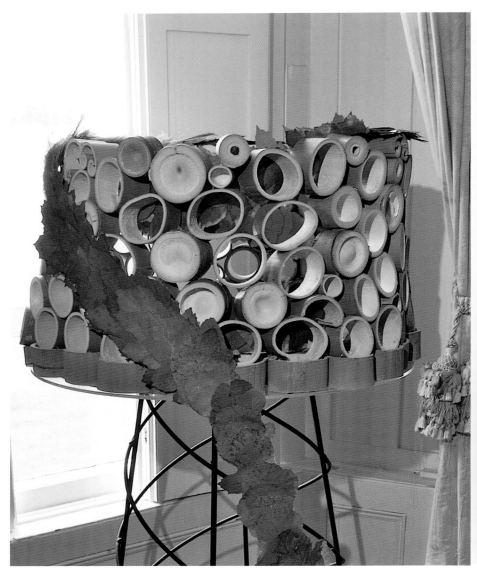

Penny Horne's fascinating lecture, "The Great American Melting Pot," is her answer to Reverend Mac's "simple" request to describe the "American style" of flower arranging at Floral Design 2006. And her answer, simply put, is: there is no real American style. Flower arranging in the United States from its earliest beginnings in colonial times emerged from its European roots and later as it became more formal, from borrowing the best of design styles from Europe. First English followed by Dutch, Italian and French design were incorporated into and fashioned the flavor of flower arranging in America. The lecture, now available in DVD format, leads us on an historical journey of flower arranging in the United States, capturing the multitude of influential people and countries that have shaped the world of American floral design and describing its blossoming through the numerous organizations that now influence and guide its direction. While there is no one standard format of American style, but rather an assimilation of floral design from all over the globe, "The Great American Melting Pot" of artistic creations holds its own place of importance on the very diverse stage of international floral art.

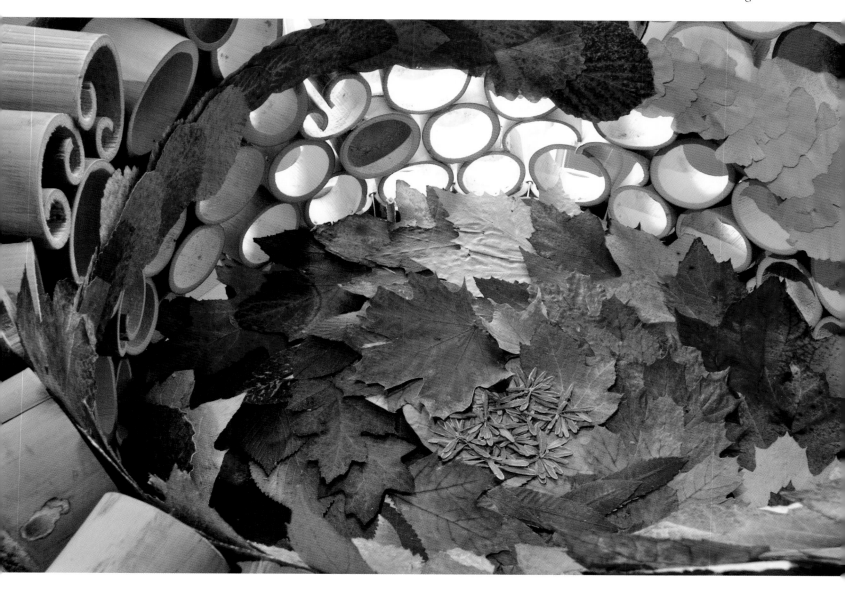

France

HANNELORE BILLAT-REINHARDT

École d'Art Floral de Versailles

SNHF

Société Nationale d'Horticulture de France

As an international judge, demonstrator and teacher, Hannelore Billat-Reinhardt loves and practises all styles of flower arranging: period, classic, contemporary, modern and abstract. Hannelore's arrangements bring us to a whole new level of understanding and appreciation of floral art. At Dromantine, she captivated her audience with a more modern and abstract approach, which she is presently researching with enthusiasm.

Created in the abstract style, which uses no container, bamboo branches are woven together holding a dracaena leaf in a perfectly balanced state of equilibrium. All plant material is natural; however, it is used in a manner that defies nature. Below (left), Hannelore presents a unique arrangement in the modern style, which can have no more than three types of plant material.

Here a container is used, but in a very free and creative manner. The arrangement emerges out of a feeling of the moment; however, while there is great freedom of creativity, there are also rules that must be respected. Below (right) we see another modern approach, but in a softer style. Only two plant materials are used here. The white peonies nestled amidst the woven leaves create a strong contrast of texture and colour.

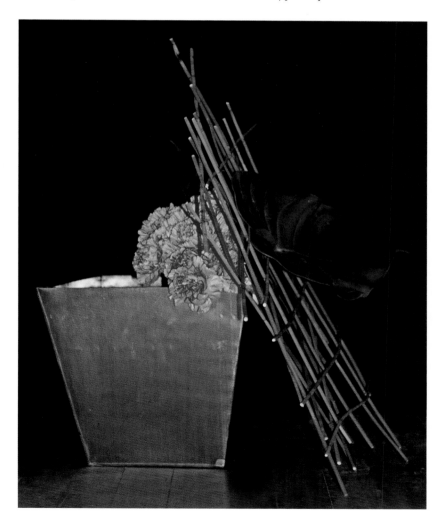

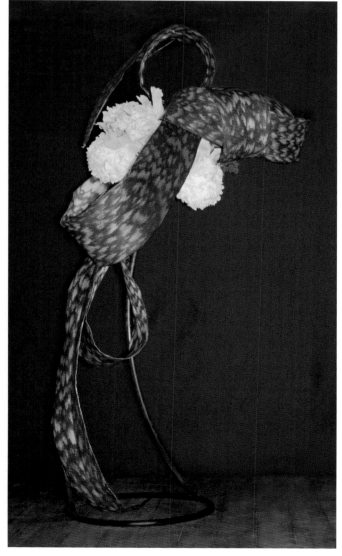

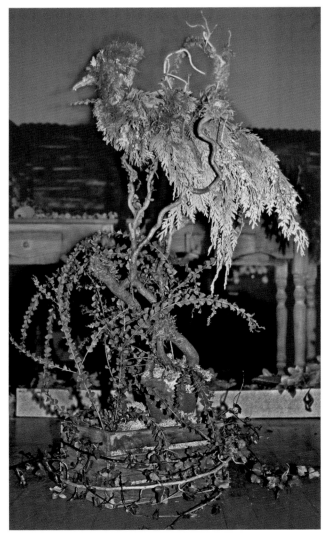

United States of America
MICHAEL WALTER
Lexington Gardens, New York

Michael Walter has defined his own unique style in his work, which is at once beautifully classic and refreshingly modern. To further distinguish his talent, Michael works almost exclusively with dried plant material along with accents of fresh flowers and greens. Using such material as boxwood, poppy pods, mosses, ferns, fruits, berries and even stone, he creates sculptural forms that are not only reminiscent of nature, but also transform and honour it. He is well known for his creative and unique topiary designs, as he demonstrated at Dromantine. Whether Michael creates a tree-sized topiary or a tiny moss-filled pot, his charismatic work demands attention and delights the senses.

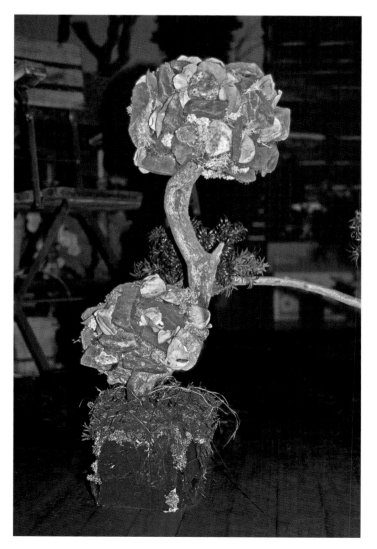
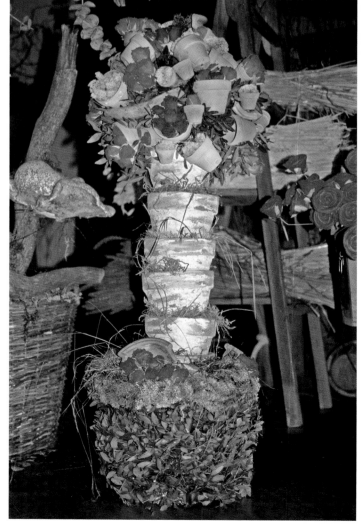

han

IKO SHIRAISHI MANAKO

ako Flower Academy

ako-JAFAS, Paris

ese Association of Flower Arranger Societies

m

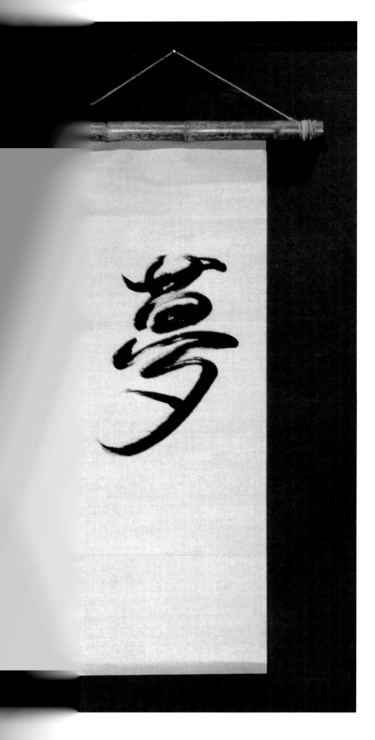

Demonstrations at Armagh

Ode

We are the music-makers,
And we are the dreamers of dreams,
Wandering by lone sea-breakers,
and sitting by desolate streams;

World-losers and world-forsakers,
On whom the pale moon gleams;
Yet we are the movers and shakers
Of the world for ever, it seems.

With wonderful deathless ditties
We build up the world's great cities,
And out of a fabulous story
We fashion an empire's glory:

One man with a dream, a pleasure,
Shall go forth and conquer a crown;
And three with a new song's measure
Can trample an empire down.

We, in the ages lying
In the buried past of the earth,
Built Nineveh with our sighing,
And Babel itself with our mirth;
And o'erthrew them with prophesying
To the old of the new world's worth;
For each age is a dream that is dying,
Or one that is coming to birth.

Arthur O'Shaughnessy

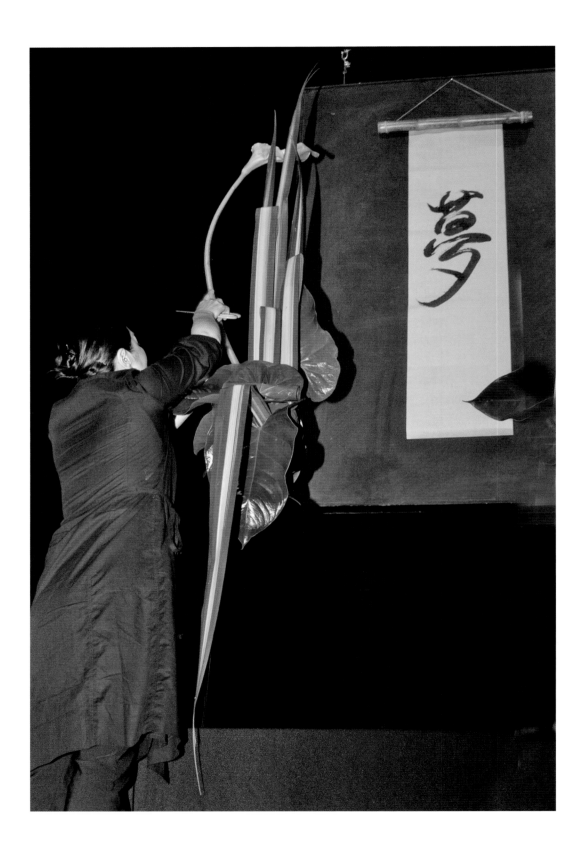

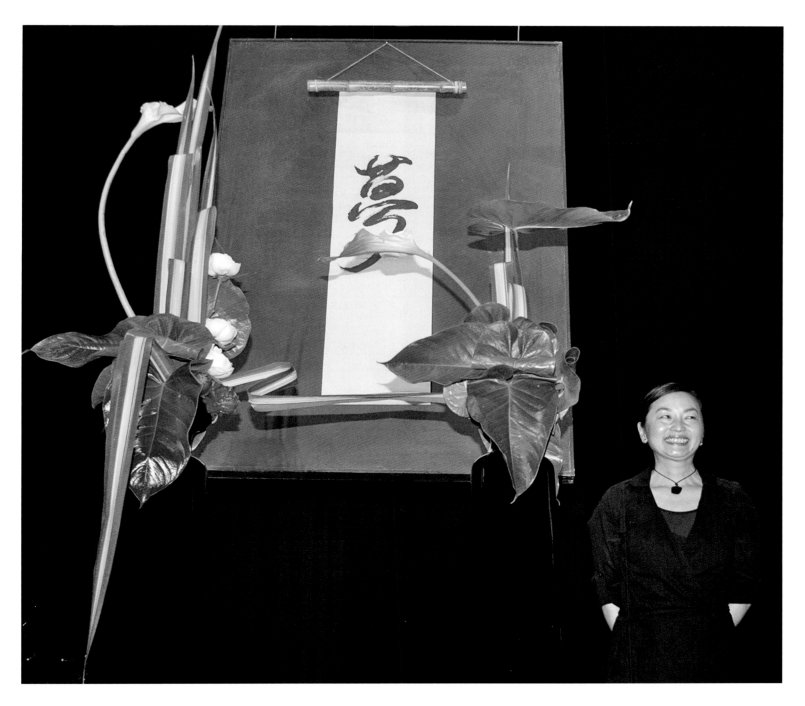

Rumiko Shiraishi Manako captures our hearts and attention with her question "What is your dream?" as she skillfully writes with eloquent calligraphic brush strokes the character *yume,* meaning "dream" in Japanese, on the empty scroll. Providing the audience with a Zen atmosphere, the stage is now set for her to create from "emptiness" a poetic and powerful floral work dedicated to everyone's dreams. The two containers on either side of the scroll represent the world where dreams are constantly drifting, halting, and being manifested. The eternal expansion of space where dreams are freely born is represented by a variety of movement of lines, curves and the flat faces of the leaves. The final creation is a moving tribute to the human quest of creating, nurturing, following, believing in and realizing our dreams.

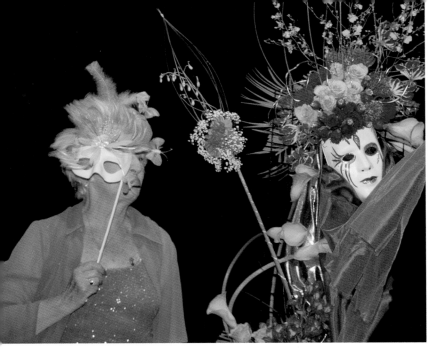

England
PEARL FROST
NAFAS
National Association of Flower Arrangement Societies

Masquerade

Prince or pauper, it matters not within the magic and mystery of a masked ball. The Carnival of Venice was the inspiration for this colourful and elaborate floral display. Theatrical masks, magnificent costumes, brilliant and rich-coloured fabrics, and exotic and vibrant flowers recreate the scintillating atmosphere of this centuries'-old celebratory delight.

Masquerade

Can you sing, can you dance,
can you play?
Always, always, always, live for today.

Come to the ball.
Dance through the hall.
A glorious play for all.
A mask is needed for this play.
Hide thine face, so you can stay.

Watch them twirl and dance.
Behind your mask, watch them prance.
Their eyes, oh their eyes, tell a story.
Of better days, of timeless glory...

Rick Wolfe

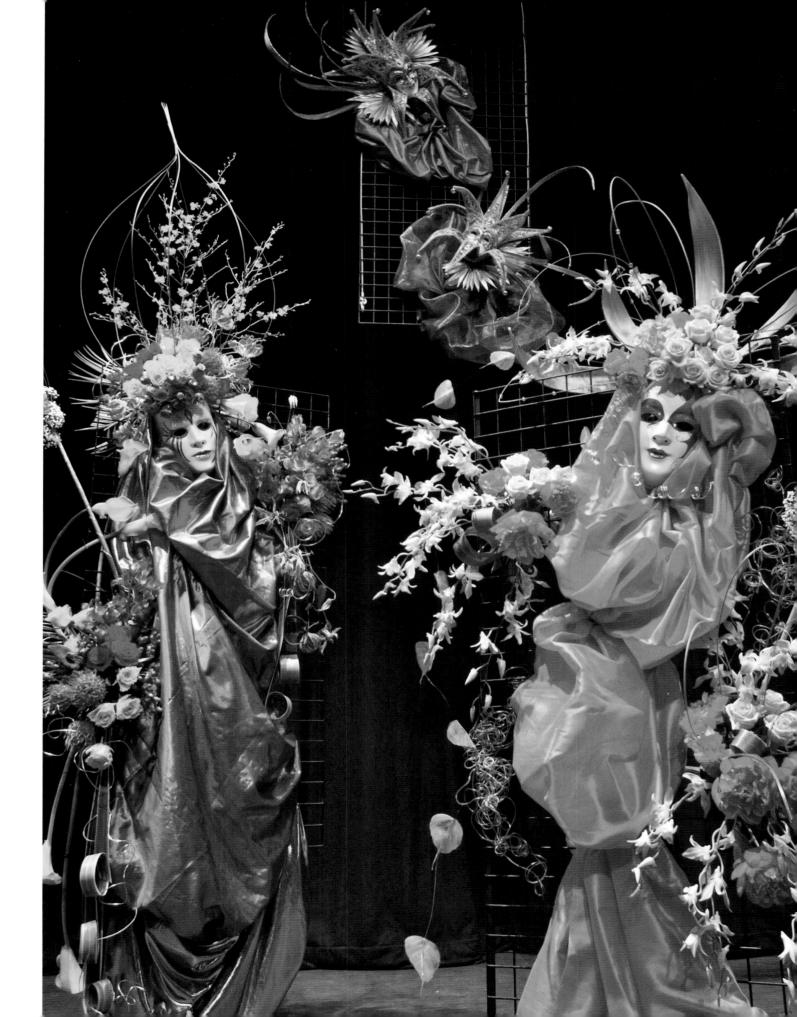

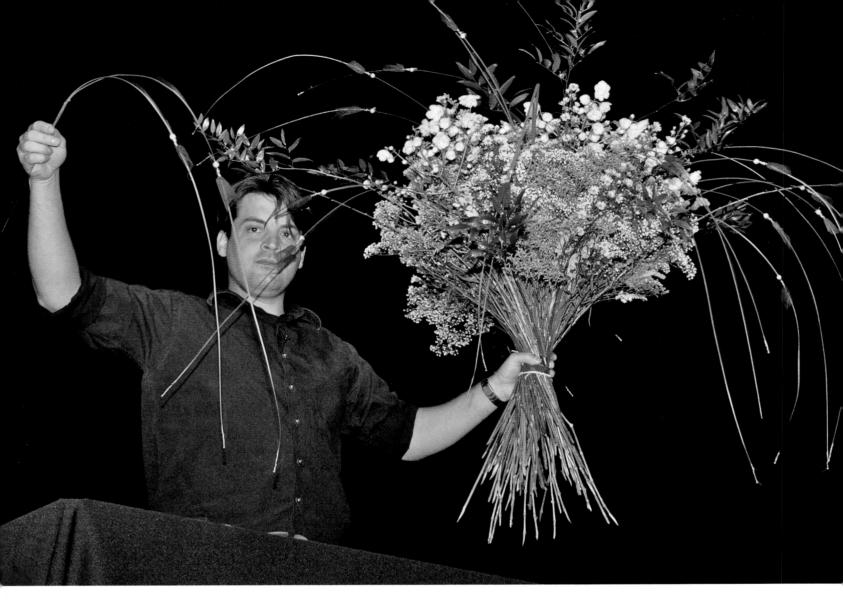

Hungary
FERENC KRUZSLICZ
The Love Whisper of Mr Darcy

The original idea for this romantic hand-tied bouquet came from 18th century novelist Jane Austen's "Pride and Prejudice," whose main character, Mr Darcy, is "every woman's dream." For Ferenc, Dromantine conjured up feelings of being in that age of society. The stately country home, the lake, the lovely hills and the beautiful sunsets all spelled out 100 per cent romance, hence the title, "The Love Whisper of Mr Darcy."

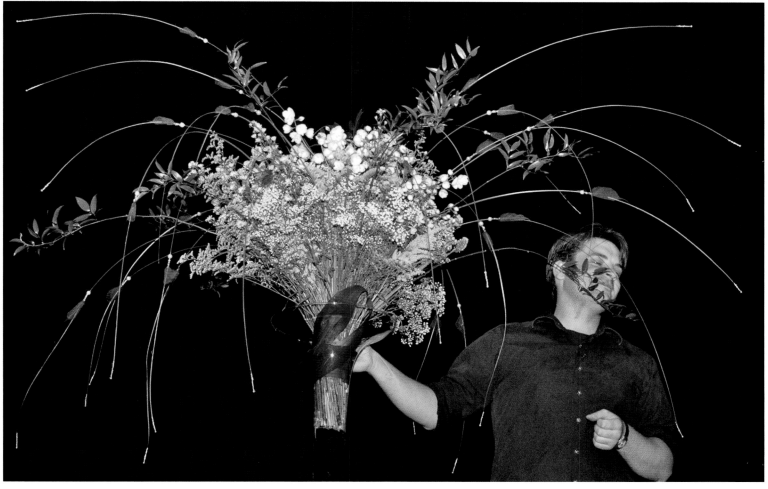

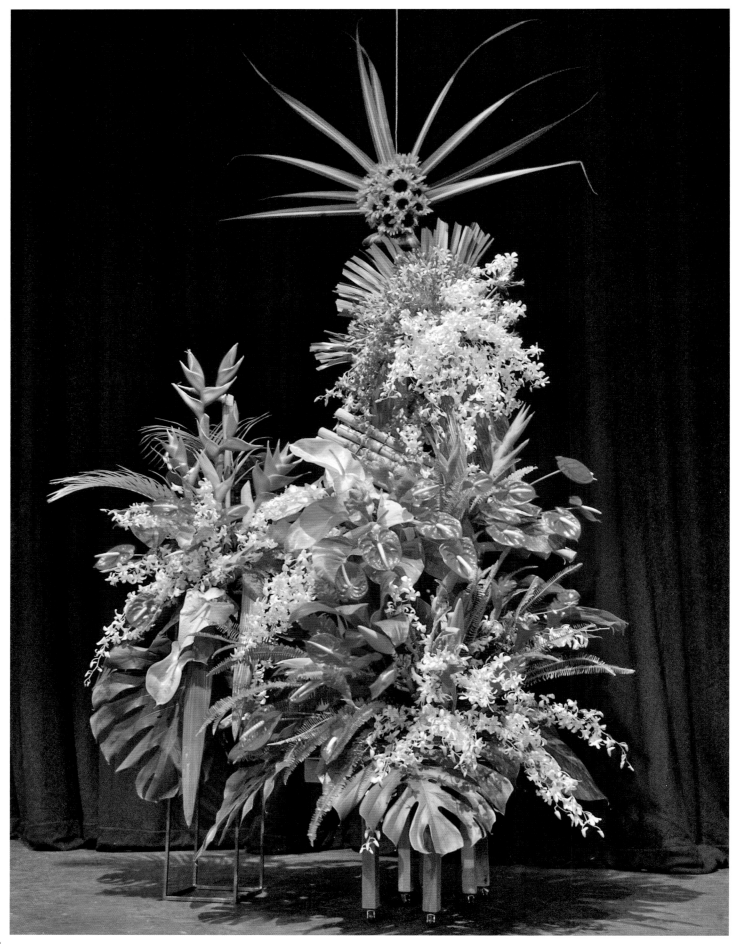

Jamaica

Mrs Ann Ramsay

Island Dreams

A tropical paradise unfolds before our eyes.
A cluster of sunflowers represents the sun
rising slowly, illuminating a clear blue sky of
agapanthus and a dazzling island below. High
mountains of heliconia ginger and anthuriums
rise dramatically among a land of lush green
foliage and cascading waterfalls of white
dendrobium orchids.

By the Brook

The trees tiptoe to touch the sky.
There are blossoms,
And the bird songs never die.
You don't need a shoe
to walk the carpet of green,
white, purple and blue;
to sit on a rock by the brook,
where the air is spiced with wild
ginger lilies, April mango blossoms,
the green wax of cocoa leaves,
the romance of the nude chocolate
and listen to the sound of the water
a quicksilver stir of youth
one minute, that takes
the round sound of woman
the next.

Ann-Margaret Elizabeth Lim

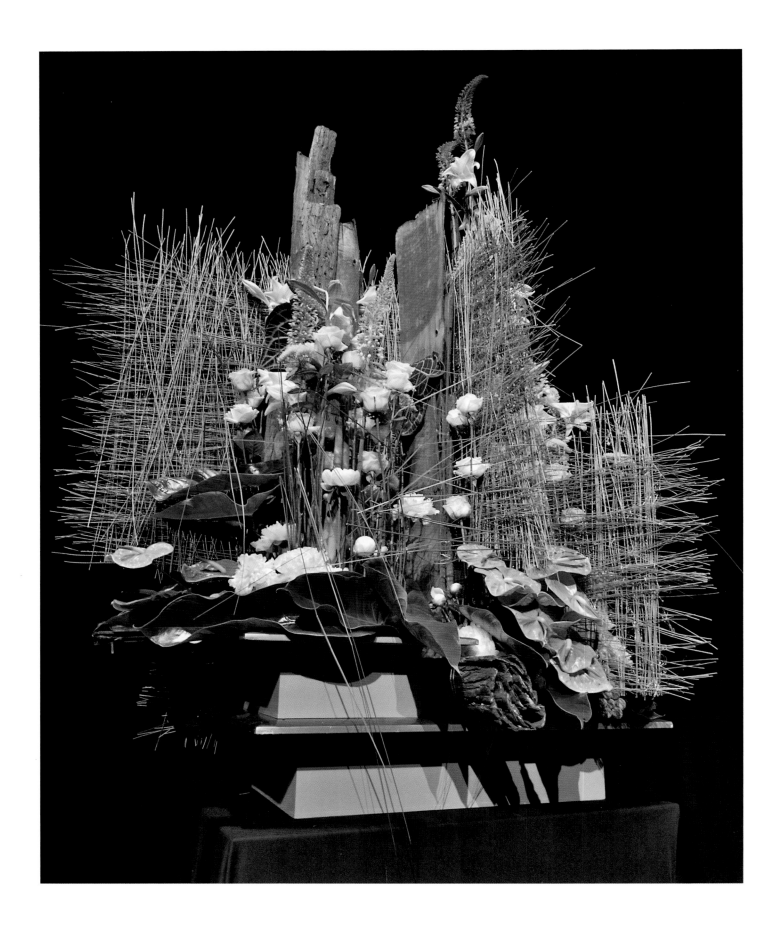

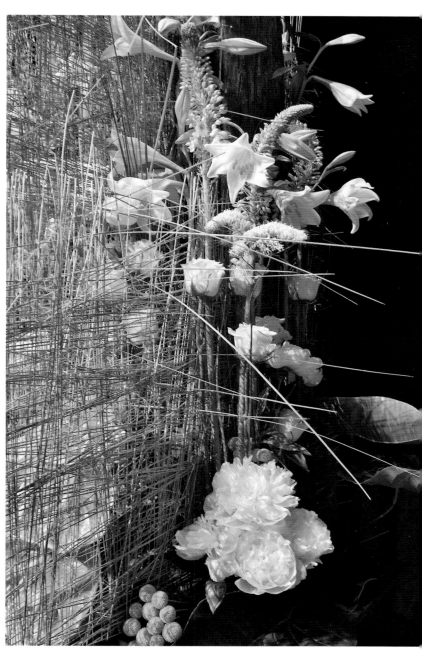

Working with different textures within the same arrangement, Zoltán creates a masterpiece of contrasts. Colours, textures and materials are woven together to create a work that is both airy and heavy, delicate and rough: "A Floral Tapestry of Texture and Colour."

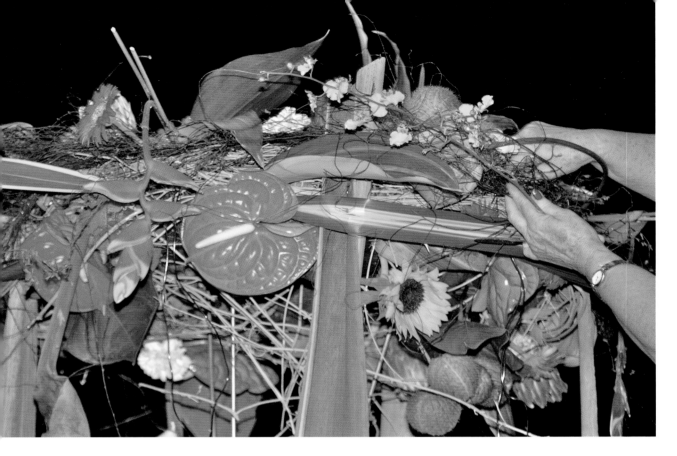

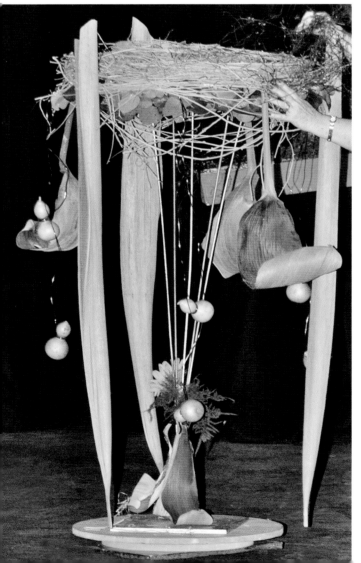

South Africa

ALTHEA HIGHAM

South African Flower Union

Contemporary African Rhythms

In a dramatic display of floral wizardry, the major portion of the arrangement is slowly lowered and attached to the base which has just been created on stage. Dramatic and unique, the suspended design of African plant materials – palm spathes, strelitzias, proteas, gourds and asparagus varieties – arranged in a contemporary transparent style achieves an Afro-European fusion of movement, texture, scale and design.

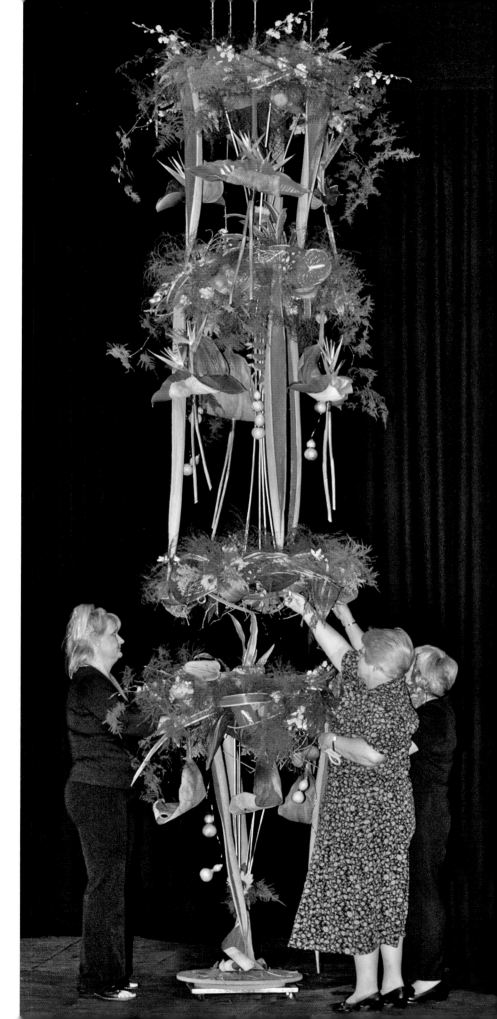

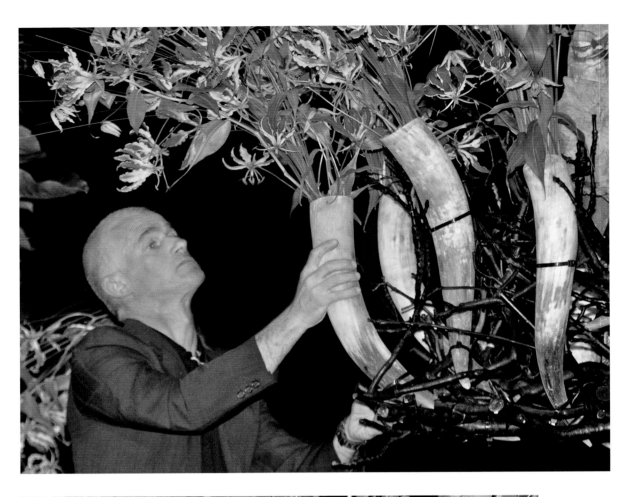

The Netherlands
ANDREAS VERHEIJEN, AIFD

A Floral Chandelier

A magnificent floral chandelier soars above the stage evoking all the drama of "The Phantom of the Opera." An abstractly woven metal structure forms the bones of the chandelier in which are placed real animal horns filled with a profusion of gloriosa lilies nestled amongst tropical flowers and foliage. Slowly a variety of other flowers are added, gradually building the chandelier to its full grandeur. The final collar of dangling glass vases filled with orchids, anthuriums and calla lilies gives the floral chandelier its touch of crystal elegance.

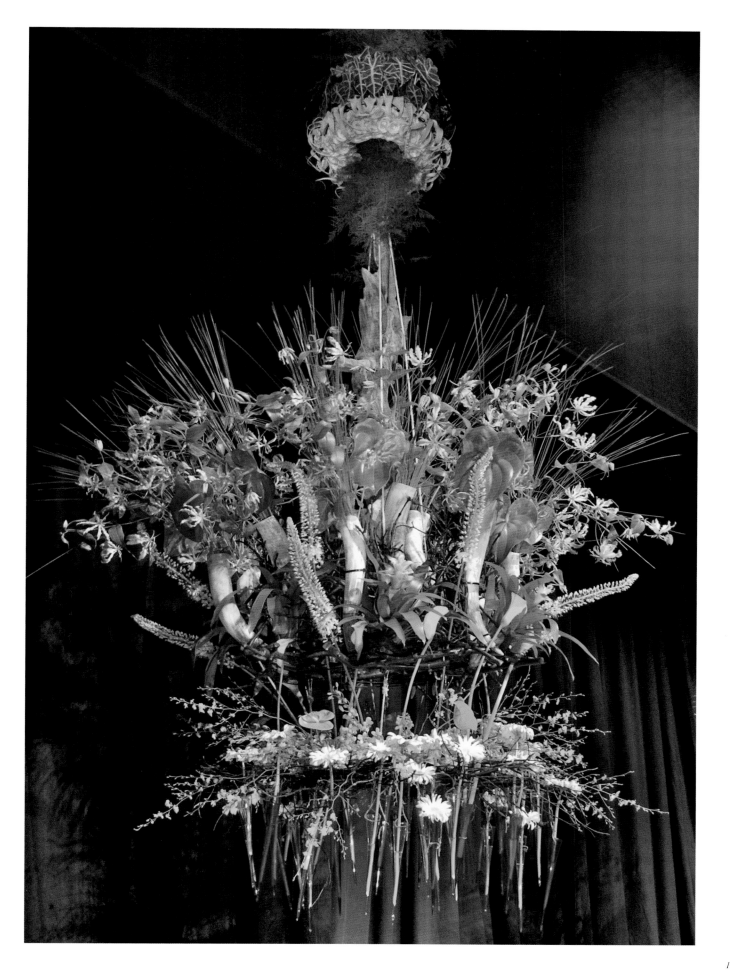

Japan

YASUKO MANAKO

School Master, Manako Flower Academy

President, Manako-JAFAS

Japanese Association of Flower Arranger Societies

East and West

Yasuko Manako delights the audience with one of her original demonstrations, "*Rikka-cho,* Fresh," creatively enhanced with her own gifts of dance and music from various countries. This performance of music, dance and floral design has been introduced worldwide as the "best of the best of East and West."

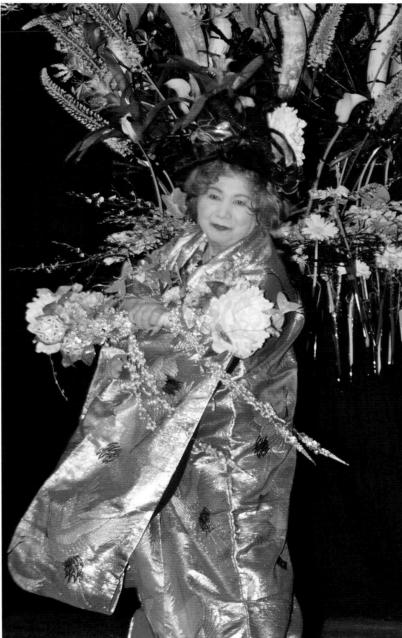

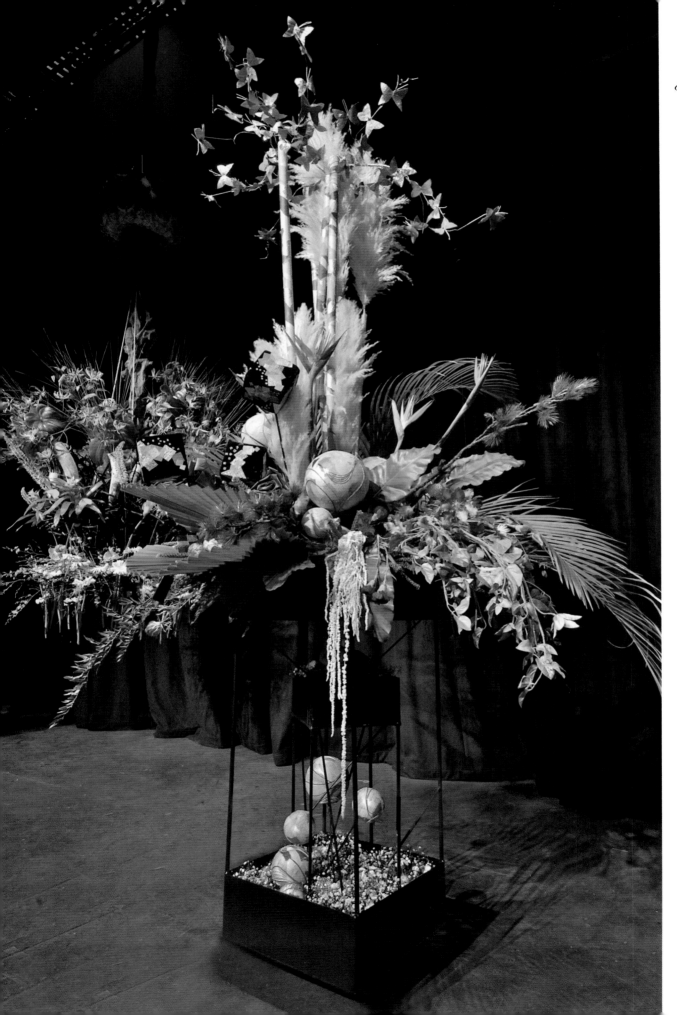

A World of Dreams

GRAND FINALE

Make the universe your companion,
always bearing in mind the true nature of things –
mountains and rivers, trees and grasses, and humanity –
and enjoy the falling blossoms and scattering leaves.

Issa

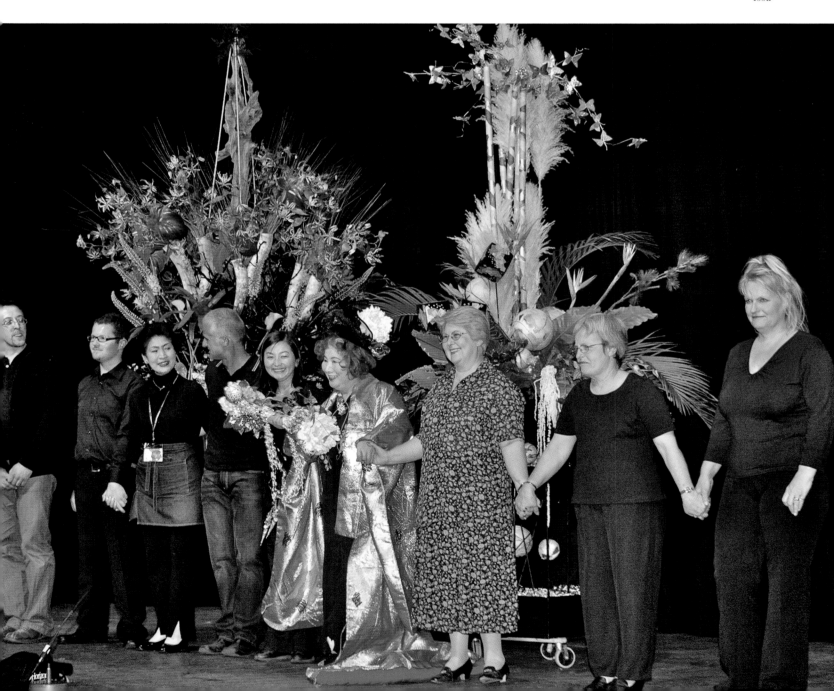

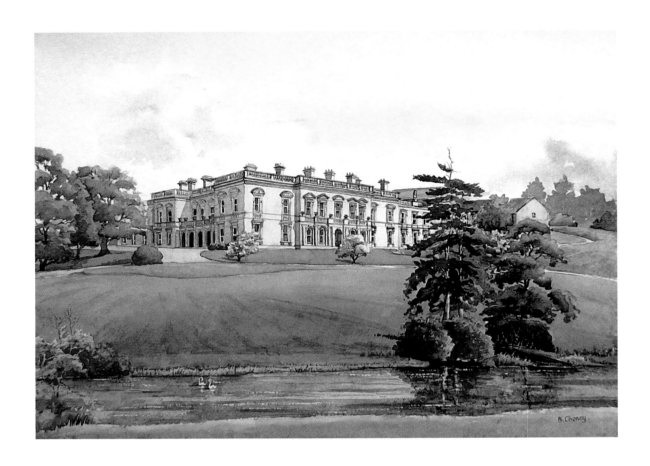

Dromantine Today

Dromantine in varied and novel ways, such as Floral Design 2006, continues to present an African worldview built on the integration of all aspects of life in an interconnected and mutually dependent world. In addressing our local and global challenges, it is recognised that the SMA can build bridges contributing to change by addressing some of the challenges of today. In what we do and in the way we do it, we are acknowledging the place of the spiritual. As human beings in the human community, we have an intimate relationship with all living and inanimate things around us. We are called to co-create the world with God, calling us to new types of witness. In a world overly individualistic, we are called to create authentic community; in a world overly materialistic and self-indulgent, we are called to treasure relationships, genuine love and care, and respect for all. Faithful to these aims, SMA at Dromantine continues to develop as a centre for the promotion of the mission of the Church, for the highlighting of African affairs, for the deepening of spirituality among all peoples of Ireland, and for the promotion of peace and reconciliation among all peoples of the world.

Fr P J Gormley SMA
Superior of Dromantine

Dromantine History

An Ancient Manor of Magenis

> Lord of the nobel clann Aedha
> Magenis the illustrious and beautiful
> They selected the warm hilly country -
> They were the lards of all Uladh.

The colourful and often turbulent history of the land we now know as Dromantine reaches back into the Middle Ages, to the illustrious and ancient clan of Magennis, who dominated the region of Upper Iveagh from the 14th to the 17th century. The above lines of the 14th century poet John O'Dugan pay tribute to this distingushed clan. From the early days, the Magennises had possessed their tribal lands in the traditional Irish system of land tenure. However, in 1607, Sir Arthur Magennis, Chieftain of The Glen, submitted to the English system of freehold tenure of land and in 1611, estates were carved out of the old tribal lands for 44 of the chief clansmen.

One of the clansmen to acquire an estate was Murtagh Macanespy Magennis, already an impoverished gentleman when he received the title-deeds to his estate, which consisted of some 4,200 acres within the precinct of Clanaghan. The property remained in the family for three generations; however, these were sad and difficult years for the landlords of old Irish stock. The years were fraught with conflicting loyalties, religious wars and confiscations, broken treaties and harsh penal laws. Murtagh's children struggled through the worst of them, grimly holding onto their inheritance until, overtaken by debt in 1741, they were forced to sell out to satisfy local Newry merchants, who had been eager to advance money to needy landowners.

The Scottish Family Innes: New Owners of the Manor of The Glen

In July 1741, the Manor of Clanagan, as it was then called, passed from the possession of the Magennises, who had held it since 1611, to the new owners of the Manor of The Glen, who were a Scottish family named Innes, descendants of the Lairds of Leuchars, Fife. The whole manor with its lands, rights and privileges was bought by John Innes's executors for the sum of £11,450, with £10,705 going to pay off debts and encumbrances. Five generations of the Innes family revered Dromantine as their home until 1921. With legitimate pride, they worked to beautify it over the years until it merited as one of the loveliest residences in the country. However, this was not accomplished without overcoming numerous obstacles and setbacks along the way.

The following 60 years from the time of purchase were fraught with legal and financial difficulties; however, after 30 years of sound investments and careful management, the estate, which in 1804 had fallen to Arthur Innes, was sufficiently solvent to bear the expense of building a new house and improving the demesne.

The picture of Dromantine of those days was very different from that of today. The old manor house, probably built in the 1640s by the Magennises, was a roomy L-shaped building. Arthur decided not only to build a new house for his family, but to change the face of Dromantine into what we see today. He constructed a fine mansion in the late Georgian style and the family took up residence in their new home by the summer of 1810. Arthur extended the demesne boundaries from 200 to over 300 acres, and built new roads around them. He also put great effort into beautifying the grounds by planting many trees, damming a lake and creating an intricate system of avenues and walkways. The two gate lodges were built and the public road from the front gate to the Belfast-Newry Road was made. A walled-in garden, orchard, coach, stable yard and farmyard were also provided at this time.

Arthur Innes deserves to rank with the greatest of his family. When he died in 1820, he left a new Dromantine that was a magnificent memorial to his genius, courage and good taste. These praises, however, are chastened by the hardship inflicted on those tenants whose farm holdings were confiscated, either wholly or partially, for being within the new demesne boundaries.

The son, who came into the property when Arthur died, was also called Arthur. He died young leaving his infant son, again named Arthur, to inherit the now magnificent estate and manor house. This Arthur also died at a young age, in turn leaving an infant son, Arthur Charles, to inherit Dromantine. In 1858, Arthur Charles married, and the following year, he set about realising his dreams to make his home more stately and imposing. Mr Curdy, an architect from Dublin, proposed to give the interior a more Italian Renaissance style by adding ornate cornices and mouldings. One sees many examples of where the interior has been changed from Regency to High Victorian.

The Manor is Sold and Passes from the Innes Family

Arthur Charles lived through the stormy years of the Land Agitation and died in 1902, the year before the Irish Land Purchase Act was passed. Six years later, his tenants bought out their farms so that when his son, Arthur Charles Wolsely, came of age in 1909, his inheritance was reduced to little more than the demesne of Dromantine. The tables had been turned in favor of the tenant farmers.

During the turbulent years in the early 1900s, Dromantine was used as a base to train the Ulster Volunteers, with guns from the Larne gun-running. Following a stint in the First World War, the young Mr Innes-Cross abruptly took his leave from Dromantine for political reasons. He sold the property in 1922 to Mr Samuel J McKeever, in whose possession it remained until 1926.

Society of African Missions

At this time, the Society of African Missions (SMA), an international missionary body founded in 1856, was looking for a suitable location for training their missionary students for Africa. In April 1926, their Superior, Fr Maurice Slattery, bought Dromantine for £6,900. The following September, the stately old mansion entered a new and more glorious phase of its history when it opened its doors to 47 seminary students from the four corners of Ireland. They quickly grew to love their new alma mater and settled down to the work they came to do, and in June 1927, Bishop Mulhern raised to the priesthood in Newry Cathedral the first 11 of the 600 African missionaries who have since passed out from Dromantine.

It soon became evident that the house needed to be extended to cope with the ever-increasing number of students. In 1931, a building programme began, which included St Patrick's wing on the north side of the house and St Brendan's and the large chapel on the west side. These buildings were kept in the same neo-classical architectural style of the original building and hence added greatly to the grandeur of the demesne. These were opened in 1937, and St Colman's wing was added with an assembly hall in 1959.

In 1972, a decision was made to move all the students to the more central location of Maynooth. Following this, Dromantine became a house for promotion of the missions of the church: keeping Africa and African issues in focus. It began to offer retreats, seminars, workshops and conferences in response to the needs of Christian people, assisting groups involved in promoting peace and reconciliation and inter-church dialogue.

To meet the growing demands of a more sophisticated population and to stem the deterioration of the old buiding, help was sought to finance the considerable job of renovation. In 1998, a grant from the Heritage Lottery Fund of £750 million was made available to get the renovation of the old listed building off the ground. The SMA also carried out extensive renovations to what had been the seminary.

In 2001, the 75th anniversary of the arrival of the SMA in Dromantine, the refurbished building was re-opened along with the Retreat and Conference Centre, which now offers 65 en-suite bedrooms with catering facilities and a range of modern, well-equipped conference rooms. The Centre is now open to conferences, retreats and study courses to people and organisations of all faiths dedicated to peace and reconciliation.

The history of Dromantine has followed many paths along its journey to its present mission in the 21st century. In addition to its continued missionary efforts, Dromantine welcomes into its fold a widely diverse group of people and cultures that nurtures a mutual respect for the diversity of the world in which we live.

Participants

The Committee for Floral Design 2006

NORTHERN IRELAND

Yolanda Campbell
Rae Dodds
Marie Gillanders
Fr P J Gormley SMA
Pat Leahey
Joan Lockhart
Fr Sean McEvoy
Rev William McMillan MBE
Ian McNeill
Bernie Monaghan

Mary Pearson
Ann Traynor
Susan Turley
Pauline White

IRELAND

Fr Eamonn Finnegan SMA
Kitty Gallagher
Nuala Hegarty
Malcolm Kitt
Dr Elma Moore

Northern Ireland

Mrs Doreen Adams, guest
Elizabeth Allen
Betty Birney
Muriel Davidson
Sandra Dorrian
Joan Johnston
Miss Evie Kent, guest
Hilda McClements
Evelyn McDonnell
Elma McDowell
Barbara McGarry
Rosslind McGookin
Sheila McMillan
Elizabeth Rea
Neill Strain
Hugh Turley

Ireland

Betty Birney
Mary Coughlan
Marie Dodrill
Bridie Dowling
Olive Flynn
Richard Haslam
Angela Kelly
Lorna MacMahon
Maura Murphy
Madeleine O'Hanlon
Mary O'Keeffe
Felicity Satchwell
Monica Redmond
Nuala Treacy
Christopher White

The Netherlands

Andreas Verheijen

France

Hannelore Billat-Reinhardt
Rumiko Shiraishi Manako
Nicole Siméon

Hungary

Zoltán Kiss
Ferenc Kruzslicz
Janos Szabe

Belgium

Spain

Sheila Mowat

Scotland

Heather Barr

England

Judy Alder
Jill Alford
Margaret Baker
Audrey Balderstone
Eileen Barraclough
Vicky Barry
Annie Beagent
Barbara Burr
Anne Codd
Bridget Cohen
Rita Cole
Margaret Cooper
Jacky Eyre
Susan Fairhurst
Jan Faulkner
Pearl Frost
Gwen Hancock
Mrs I Jackson
Sheila Jackson
Susan Ann Kehoe
David Lloyd
Jenny Mellors
Angela and Steve Merryfield
Joy Murphy
Mary Napper
Jane Neatby
Valerie Palfrey
Irene Ann Parker
Susan Phillips
June Pitts
Jean Plaskett
Sandra Price
Yvonne Saunders
Val Seed
Pat and Roger Stanley
Anna Subba Row
Linda Taylor
David Thomson
Heather Tomson
Vikki Traherne
Rose-Marie Tree
Athena Tulba
Margaret Webster
Margaret Williams

Isle of Man

Annette Bratt
Leonore Fitton
Brenda Garrad
Eileen Gill
Cindy Quirk
Shirley Reid
Beryl Whiteway

Channel Islands

Ann Bushell

Trinidad and Tobago

Janice Barnes
Janice Benjamin
Joan Hampton
Pearl Barbara Iffil
Georgia Raj Kumar
Enid Lashley
Cheryl Mahon
Shirley McAlpin
Joyce Mungal
Chloe Paul
Ingrid and Mario Young

Jamaica

Juanita Fuertado
Olive Rose Henry
Lucille Levene
Novlette Phillips
Mrs Ann Ramsay
Sharon Sinclair
Cicely Tobisch
Carice Wright

Barbados

Joan Linton
Angela Owen
Anita Yarde
Megan Weekes

Japan

Keiko Brugherolles
Sonoe Fujimoto
Yasuko Manako
Masuko Nuruse
Kazuko Okawa
Harue Sato
Setsu Shimozawa
Chieko Shiraishi

United States of America

Judy Allrich
Carol Asher
Betty Brown
Bliss Caulkins Clark
Susan Dutcher
Melinda Earle
Lydia Galton
Audrey Gonzalez
Judy Harrold
Penny and Ted Horne
Maryglen Kieckhefer
Miriam Lewis
Jan Linkenbach
Mr and Mrs McClellan
Mieko Obermuller
Frankie McDonnell Peltiere
Maribeth Price
Jill Stapleton
Tasha Tobin
Jeannie Vanderame
Michael Walter

Canada

Beth Frost
Georgie Lefroy
Maureen Naylor
Claudette Smith

Uruguay

Graciela Betizagasti
Maria del Carmen Leis
Rosario Enrique Fazzio
Marta Lorenzo Pereira
Octavio Sciandro
Magdalena Sienra de Pacheco
Rosemarie Symond Chilibroste

South Africa

Helen Barnard
Helen Bellew
Beverley Bosenberg
Lynn Clark
Joan Dooley
Yvonne Eijlers
Dawn Fallet
Fay Fenn
Shirley Gillitt
Jean Hancox
Vaughn Harrington
Pam Harvey
Althea and Gerry Higham
Linda Larratt
Elbeth Liebenberg
Henriette Louw
Marjolijn Malan
Carolynne Spiers
Beverley Westhof
Jane Whitby

Swaziland

Sandra Forbes
Margaret Dean Smith

Zimbabwe

Morag Flight
Lynda Grace
Margaret Anne Shattock

Acknowledgements

Some things are meant to be. This book is one of them.

United by a love of flowers, floral designers came to Floral Design 2006 from all corners of the world in the spirit of sharing life-to-life inspiration. It was a remarkable collaboration of the human spirit that created an oasis of respect and friendship among a very diverse group of people, dissolving all national, religious and cultural boundaries, which can often separate and divide. It was my honour to record this extraordinary event with my heart and with my camera's eye. From the moment I heard that Floral Design 2006 was in the works, I knew that the gathering would be unique and merited a book in its honour. It is my joy to see this dream fulfilled.

Without my treasured friendship with Reverend Mac and his wife Sheila, this book would not have happened. They welcomed me into their home and family and introduced me not only to Dromantine and SMA, but also to beautiful and mystical Ireland, a land and people I have grown to love. I thank them from the bottom of my heart. Indeed, Reverend Mac's friendships and the respect he enjoys from all those who attended were the driving force behind the magnitude and success of this international gathering.

While the planning of Floral Design 2006 was well in progress, the book idea had its official beginnings at a meeting around the grand dining table at Dromantine one winter afternoon in 2005. Fr P J, Fr Eamonn, Reverend Mac, Bernie and myself discussed at length the possibilities of this exciting project. I thank them most sincerely for listening to my proposal, capturing my spirit and nurturing the seeds of enthusiasm that were planted that day. Individually and together, they were instrumental in the success of the symposium and the making of this book.

Many thanks to Sr Mary and to all the fathers who so warmly welcomed me into Dromantine and made me feel at home while I was there. And special thanks to those who were so kind to taxi me into town and back, especially Fr Des, Fr Mossie and Fr Peter T, who were also delightful company. A sincere thank-you to Fr Fachtna for his time and interest in my work and his valuable contribution to this book. Thank you to Fr Tom C for offering his photography skills at the eleventh hour. Thank you to Fr Kevin M for his enthusiasm and support. And to Fr Peter Devine (Doc), who passed away in January 2007, I thank him for his friendship and the much-appreciated extra help he gave to the floral designers.

Thank you to all the staff at Dromantine who made my stay so enjoyable while I was photographing the event, especially the kitchen staff who fed everyone so well and the office staff who cheerfully helped with all communications.

Thank you to Penny Horne for offering her help and support in our many telephone conversations and for the images she contributed on pages 130 and 131, and the bottom of pages 132 and 133. Thank you to Lorna MacMahon for the beautiful images of her garden on the bottom of page 126 and page 127, which she took especially for the book. Thank you to Beth Cheney for her lovely watercolour of Dromantine and the lake on page 154.

Thank you to Mike at Prism Photographics, whose extraordinary production skills and knowledge of colour were paramount in the successful making of this book. A sincere thank you to my editor and friend Jean, whose eye for detail knows no bounds, and again to Bernie for staying with me to the very end.

Thank you to all the floral designers who exhibited, assisted and participated in this extraordinary event. Each individual contribution, be it an active or supportive role, was significant and contributed to the unified success of the festival. The images reveal the high level of dedication, expertise and creativity that each designer possesses.

Thank you to Fr P J and Bernie for their help in the research of the poetry selected. The works have enriched the book and bring new life and depth to the floral creations.

Thank you to all the poets long deceased whose timeless words of beauty and inspiration remain their living legacy for our enjoyment in this book. And a very special thank-you to those living poets whose work appears, especially poet laureate Dr Daisaku Ikeda, who so generously offered the use of numerous poems celebrating the beauty of life and the human spirit.

Many hands not mentioned here had a hand in the creation of this memorable event. I thank each and every one of them.

And lastly, but always, thank you to the flowers that have the power to soothe, inflame, inspire and restore the human heart.

PAMELA J